Introduction to Museum Work

Second Edition, Revised and Expanded

G. Ellis Burcaw

The American Association for State and Local History

Nashville

First Edition 1975
 Second Printing 1976
 Third Printing 1978
 Fourth Printing 1979
Second Edition, revised and expanded, 1983
 Second Printing 1984
 Third Printing 1986
 Fourth Printing 1987
 Fifth Printing 1989

Library of Congress Cataloging-in-Publication Data

Burcaw, George Ellis, 1921-
 Introduction to museum work.

 Bibliography: p.
 Includes index.
 1. Museums 2. Museum techniques I. Title
AM5.B88 1983 069.5 83-15520
ISBN 0-910050-69-4

Contents

Preface

Since its first publication a few years ago, this book has achieved a worldwide reputation and has been accepted by the Documentation Center of the International Council of Museums as exemplary of museum training that reached its standards. According to reports, it is used as a textbook in museum studies programs in Australia, India, Czechoslovakia, Italy, England, Brazil, Venezuela, and elsewhere in addition to its widespread use in North America. It also serves as a convenient summary of contemporary museum theory and practice for museum workers everywhere.

In the eyes of our colleagues in other parts of the world, *Introduction to Museum Work*, deservedly or not, represents the museum professionalism of Western countries and has been so referred to in their publications.

Few attempts, if any, have been made by others to provide the fundamentals of museology (embracing all kinds of museums and all kinds of museum work) for the student preparing for a museum career and for the beginning museum worker. Exercises at the ends of chapters in this book provide students with review topics and work projects as well as subjects for group discussions. Some of the exercises have no right or wrong answers and merely focus attention on issues. At the same time, it should be emphasized that this is an introductory text; it is a book *to grow out of*. It relies heavily on basic definitions and distinctions. Postgraduate students and experienced museum professionals, especially, will want to delve more deeply into various aspects of museum work and techniques than is done in this book. The justification of a textbook is that it assembles and organizes a large amount of material and presents it in condensed form for the reader's ease of orientation and understanding.

Preface

The term *museology* has a long and legitimate history, and it is slowly becoming better known. Few opportunities for museum training existed in the past, but such opportunities now are steadily growing in number. The Smithsonian Institution's Office of Museum Programs (P. O. Box 37481–OMP, Washington, D.C. 20013) publishes a directory of museum studies programs without attempting to evaluate them. There are today so many such programs that the student's problem is not so much *where* as it is *which*. Unfortunately, our professional organizations are not yet prepared to accredit programs and certify graduates. Museum training, nevertheless, is increasingly in demand as a requirement for professional museum work, as evidenced by current descriptions of job vacancies. That speaks well for the growth of the museum profession and for rising standards in museums everywhere. Less and less frequently are communities handicapped by the commonly held—and gravely mistaken—opinion of the past that anyone in town who could spare the time could manage the local museum.

A museum worker in a responsible, decision-making position needs professional training, needs the specialized knowledge, attitudes, and standards applicable to his work that the ordinary educated layman does not have. A good museum studies program fosters and directs that development by first providing the student with an introduction to museum theory—museology—then presenting work techniques and procedures—museography—and, finally, by requiring internship experience in one or more good museums. This is not the ultimate for the museum professional, however; the true museum professional will be a lifelong learner, using publications, workshops, seminars, in-house staff training, and museum conventions to continue professional growth in the field.

Preface to the First Edition

This is not meant to be a complete textbook for museum workers. It is a supplement to the available publications which deal with museums, museum work, and museum theory,[1] which is based on the lectures given at the University of Idaho in the course Introduction to Museology. The material in this book relieves the student from having to assimilate a great amount of information from many different sources.

Museum training takes several forms: college and university courses for credit; correspondence study; on-the-job practical training; short-term workshops and seminars; professional meetings; scholarships, fellowships, and internships; vocational training; special programs leading to a certificate; and others. The directory of museum training (available from the American Association of Museums [AAM], 2233 Wisconsin Avenue, Northwest, Washington, D.C. 20007) describes formal opportunities in the United States and Canada.

Though the term *museology* is not in common use today, it has a long and legitimate history. Few people, within or without the museum world, have regarded museum work as a profession in its own right. The extreme position of the uninformed layman has been (and all too often still is) that anyone who can spare the time can manage or do the work of the local museum. Not significantly differ-

1. Standard works which would be used along with this supplementary text might include: Carl E. Guthe, *So You Want a Good Museum* (Washington, D.C.: American Association of Museums, 1957, 1973): Carl E. Guthe, *The Management of Small History Museums* (Nashville: American Association for State and Local History, 1959, 1964); Raymond O. Harrison, *The Technical Requirements of Small Museums*, rev. ed. (Ottawa: Canadian Museums Association, 1969); *The Organization of Museums: Practical Advice*, Museums and Monuments Series, Vol. IX, (Paris: UNESCO, 1960).

ent is the opinion that is occasionally heard from the large museums, of whatever kind, that museum workers need but to be specialists in a particular kind of job (and need have no theoretical understanding of museums in general). This widespread point of view has led to the tacit conclusion that there is no museum profession, no such thing as museology, and, consequently, no need for general museum training. A generation ago one could count on one hand, even with a finger or two missing, the opportunities that existed for formal museum education. Now such opportunities number in the dozens, and many schools offer or plan to offer master's degrees in museology programs. A few universities are even planning study and work programs that will lead to the doctorate.

Obviously, museum boards and museum directors are raising their standards; and museum jobs, which are steadily increasing in number, will go more and more to those who have not only a sound liberal arts education but also museum training. Learning the principles of museology on the job is just as inefficient and uncertain as learning any other profession on the job.

The museum worker, especially one in a decision-making position, must be or become a professional—a person who has knowledge and standards which the educated layman does not have. If those who oversee a museum do not have professional attitudes toward it, it may not be managed well. If, for example, the museum happens to have a good director or a good department head, it may decline rapidly if an ignorant or careless board of trustees replaces him with someone who is not a professional museologist, however faithful and skillful a taxidermist he may be, or however effective a public relations person he may have been in some other employment.

Training in museology is designed to broaden the outlook of museum workers and to introduce students, who are not yet launched on a career, to museums and museum work. I hope that this supplementary text may be of use to students, whether or not they have access to an introductory classroom course in museology, and to those devoted amateurs who are already working in museums and who recognize the desirability of improving their skills. Its purpose is to help develop professional attitudes and standards.[2]

<div align="right">G. E. B.</div>

2. If no other museum training is available, the student or museum worker of any age might consider a correspondence course. He should inquire at his nearest college or university, or write to the National University Extension Association (NUEA), Suite 360, 1 Du Pont Circle, Washington, D.C. 20036.

Part I

Museums and Collections

1
Museum Defined

Since this book is about museums and museum work, it is necessary to begin with an understanding of what a museum is. Put another way, the most important single accomplishment for the student is to learn to define the word "museum."

A newspaper story a few years ago was headed, "W—— Plans Museum For Celebration." The story said that the owner of a vacant business building had given permission to the local Booster Club to use it "as a museum during the W—— Days celebration July 2. Antiques and artifacts for the museum will be accepted either on a permanent or on a loan basis. These may be brought in as soon as there has been an opportunity to clean the building. Anyone who has items to display for that day only may do so, according to the program chairman."

Another news item described a new library building at a junior college. In addition to mention of classrooms, offices, kitchen facilities, and restrooms, the article said, "the basement contains a museum of Indian artifacts, a storage area, (etc.)." Has the word "museum" been properly used in these news stories?

Before we can answer that question, we need to define some terms, establishing a basic vocabulary.

Definitions

Object

a material, three-dimensional thing of any kind. "The paper bag contained three objects."

Museum object

an object in the collections of a museum, collected for its own sake. For example, a cassette tape collected as such and not

for whatever sound might have been recorded on it. "The curator brought a museum object with him."

Specimen

usually synonymous with museum object but properly having the connotation of an example or sample; a representative member of a class of objects. "The sedimentary rock exhibit needed a limestone specimen."

Artifact

an object produced or shaped by human workmanship or, possibly, a natural object deliberately selected and used by a human being. (For example, a shiny pebble picked up on the beach and carried as a good luck charm.) A cultural specimen. "The archaeologist examined the tray of rocks to see if it contained any artifacts."

Art object

an artifact of aesthetic interest (though not necessarily intended to be an art object by its creator). "The niche in the gallery wall was meant to hold an art object."

Work of art

something of aesthetic importance created by a human being (note that works of art are not necessarily art objects; for example, a symphony). "Her clay pot was a work of art, but so was her cherry pie or, for that matter, her dancing."

Collections

the collected objects of a museum, acquired and preserved because of their potential value as examples, as reference material, or as objects of aesthetic or educational importance. "The museum collections are housed mainly in the south wing."

Collection

a unit of the collections, consisting of objects having something of importance in common. One may speak of the bird's-egg collection of a natural history museum, or of the J. W. Whiteford collection if Mr. Whiteford has donated a large number of important, similar objects to the museum. "The handgun collection was moved in order to make room for the Johnson and Smith collections when they were acquired."

Accession

the acquiring of one or more objects at one time from one source, or the objects so acquired. "We made ten accessions last month totaling 218 objects. The Ramsey accession was placed in the top drawer overnight. When he delivered the sofa after lunch he told us that that completed the accession. The sword was the third accession from Miss Baum. A previous accession from her consisted of over a thousand butterflies."

Registration

assigning a permanent number for identification purposes to an accession and recording this number according to a system. "As soon as the accession was registered, it was turned over to the graduate students for study."

Cataloguing

assigning an object to one or more categories of an organized classification system (to be described in a later chapter). "The chair was catalogued as a Civil War item, and it was also entered in the catalogue with the furnishings of the former governor's mansion."

Classification of collections

the establishment of the major categories of the collections on the basis of anticipated use. This is a prior condition, or prerequisite, of good collecting. Art objects are collected primarily for their aesthetic qualities; as unique, artistic creations. History objects are collected primarily with the intent of interpreting (explaining) the past. Science objects are collected primarily to demonstrate and/or interpret natural phenomena and the laws and applications of science. "The art curator saw no value in the old lithograph and called it hideous, but it was just what the history curator had been looking for to complete the decorations of the parlor of the historic house that was being restored as an annex of the museum. The curator of botany was on an expedition collecting specimens for an exhibit of tundra vegetation."

Display

the showing of objects, depending on the interest of the viewer in the objects themselves. "A shoe store displays shoes in its window."

Exhibit

of more serious, important, and professional connotation than "display." It is the presentation of ideas with the intent of educating the viewer, or, in the case of an art exhibit, a planned presentation of art objects by an informed person to constitute a unit. As such, it might be an identifiable part of an exhibition. "A museum uses objects and labels in preparing an exhibit." "There was an exhibit of engravings in the Victorian Art Exhibition."

Label

written material in an exhibit to identify, to explain, and to inform. Labels may also be called signs, titles, captions, text, etc. Often the labels accomplish more real education in an exhibit than the objects. "The main label was placed at eye level. The only other labels in the case were the captions on the photographs."

Exhibition

an assemblage of objects of artistic, historical, scientific, or technological nature, through which visitors move from unit to unit in a sequence designed to be meaningful instructionally and/or aesthetically. Accompanying labels and/or graphics (drawings, diagrams, etc.) are planned to interpret, explain, and to direct the viewer's attention. Usually, an exhibition covers a goodly amount of floor space, consists of several separate exhibits or large objects, and deals with a broad, rather than a narrow, subject. "The art museum director organized an exhibition of the 19th-century paintings." "We added an exhibit of quartz crystals to the rock and mineral exhibition. We then displayed some crystals in the sales room."

Art show

a temporary display of art objects, commonly the paintings of one or a few contemporary artists; informal connotation.

Art gallery

a commercial establishment for the buying and selling of art objects; or a separate exhibition room devoted to art in a general museum; or an art museum; The word "gallery" places the emphasis on the *displaying* of works of art, regardless of the ownership of the objects. "When the art teacher

retired, she opened a gallery on Main Street to handle the work of her former students."

Art museum

a museum devoted to one or more of the art fields (dealing with objects). The emphasis here is on the *ownership and preservation* of important collections. "The finest collection of Oriental ceramics in the Southwest is in that art museum."

General museum

a museum dealing with several or all fields instead of just art, just history, just geology, etc. "The director is an anthropologist and his assistant is a historian; but since theirs is a general museum they need to hire a curator of art."

Encyclopedic museum

a general museum that has practically no limitations as to time, space, and subject placed on its collections, and which seeks broad coverage in all fields. "The coverage of some subjects is rather superficial in that encyclopedic museum, but at least they can claim with some justification that they have something of interest to every visitor."

Historic building or site

a structure or location of significant historic connections, often associated with a famous person or event; may include exhibits of pertinent objects. "The museum took over the administration of two historic houses, and the curator of history immediately began to plan for the authentic refurnishing of some of the ground floor rooms."

Preservation project, old fort, "village," etc.

preservation, restoration, or reconstruction of one or more buildings so as to re-create the environment of a past time and place.

Botanic(al) garden

grounds with or without greenhouses, for the scientific cultivation of plants for study and display.

Arboretum

a botanical garden that specializes in trees.

Herbarium

a systematic collection of preserved plant specimens.

Zoological garden
> a professionally designed and managed compound where live animals are kept for study and display.

Aquarium
> a building equipped with tanks for a collection of animals that live in water.

Children's museum
> a museum intended exclusively for young children, with everything scaled to their physical size and mental capacity, usually managed by elementary school teachers, with hobby classes, story hours, etc.

Planetarium
> a machine which projects tiny spots of light on a domed ceiling to represent the stars and planets, and the building which houses such a projector.

Nature center
> a facility for outdoor learning about nature, including a natural site for field study, with facilities and services for an interpretive program.

Visitor center
> a facility for the interpretation of a historical site or natural region, usually with a small auditorium, exhibits, and an information desk. Established by the National Park Service, forest service, state park departments, and other agencies accommodating tourists.

Science center
> a kind of permanent exhibition (like a miniature world fair) which emphasizes the spectacular aspects of physical science such as space exploration, optical illusions, television, and electronic cooking.

Art center
> an establishment by and for a community where art lessons are taught, the work of local artists is shown, and other art interests of the community are accommodated. The performing arts may be included, but ordinarily there is no permanent collection of objects.

Other definitions will be given throughout the book, but we are now ready to consider definitions of "museum."[1] Note that a "center" is not a museum. A "center" may be, but is not necessarily, a permanent institution, educational, nonprofit, and the owner and preserver of a collection. The essential distinction is this: A center exists to make possible entertaining activity; a museum exists to make important educational or aesthetic use of a permanent collection.

"Museum" Definitions (from several sources, numbered for future reference).

A museum is
1. a building or space within a building significant chiefly for preservation and/or exhibition of collections.
2. a building to house collections of objects for inspection, study, and enjoyment. (Douglas A. Allen)
3. an institution for the safekeeping of objects and for the interpretation of these objects through research and through exhibition. (Edwin H. Colbert)
4. a house of marvels, or a house of keeping (from two terms in the Gaelic language meaning "museum")
5. any permanent institution which conserves and displays for purposes of study, education, and enjoyment collections of objects of cultural or scientific significance. (International Council of Museums)
6. an institution for the preservation of those objects which best illustrate the phenomena of nature and the works of man, and the utilization of these for the increase in knowledge and for the culture and enlightenment of the people. (George Brown Goode, 1895)
7. a permanent establishment, administered in the general interest, for the purpose of preserving, studying, enhancing by various means and, in particular, of exhibiting to the public for its delectation and instruction groups of objects and specimens of cultural value: artistic, historical, scientific and technological collections, botanical and zoological gardens and aquariums, etc. Public libraries and public archival in-

1. Perhaps the most useful feature of a definition of "museum" is precisely that it enables one to see weaknesses in a museum or, at least, that it helps one to maintain a proper set of values in the face of adverse pressures.

stitutions maintaining permanent exhibition rooms shall be considered to be museums. (International Council of Museums, 1960)

8. a nonprofit permanent establishment, not existing primarily for the purpose of conducting temporary exhibitions, exempt from federal and state income taxes, open to the public and administered in the public interest, for the purpose of conserving and preserving, studying, interpreting, assembling, and exhibiting to the public for its instruction and enjoyment objects and specimens of educational and cultural value, including artistic, scientific (whether animate or inanimate), historical, and technological material. Museums thus defined shall include botanical gardens, zoological parks, aquaria, planetaria, historical societies, and historic houses and sites which meet the requirements set forth in the preceding sentence. (American Association of Museums, about 1962)[2]

9. a permanent, educational, nonprofit institution with catalogued collections in art, science, or history, with exhibitions open to the public.

10. an organized and permanent nonprofit institution, essentially educational or aesthetic in purpose, with professional staff, which owns and utilizes tangible objects, cares for them, and exhibits them to the public on some regular schedule. (American Association of Museums' definition for the purposes of the accreditation program)

For further clarification, the key words used in the definition are further defined as follows:

a. organized institution: a duly constituted body with expressed responsibilities.

b. permanent: the institution is expected to continue in perpetuity.

c. professional staff: at least one paid employee, who commands an appropriate body of special knowledge and the ability to reach museological decisions consonant with the experience of his peers, and who also has access to and acquaintance with the literature of the field.

d. tangible objects: things animate and inanimate.

2. With minor changes, this has been adopted as the official definition of the Canadian Museums Association.

 e. care: the keeping of adequate records pertaining to the provenance, identification, and location of a museum's holdings and the application of current professionally accepted methods to their security and to the minimizing of damage and deterioration.

 f. schedule: regular and predictable hours which constitute substantially more than a token opening, so that access is reasonably convenient to the public.[3]

11. a permanent, public, educational institution which cares for collections systematically. (Short definition, used for convenience in this book)

 Since this is a condensed definition, some explanation of the terms used may be in order:

 a. permanent institution: the museum is an organization that will in theory have perpetual life, and a life of its own apart from other organizations. The existence of the museum is assured regardless of who its employees may be at any given moment, or regardless of temporary economic recessions.

 b. public: the museum is not only open to the public, but exists only for the public good.

 c. educational: the museum exists for the purpose of providing education, inspiration, and aesthetic enrichment for all the people; development of the individual; and cooperation with other public educational agencies. It does not exist primarily for entertainment, commercial profit, the personal satisfaction of its employees or sponsors, the self-seeking interests of a clique or club, the nostalgia of elder citizens, to serve the private hobby interests of a few, to promote tourism, or any other noneducational end. For the educational use of collections, research is essential and requires such facilities as a reference library and a study room.

 d. collections: important objects useful in an educational and/or aesthetic program; significant objects, not curiosities, relics, rarities, or "collectors' items." Two points must be stressed here: 1) The distinction between art museums, which are, strictly speaking, not educa-

3. Marilyn Hicks Fitzgerald, *Museum Accreditation: Professional Standards* (Washington, D.C.: American Association of Museums, 1973), pp. 8–9.

tional, and all other kinds of museums, which are. In the short definition, the word "educational" is used to mean all the proper work of all kinds of museums. That is, not only the imparting of information but cultural enrichment and a broad exposure to the accomplishments of civilization and its gifted individuals. 2) The kinds of objects that belong in the collections of museums are not necessarily the kinds that the general public would recommend. More about this later.

e. systematic care: thorough documentation, good and permanent records (registration and cataloguing), eternal preservation and security, organized filing of objects (storage) that is logical and accessible.

12. a nonprofit institution, in the service of society, which acquires, conserves, communicates and exhibits, for purposes of study, education and enjoyment, material witnesses of the evolution of nature and man. (International Council of Museums, draft version of new statutes, 1973)

In addition to the above definitions, the following statements are pertinent to an understanding of what a museum is:

"Museums of whatever kind all have the same task—to study, preserve, and exhibit objects of cultural value for the good of the community as a whole." (UNESCO)

"The term 'museum' must today be reserved for official institutions in the public interest." (Germain Bazin)

The Swiss National Museum was appointed, by statute, "to house important national antiquities that are historically and artistically significant and to preserve them in well-ordered arrangement." (1890)

"An efficient educational museum may be described as a collection of instructive labels, each illustrated by a well-selected specimen." (George Brown Goode, Director of the U.S. National Museum 1889)

Finally, two further definitions from the International Council of Museums:

Museology is museum science. It has to do with the study of the history and background of museums, their role in society, specific systems for research, conservation, education and organization, relationship with the physical environment, and the classification of different kinds of museums. In brief, museology is the branch of

knowledge concerned with the study of the purposes and organization of museums.

Museography is the body of techniques related to museology. It covers methods and practices in the operation of museums, in all their various aspects.

EXERCISES—CHAPTER 1

The logical starting point in museum training is a clear understanding of what the museum profession regards as being a "real" museum. Anyone has the freedom to call anything by any name. Not everything called a "museum" would be so called by museum professionals. The student must come to appreciate the differences between the kind of institution that can qualify for accreditation by the American Association of Museums and the kinds that cannot. As you write your responses to the following, show that you have assimilated the definitions and that you know what a museum is.

1. On the basis of definitions given in chapter 1, including that illustrating the distinction between a center and a museum, what is the prime function of a museum? What is the first obligation of a museum?
2. *On the basis of the previous question,* would you say that museums exist for the sake of exhibits? Why? What would you say about an institution that has an excellent Sunday afternoon lecture series but no catalogue of the collections?
3. From the definitions of "museum" what would you say is the whole purpose of a museum, or why do museums exist? (Briefly.)
4. What would be your reaction if someone pointed out an old building to you in your home town (such as the post office or the high school), and said, "That building would make a good museum"? On the basis of this lesson, criticize the statement. Do not get into architectural technicalities; that will be our concern in a future chapter.
5. Compare museum definitions 6 and 9. Which seems more descriptive of a good, true museum, and why?
6. For the purposes of this book we shall use definition No. 11. Visit a museum in your vicinity and examine its operation sufficiently to apply this definition to it. Is it a true museum? If not, how does it fall short? If it can be considered a museum, what is the greatest weakness in its operation on the basis of the definition?
7. Is a library a museum? Why?
8. Is a planetarium a museum? An aboretum? A zoo? An art center? A historical society? (Explain your answer in each case, that is, say "why," and base your answers on definition 11.)

9. Refer to the two news items cited at the beginning of Chapter 1. Was the word "museum" properly used in these news stories? Why?

10. Unless you specifically covered this topic in your answer to number 7, what is the difference between a book or a videotape in the collections of a library and in a museum?

2

History of Museums

In the first chapter we were concerned with what a museum of today is. We must now consider museums of yesterday. We must not assume that museums suddenly sprang into being, like an invention. Museums have a long history and have changed in nature, as have other institutions.

Two related natural tendencies or "instincts" of people seem to be universal and timeless. These are the desire to accumulate objects and the desire to show them to other people. We should recognize, however, that "human nature"—whatever that is—is molded in large measure by culture. People in other parts of the world may hold material objects in less esteem than we do.

In our culture, almost every person collects something, or at least has a few objects of which he is especially fond and which he is happy to have other people admire. Almost every community has one person (or several people) noted for a collection on display in his home. Such collections may be of rocks, house plants, arrowheads, souvenir cups and saucers, Navajo rugs, guns, butterflies—the list is endless. Many people who have used their leisure hours in accumulating objects decide on retirement to "open a museum." Often a local museum gets its start when one or more local collectors lend or donate collections for this purpose.

Hand-in-hand with this natural tendency to collect things (obviously, more developed in some people than in others) is the desire to show them to others; to seek approval and admiration, to gain prestige by the respect and envy engendered by the ownership of interesting, beautiful, unusual, and commercially valuable objects. (This is not to say that this is the sole or even the main motivation for collecting. Once a collection exists, however, the common tendency of

the owner is to have other people see it and admire it, and there will always be people happy to oblige.) This, then, creates museums.

Almost every community of any size in the United States has its "museum," which is visited and enjoyed. (Whether it actually accomplishes a significant amount of public education is another matter.) Collections have existed from the earliest times, though notable collections in the past have belonged to individuals of power and wealth, not to the general public. For example, archaeologists have reported finding objects of an earlier time together in a palace of a later time; obviously, the king's personal collection of antiquities. Wealthy individuals in ancient Rome had enormous collections of paintings, statues, gold and silver vessels, tapestries, and other works of art. This kind of "hoard" is known throughout history.

Of course, collections are (and have been) made with different motivations and serve different purposes. Dr. Alma Wittlin lists six different kinds of collections based on different motivations on the part of those who have assembled them: Economic hoard collections (a pirate's treasure); social prestige collections (the art collection of a newly rich family; conspicuous consumption); magic collections (the bones of saints in churches); collections as expressions of group loyalty (football trophies in the high school lobby, or a museum on an Indian reservation containing objects formerly made and used by that tribe); collections as means of emotional experience (those that result from an overwhelming passion and drive to collect, whether they be of paintings, sea shells, stamps, or whatever); collections as means of stimulating curiosity and inquiry (for example, the clothing and tools of primitive tribes assembled from afar for a world fair).[1] Dr. Wittlin points out that though some motivations which were at work in the past are not now considered appropriate for building the collections of a public museum, they may still be powerful driving forces in the minds of museum trustees and others who have connections with our museums. In other words, regardless of the lip service paid to "public education," "modern museum methods," and the like, you may wonder why your museum is not more in tune with the times, why its new building will look like a Greek temple on the outside and have an inefficient interior arrangement, and why it is not more responsive to the needs of your community. If you do wonder, look more closely to

1. Alma S. Wittlin, *Museums: In Search of a Usable Future* (Cambridge, Massachusetts: M.I.T. Press, 1970). This book is recommended for reading on the history of museums, as is Germain Bazin, *The Museum Age* (New York: Universe Books, 1967).

see what medieval notions are moving the people who move your museum.

This is not meant to imply that people capable of creating real museums exist only in the present. The Museum of Alexandria in Egypt was essentially like those of today. A little history may provide orientation.

On the death of Philip of Macedon, ruler of Greece, his son Alexander III ("The Great") set out to conquer Persia and build an empire. On his death at the age of 33 in 323 B.C., his generals divided his empire. His half-brother, Ptolemaeus (Ptolemy I), chose Egypt and adjoining parts of North Africa and Arabia for his share. His capital was Alexandria on the Mediterranean Sea (founded by Alexander for the administration of Egypt). Alexandria was a Greek city, and for hundreds of years an important center of western civilization. Ptolemy's descendants, also called Ptolemy, continued to rule until Egypt became a Roman territory. The last of the dynasty was Ptolemy XIV, son of Cleopatra and Julius Caesar, murdered by Augustus in 30 B.C.

About 290 B.C., Ptolemy I established a center of learning dedicated to the muses (hence "museum," house of the muses, "mouseion" in Greek). It consisted of a lecture hall, a mess hall, a court, a cloister, a garden, an astronomical observatory, living quarters, the library, and collections of biological and cultural objects. In fact, the collections probably embraced all the museum fields. The head, or director, of the museum was technically a priest. There were four groups of scholars: astronomers, writers, mathematicians, and physicians. All were Greeks, and all received salaries from the royal treasury. Research was their function and purpose. In later decades, as students multiplied about the museum, its members undertook to give lectures; but it remained to the end an institute for advanced studies. The Mouseion was the first establishment ever set up by a state for the promotion of literature and science. It was at the same time the first museum, research center, liberal arts college, and advanced study institute—the distinctive contribution of the Ptolemies to the development of civilization.

Ptolemy died at age 84 in about 283 B.C. It is interesting that he founded the Mouseion when he was 77 years of age. His descendants strove to improve it, especially the library; it was the greatest achievement of his dynasty.

The museum library was housed partly at the museum itself and partly at the Temple of Zeus (Jupiter Serapis). At its height it consisted

of about 400,000 volumes, or as many as 700,000 different scrolls. The most famous library of all time, it came to overshadow the collections of objects. Some authors have, therefore, regarded the museum or collections, as being located in the library, rather than the library as being located in the museum. Civil commotions damaged the library at various times, and the collections and library housed in the museum proper were largely destroyed during an uprising or riot in the reign of Aurelian (A.D. 270–275). The part of the library located in the Temple of Zeus was destroyed under Theodosius the Great in the name of Christianity when he destroyed all the heathen temples (about 380-390). The destruction is erroneously attributed to the Arabs under Omar when they conquered Egypt in 642.

We must not assume that Ptolemy I created the concept of the museum. That distinction goes to Demetrius of Phalerum (the original port of Athens) who moved to Alexandria on his expulsion from Athens in 307 B.C. He, of course, was influenced by the schools of Athens which used natural objects as teaching aids. They in turn were to some degree a legacy of Aristotle, who had a school in Athens (the Lyceum) from 335–323 B.C. Aristotle taught that knowledge must be based on the direct observation of nature, that scientific theory must follow fact, and that knowledge can be categorized along logical principles. Ptolemy likely held Aristotle, who was identified with Macedon and had been Alexander's tutor at the Macedonian court for seven years, in great esteem. Aristotle's philosophy and methods, as expounded to Ptolemy by Demetrius, if need be, would have had a friendly reception.

The reason for this lengthy description of the Mouseion is to make the point that the museum as an educational institution—as a center for research with material objects and for the dissemination of knowledge—is not just a theoretical ideal. There has been a long gap, but during the last hundred years, modern man has been catching up with the ancient Greeks. What the human brain and an enlightened government accomplished two thousand years ago can be accomplished—and is being accomplished—in our time.

After the Greeks, museums as such disappeared for hundreds of years, though we read of the collections of Roman temples. During the Middle Ages, the great churches and abbeys accumulated natural curiosities and religious relics. Private collections of curiosities of art and nature became widespread in Europe in the 17th and 18th centuries. Called "cabinets" or "Wunderkammers," they were a hobby of

the wealthy. An example is the collection of Albrecht, Duke of Bavaria, who competed with other European royalty to amass art and oddities. His collection included some 800 paintings, an egg which an abbot had found within another egg, manna which fell from heaven during a famine, a stuffed elephant, and a basilisk.

This emphasis on the entertainment value of an object—because of its strangeness or rarity, or because it gives the viewer a thrill—is the basis of the carnival side show, the wax museum, the "snake farm," and a multitude of miscellaneous collections called museums which reach out for the tourist seeking light entertainment. Some museologists would say that art museums are, though a step up, still on the same ladder. That is, that the guiding principle of the art museum is the collecting and exhibiting of unique and wonderful objects to create an emotional response in the viewer. We shall have more to say in later chapters about the philosophy of the art museum. At this point, however, we should emphasize that the nobility not only collected two-headed animals and other curiosities, they also developed a passion for accumulating real works of art. The collections of paintings and sculpture of most royal families grew to the point that they overflowed the palaces and had to be housed in buildings erected for the purpose. (Most of the important art museums in Europe began as royal collections.) A logical development of the Renaissance was the gradual opening of such royal "art museums" to the public.

Though we take for granted the idea that a museum should be open to the public, such was not always the case. One of the earliest known examples of public admission to a museum is that of Abbot Boisot of the Abbey of Saint Vincent in Besançon, France. On his death in 1694 he left his personal collections to the abbey, with the provision that the public be admitted regularly to see them. The British Museum was founded in 1753 and was said to be open to the public, but it received only 30 visitors daily. These had to apply for admission well in advance. The 15 people allowed in to view the museum at one time were required to stay in a body and were limited to two hours. As late as 1800, persons desiring to visit the British Museum had to present their credentials to the office; if acceptable, they had to wait two weeks for an admission ticket.

The royal French government in 1750 began to open the picture gallery of the Palais de Luxembourg regularly to the public. (Though who were the "public" who were actually admitted? Surely not the dirty and ragged poor.) Plans to make the royal collection in the

Louvre accessible to the public at stated times existed toward the end of the 18th century, but it was the French Revolution that actually created the first public museum by opening the Louvre.

Natural science was not popular in the early 1800's. There were neither collections nor books in this field. For example, it has been reported that there was not a single book on mineralogy for sale in the United States. Not until after 1850 did coherent display of scientific collections for educational purposes begin.

The beginnings of anthropology and the systematic treatment of art date as well from the second half of the 19th century. Paintings were shown chronologically by school at the art museum in Vienna in 1781, but this approach was a rare occurrence until the 1880's, when the Cluny Museum in Paris handled its collections systematically. In 1888, the museum in Nürnberg, Germany, opened to the public six rooms arranged by period. Although we expect any good museum today to have its exhibits arranged according to a logical plan, not all museums show good museological practice. One may still observe paintings hung with no grouping by country, school, time period, or even by artist. In a large and well-known museum in Europe, I have seen paintings arranged on gallery walls by size, with examples by the same artist found in different rooms.

The concepts of the public, educational museum, the systematic treatment of art, and the strong interest in anthropology, science, and technology date from after the middle of the last century. Even though the word "museum" has been in use in the English language for nearly three hundred years,[2] the museum as we know it today—the museum as defined in Chapter 1—is of recent origin.

World Fairs[3]

It has been said that the museum is a development of the last century, stimulated by the great world fairs. Since the 1870's, practically every large fair has created museums. The Centennial Exposition

2. The Ashmolean Museum of Oxford University, the first university museum of modern times, was founded in 1683. It was the first institution in western Europe to call itself a museum.

3. Kenneth W. Luckhurst, *The Story of Exhibitions* (London and New York: The Studio Publications, 1951), was used as a source for much of the information on world fairs given in this chapter. This book provides an interesting history of the great international exhibitions with excellent illustrations.

in Philadelphia in 1876, for example, spurred the building of the American Museum of Natural History, the Metropolitan Museum of Art, the Boston Museum of Fine Arts, the National Museum (of the Smithsonian Institution), and several museums in Philadelphia. Douglas Allan says, "A museum was thus, in the initial stages, a response to the need to house collections brought into being by the enthusiasm of collectors."[4] Put another way, once a government has spent a great deal of money assembling objects to be shown at a world fair, it can hardly throw these objects away when the fair closes. They are ordinarily turned over to museums for preservation and use, and often in the past museums were created because the collections existed and needed to be housed. The public interest in science and art and in visiting exhibitions, stimulated by great world fairs, has also led to public support for the establishment of museums, apart from considerations of caring for collections that already were in existence.

How do world fairs relate to museums? They have certain characteristics in common:

1. Both assemble objects and put them on exhibit.
2. Both use labels and explanatory devices to make the exhibits meaningful to the general public.
3. Both receive and provide for large numbers of visitors; directing them and providing for their comfort and safety.
4. Both provide for the housing and security of exhibits and of the objects within the exhibits.

On the other hand, there are essential differences:

1. World fairs are not permanent institutions.
2. Their main purpose is not education, in the strict sense, but rather entertainment and propaganda.
3. World fairs are based on exhibits, not collections.
4. They combine all kinds of activities, sponsors, and exhibits at one time and place.

An inquiry into the nature and history of world fairs will be helpful at this point, because not only have they been responsible for the creation of museums, but they are also a continuing source of ideas and inspiration for museum exhibition techniques. Indeed, some of the newer institutions, especially in the field of science and industry, appear to blend world fair and museum (the science center).

4. Douglas A. Allan, "The Museum and Its Functions," *The Organization of Museums: Practical Advice*, Museums and Monuments Series, No. IX (Paris: UNESCO, 1960), p. 15.

Two terms need to be defined: 1) A fair is a gathering of buyers and sellers to transact business. 2) An exhibition (in the nonmuseum sense) is a public showing of objects. Synonyms are "show," as in "auto show," "flower show," etc., and "exposition," as in "Century of Progress Exposition" (the Chicago World Fair of 1933 and 1934).

A farmer's market, a flea market, and a sidewalk art sale are fairs. A "county fair" is not a fair but an agricultural exhibition. A trade show is primarily a fair (where manufacturers and wholesale dealers show products to retailers to stimulate marketing). There is, of course, overlapping of function between the two, but the essential thing about a fair is that it exists mainly for selling. The essential thing about an exhibition is that it exists mainly for showing. The term "world fair" is itself incorrect in that it is in reality a gigantic exhibition, not a fair in the strict sense. The point of making this distinction here is so that the student will not be confused when reading the writings of Europeans, who are less likely than Americans to blur the meanings of these terms.

Let us consider the motives that are involved in a large nonmuseum-based exhibition. The exhibitor's motives are: 1) To draw attention to himself or his organization. 2) To advance his material interests or to promote a cause. 3) To entertain for public relations purposes (good will). 4) To compare his product with that of his competitors. The visitor's motives are: 1) To be entertained (recreation). 2) In the case of art exhibitions, exhibits, buildings, flower gardens, etc., to receive the higher form of amusement which might be called "cultural pleasure," "aesthetic appreciation," "emotional involvement," etc. 3) To learn. 4) To transact business or to gain information that may lead to the transaction of business (looking over new refrigerators).

Obviously, these lists do not coincide. Museum curators as well as trade show exhibitors must keep in mind that the viewer of their exhibits must enjoy himself and feel that he is receiving something of value. Only then will the exhibitor achieve his own goals.

The greatest of the exhibitions are the world fairs, sometimes called expositions, or international exhibitions. Some of their characteristics are that they are international, involving governments and large organizations (such as General Motors and the Catholic Church); they are impressive spectacles, immensely appealing to the public and highly entertaining; they have large assemblages of exhibits created by professional, commercial designers (world fairs present examples of the highest development of the art of exhibition); they are show-

places and proving grounds for innovations in the arts and sciences; and in spite of good organization, international exhibitions are so very expensive that they often go bankrupt.

World fairs are a natural development from the industrial, national, and art exhibitions which were held in the early part of the 19th century. The first world fair, or international exhibition, was the Great Exhibition of Industry of All Nations held in London in 1851. It was highly successful, immediately imitated by other countries, and exerted an influence on all world fairs for the remainder of the century.

The original idea of an international exhibition is credited to Prince Albert of Saxe-Coburg-Gotha, the German cousin and husband of Queen Victoria. He was acquainted with the large exhibitions and fairs held in Germany which attracted visitors from many countries. The London exhibition was housed in a single building called the Crystal Palace. Largely prefabricated and made of mass-produced components, the building was erected in only 17 weeks, though it covered an expanse of 18 acres (about the equivalent of 12 football fields).

The excuse to organize a great exhibition is often the celebration of a historical event. Examples are the Centennial Exposition in Philadelphia in 1876, the World's Columbian Exposition in Chicago in 1893 (one year late), the Louisiana Purchase Exposition in St. Louis in 1903, and the Century of Progress Exposition in Chicago in 1933. Great expositions were held in Montreal in 1967 and in Japan in 1970.

Paris has probably been the greatest single center for world fairs, but they have been held in many different countries. During the last century they were housed in single large buildings, one of which eventually reached a size of 53 acres (Paris, 1878). In this century many separate buildings have been used in each of the great "fairs." In the Louisiana Purchase Exposition in St. Louis in 1903 1,576 separate buildings roofed an area of more than 300 acres. The exposition area had 45 miles of roads, 13 miles of exhibition railway, and to see all the exhibits in just one of the buildings—the agriculture building—required a walk of nine miles. The exhibition went bankrupt.

International expositions are of considerable interest to the museum worker because in large measure they have the kind of success he is seeking. Every museum director would like the great publicity, large crowds of visitors, expensive and impressive installations, electronic teaching devices, and artistic and educational exhibits of world fairs. Studying the exhibit techniques of the expositions can help the museum worker to improve the exhibits in his own

museum. The principles of good exhibit practice are the same wherever the exhibit is found. They are:

1. The exhibit must first attract the visitor's interest.
2. It must inspire his confidence in the exhibitor and in what he has to say or offer.
3. Having gained the visitor's confidence, the exhibit must reward him by showing him something seriously worth seeing and by enabling him to understand what he sees.
4. It must do this in a pleasing way and in good taste.

EXERCISES—CHAPTER 2

Collections, and what are called museums, may be founded and maintained for different reasons. People who create and promote museums have different motives and different philosophies. Confusion and conflict in museum operation sometimes occur because of a simple lack of agreement as to what a museum ought to be. It is, therefore, essential to the good health of a museum—especially a small regional museum managed by nonprofessionals—that the purpose of the museum be spelled out in detail in writing.

The acceptable museum of today is one that would want to and would qualify for accreditation by the American Association of Museums. In general, "museums" of the past were not truly museums in today's sense. Many so-called "museums" of today more closely resemble those of the past than they do true, twentieth-century museums.

For this assignment, visit and consider one or more museums in your vicinity; or answer the questions on the basis of your remembrance of one or more museums which you have visited in the past; or, if necessary, imagine a museum existing today that you could describe in detail.

1. How does a particular museum (or how do several museums) with which you are familiar resemble:
 A. a Wunderkammer
 B. a private collection
 C. a reference collection for scholars or experts
 D. a place of entertainment?
 (Try to find an example of each.)
2. What antiquated or short-sighted notions that are contrary to the concept of the public educational museum have you observed in operation in any museum? (This may relate, for example, to Dr. Wittlin's list.)
3. Reviewing in your mind the development of the museum of today, what trend do you see for the future? In other words, what do you imagine tomorrow's

museum will be like (philosophically or conceptually, not in terms of techni-
cal facilities)?

4. What can you say about the kinds of museums you would expect to find
 A. in one of the new African nations
 B. in a city in the United States
 C. in a European capital
 D. in a rural location in Europe
 based on the history and development of museums? Think in terms of
 politics, especially.

5. From your experience, what can you say about the attitudes toward collect-
 ing and exhibiting on the part of artists or art curators as compared with that
 of curators in the sciences? (If you have no actual experience in this regard,
 state what you would imagine the differences to be on the basis of the nature
 of the material and the histories of art and science museums.)

6. From your familiarity with county and/or state fairs
 A. what aspects justify the term "fair"?
 B. what aspects justify the term "exhibition"?

7. What is the role of amusements (roller-coasters, sideshows, gambling
 games) at a county fair? What can the museum learn from this, or what
 application might there be to the program (operation) of a museum?

8. At a world fair, a trade show, the exhibits at a convention, or elsewhere, you
 have probably observed the work of professional exhibit designers. Com-
 pare this with museum exhibits with which you are familiar and comment on
 the differences and similarities.

9. Describe your own collecting experience. What do you collect? Why do you
 do it? In what way and under what circumstances do you show your collec-
 tion to others? What is your motivation for exhibiting? (Do not be superficial. If
 you give this question serious thought and attempt to answer it fully and
 without reserve, you will gain in understanding of how museums are created
 and managed. People are much the same. Museum trustees, directors,
 curators, and technicians are like you. To understand them, try to under-
 stand yourself.)

10. Describe the principal private collection in your locality. (If you have not yet
 seen it, contact the owner, explain your interest, and try to see it and
 interview the owner.) What does the collector say his reasons are for collect-
 ing? What is his attitude toward placing the collection in a public museum?
 Which of Dr. Wittlin's list of motivations do you feel are at work?

3

Museums Today

As may be expected, museums are enjoying a phenomenal growth in the United States and Canada. Reports indicate that the Canadian province of Alberta had 18 museums in 1952, 39 in 1964, and 86 in 1971. Reports also indicate that, currently, four to six new museums are formed each week in the United States. A few years ago an estimate counted a new museum in this country every three days.

Some 200 museums existed in the United States in 1876; 600 in 1919; 2,500 in 1940; 5,000 in 1965; and perhaps as many as 7,000 in 1974. This approximates a tripling every thirty years. That rate has not endured, but the number of museums does continue to grow.

The American Association of Museums is the professional organization of museums and museum employees.[1] Its *Official Museum Directory*, revised periodically, is the only complete source of information on the museums of the United States and Canada. A glance through the directory makes obvious at once the fact that museums are not evenly distributed either geographically or by population. While densely populated states in the East have approximately one museum per 15 square miles or 15,000 people, some of the western states have only one per 5,000 square miles and 50,000 people. The comparison does not end here, of course, because the size and quality of the museums must be taken into account. How many relic-filled settler's cabins in western towns would it take to equal in educational and aesthetic value only one museum in New York City, the Metropolitan Museum of Art, which is said to have more professional employees than all the art museums of Italy? Parenthetically, the Met also forms

1. For information about publications and benefits of membership, write to 1055 Thomas Jefferson Street, N.W., Washington, D.C. 20007.

an interesting contrast with another great art museum, the Prado in Madrid. According to reports, the Met has eighty to ninety times as many employees as the Prado, and the Met's director is paid more than ten times as much as the Prado's director.

One can say, in general, that while good museums can be found in all regions, they tend to be concentrated in large cities in the East, in the Middle West, and on the Pacific Coast. In other words, museums are where the people are and where the wealth is.

It has been estimated that there are 12 to 14 thousand museums in the world, of which half are in the United States;[2] half of these have been created since World War II. Half of the American museums are small, regional history museums. Obviously, a problem exists regarding the quality and value of the collections and the program of the small museum which is founded and operated by uninformed and untrained amateurs. Accreditation of museums, the certification of trainees, and, above all, the recognition on the part of trustees of the importance of securing professional staff to manage museums will help to raise the standards of the local museum.

A pamphlet given to American students en route to Europe states, "In a European museum you will never have that feeling of looking at a vast pile of objects brought together by an amateur with more money than taste." That this is generally true is at least in part a consequence of the governmental supervision of museums in most countries of the world. Most of the museums of France are supervised by the great art history museum in Paris, the Louvre. The Belgian government does not permit the local amateur establishment of museums and is reluctant to establish museums even under its own direction without strong justification. Much the same can be said for other countries. The new governments in Africa deliberately establish museums for their propaganda value. Museums are used as a medium for conveying information and establishing desirable public attitudes. With expert direction and supervision of museums by the national government, professional standards can be maintained. (One is reminded of the generally high quality of National Park Service visitor

2. ICOM reported in 1973 that there may be as many as 20,000 museums in the world, employing about 100,000 people. If this is true, the United States may have less than one third of the world's museums. Of course, the difficulty of dealing with figures of this kind is that there is no common agreement as to what a museum is, or how rigidly to apply the professional definitions of a museum given in chapter one. No one could say, for example, how many museums there are in any one of our states.

centers in this country.) At the same time, democratic countries value the rights of individuals for self-expression and for pursuing vocations and avocations of their choice. Furthermore, supervision of many museums from one office may incline to monotony in presentation, bias, conservatism (in hewing to the line of the political philosophy in power), and discouragement of innovation, fresh approaches, and subjects of purely local interest. This is a philosophical issue which need not concern us further at this point, but let us recognize the familiar source of conflict involving central planning and direction—which may be efficient but may also be narrowly orthodox—versus local planning and direction—which may be inefficient but may also be nearer to the hearts of the local inhabitants.

As the educational level of the average person rises and his leisure time increases, museums are playing an ever-increasing role in the lives of ordinary people. "Our age has the mission to initiate into the cultural life segments of society which have hardly been prepared for it by their day-to-day family surroundings, and for whom the increase in leisure time offers more and more opportunity to visit museums."[3] Families that can travel, and they are in the majority, can experience a great variety of museums. In the New Orleans Jazz Museum the visitor can pick up a telephone, dial a number, and hear a musical selection of his choice. The Pacific Science Center in Seattle (a holdover of the 1962 world fair) teaches mathematics by means of devices that are fun to watch and to operate. In Bath, Maine, the Marine Museum teaches about America's sailing ships of the last century. The Kiwanis Club of Lewiston, Idaho, is restoring two trolley cars that were in use from 1905 to 1925. Mohave and Chemehuevi Indians in Arizona have mortgaged tribal lands in order to buy at auction objects made by their ancestors and placed them in their tribal museum.

Somewhat more frivolous collecting interests many people. The jersey of George Blanda of the Oakland Raiders was placed in the Pro Football Hall of Fame (Canton, Ohio) in 1970. Some communities try to capitalize on a historic event in order to build local solidarity and to attract tourist dollars. Not all such efforts are successful. The Associate Press reported that Reynoldsburg, Ohio, was trying to drum up enthusiasm for a tomato festival on the justification that the basic strain of tomatoes had been developed there by a botanist years ago. Reynoldsburg, however, "never has been a tomato town," and

3. Pierre Gilbert (Director of the Royal Museums of Art and History, Brussels), "The Museum and the Art of Teaching", *Museum*, XX, No. 4 (1967), p. 291.

"frankly, some people couldn't care less whether this is the birthplace of the tomato," said Councilman Gilbert Whalen.

Whatever it is, a museum is probably dedicated to it somewhere. There is a spaghetti museum at Pontedassio, Italy. Germany has a brewing museum in Munich, a wine museum in Speyer, a doll museum in Nürnberg and a bread museum in Ulm. A museum in Wuppertal is devoted to clocks and one in Schorndorf to thimbles. Paris has museums of money, medals, carpets, and music. In this country there is a trend toward ethnic museums in cities. A successful early example is the Anacostia Neighborhood Museum in southeastern Washington, D.C. A "branch museum" of the Smithsonian Institution, its exhibits are not limited to Negro history and culture but include a small zoo, arts and crafts, and a walkthrough general store of around 1890.

Some of the world's greatest museums serve as models for the profession and are worth mentioning here. Their names are well known to museologists. The Smithsonian is not a single museum but, actually, the world's greatest museum complex. It includes the National Museum (Natural History), the National Gallery of Art, the Museum of History and Technology, the Rock Creek Park Zoo, and other branches.

Also previously mentioned was the Metropolitan Museum of Art in New York City. Just across Central Park is one of the greatest of the natural history museums, the American Museum of Natural History. A worthy rival for top honor is the Field Museum of Natural History in Chicago, whose collections date from the World's Columbian Exposition of 1893 in Chicago. The Museum of Science and Industry in that city is housed in one of the buildings of the 1893 world fair and got its start as a result of the Century of Progress Exposition in 1933 and 1934.

The greatest of the museums of technology is the Deutsches Museum in Munich, a city which is noted for its great museums. Perhaps the most famous, and some would say the greatest, museum in the world is the Louvre in Paris, housed in what was formerly a palace. Its collections include antiquities from the near East as well as a great number of paintings, some of them gigantic in size. The British Museum in London is likewise noted for antiquities, such as the Elgin Marbles, the statuary removed from the pediments of the Parthenon. The largest museum dedicated to the decorative arts, the Victoria and Albert Museum, is also in London.

Scandinavia has dozens of "folk museums." Many of these are "open-air" collections of actual buildings moved from afar and as-

sembled on one site. Sometimes they are furnished and adjacent exhibit buildings show costumes, agricultural implements, and other objects illustrating rural life in the past. The best-known of these is Skansen in Stockholm, Sweden. A somewhat similar establishment in the United States is Greenfield Village in Dearborn, Michigan. Here Henry Ford gathered on a large tract of land more than 100 buildings of all kinds, ranging from homes to factories. At one side is the Henry Ford Museum, one of the largest history museums in the world, with interiors of rooms and stores, collections illustrating the development of technology, and an enormous transportation section. Colonial Williamsburg in Williamsburg, Virginia, is the world's largest and most expensive historic restoration project. Actual buildings remaining from the 1700's as well as reconstructed buildings appear in their original locations.

The International Council of Museums (ICOM),[4] an independent organization of museums and museum workers, sponsored by UNESCO, maintains a documentation center in Paris from which one may obtain information concerning museums in all parts of the world.

EXERCISES—CHAPTER 3

The purpose of this assignment is to familiarize you with the state of museums in your own locality. It will be necessary for you to learn at least:
 A. when they were founded and by whom (i.e., how did they come to be created?);
 B. how active they are today as compared with other local museums and as compared with themselves in the past;
 C. what sentiment exists for the creation of new measures and where new museums are likely to come from, in your judgment.

1. How many museums are there today in your locality (city, county, twenty-mile radius of your home, or whatever is convenient—but try to include at least four museums, preferably ten or twelve)? How does this compare with the museum count in your locality twenty or more years ago?
2. What plans exist for creating museums in your locality? What organizations and what kinds of individuals are behind any actual movement in this direction?
3. What trends do you see? (In other words, what is the future for museums in your locality? Be able to justify your opinion.)

4. For information regarding joining, and the benefits of membership, address the ICOM office at the American Association of Museums, 1055 Thomas Jefferson Street, N.W., Washington, D.C. 20007

4

Museums and Museum Fields

A museum is characterized mainly by the kinds of objects it collects. That is, the subject field or discipline with which the museum is mainly concerned determines its kind. Confusion as to the proper role of a museum is sometimes the result of a lack of understanding as to the precise nature of the various subject fields. At this point, therefore, we should review them.

The main division in the museum world is between art museums and all other kinds. This is a result of a basic philosophical difference. Art is concerned with unique, highly unusual productions of gifted human beings. These productions, called "works of art", are valued for their own sake. If the creation by the artist results in a durable, material object, it becomes the concern of the art museum. All other kinds of museums are concerned with typical, common, quantity-produced, and natural objects that are valued not in themselves but as examples of the natural world and of human cultures. (This will be further explained in later chapters dealing with the theory of collecting.) In this latter group of museums an additional division exists between the collecting of artifacts as examples of human history and the collecting of natural specimens as examples of the world of nature. The threefold classification of museums is *art, history*, and *science*.

Art Museums

Artists do not agree on a definition of art, and we shall not attempt one at this time. However, we can say that art plays on the senses by the selection, ordering, and arrangement of that which will produce sensation. Art may be created by making things to look at or sounds to listen to, tastes and smells to experience, or even ideas to titillate the mind. Art is infinite. No one can draw up a list of all the arts.

31

For museum purposes, we recognize, at least, that there are the kinds of art activity or creation which result in an object or an arrangement of objects (a material production); and there are the kinds which result in an event or sequence of events, or sequence or arrangement of sounds, movement, or sensations. We may call the latter kinds the *performing arts*. These are nonmaterial, existing as fleeting productions through time; they can never be repeated exactly. Even a novel never produces the same effect on a second reading. (The novel, of course, belongs to the literary or language arts, which are even more removed from the museum's prime concerns than are the performing arts.) Since the performing arts do not create objects which can be collected and used by museums, there are no performing art museums. A so-called "museum of the dance" or "museum of the theater" is either a museum of the *history* of the dance or the theater, or it is not really a museum.

The arts that produce material objects may be divided into two main categories: the Fine Arts and the Applied or Useful Arts. The distinction is whether an object exists solely as an art object—a thing of beauty—("art for art's sake") or whether it is primarily functional—a rug, a chair, or a bridge—and secondarily good to look at. In the museum context the Useful Arts are the *Decorative Arts*, a term applied to objects in interior decoration (furniture, silverware, draperies, etc.). Closely related are dress designing, jewelry making, flower arranging, and others.

The *Fine Arts* embrace two-dimensional pictures produced by painting, drawing, or one of the printing processes (etching, engraving, woodcuts, etc.); or three-dimensional material objects produced as sculpture or as ceramics (baked, molded clay). The fine arts sometimes include architecture (though it is allied with engineering and is certainly a "useful" art) and sometimes landscape gardening.

The third major subdivision of art as regards museums is *Folk Art*, sometimes further broken down into primitive or tribal art, peasant art, "ethnic art," and pioneer arts and crafts. This kind of art is of the people, not created by professional artists as art. The distinction is largely between popular art and elite art which will be discussed later. The materials of folk art include such diverse items as Navajo Indian blankets, Ukrainian painted Easter eggs, and cornhusk dolls from the Appalachians.

In brief, art museums collect the elite artistic productions of civilized societies—paintings, drawings, photographs, statues, furniture, jewelry, textiles, metalware, and some of the crafts of pre-

civilized and pre-urban peoples as well. Major art museums collect and exhibit objects from the ancient civilizations of the Mediterranean and the Near East—Egypt, Babylonia, Greece, etc. These include statuary, jewelry, and other objects of art but also such objects as mummies, tomb inscriptions, metal tools and weapons, and common vessels which have more significance in ancient history and in anthropology than they do in art. Ancient history and classical archaeology have traditionally been included in art museums, however.

History Museums

History museums in the United States and Canada, in the main, are concerned with local history, that is, the history of the region in which the museum is located. All objects made or used by human beings are of potential interest to the history museum. Obviously, selectivity is essential. History museums specialize in a certain time period, a certain limited geographical region, or a particular field. Historical fields include transportation, industry and technology, arms and armor, horology (clocks), numismatics (coins), philately (stamps), costumes, home furnishings, and many more. The essential requirement in a good history museum is that objects must be collected to serve the purpose of public education. For the most part, they must be typical, at one time commonplace, items that can be used to illustrate the facts of history.

Science Museums

There are two major kinds of science museums—technology, or science and industry museums; and natural history museums.

Science and Industry Museums

A museum concerned with teaching the principles of physics, chemistry, and mathematics utilizes models, pictures, and other audiovisual aids. They show and explain commercial products such as automobiles and telephones. For the purposes of "public relations"—advertising, sales promotion, creating good will—industrial and governmental organizations and agencies install impressive exhibits at great expense in technology museums and science centers in major cities. Since no actual museum objects exist apart from the fields of art, history, and natural history, so-called museums of sci-

ence and industry occupy a special niche in the museum world and perhaps should not be considered real museums. In fact, most of them are science centers, not science museums.[1]

Natural History Museums

This field, which includes the world of nature and noncivilized man as a part of that world, has four subfields: *Zoology, Botany, Geology,* and *Anthropology.* Zoology, the study of animals, and botany, the study of plants, together make up biology, the science of life. Traditionally, in natural history museums zoology and botany have been separate departments, each with subfields such as herpetology, ichthyology, mammalogy, and others, depending, of course, on the size and completeness of the collections. The botany department will include a *herbarium* or "archives" of plant specimens, mostly dried and mounted on standard sheets of paper together with pertinent information.

Geology is the study of the earth, dealing chiefly—in a museum at least—with rocks and minerals. Mineralogy is one of the important subfields. Another is paleontology, the study of past life, especially extinct forms of plants and animals known only through fossils. Logically, paleontology might be included under biology, but since its objects are rocks, it is more at home with geology in the museum setting.

Anthropology, the science of man, has a major division between *physical anthropology,* the study of man as an animal, and *cultural anthropology,* the study of man through his learned behavior or culture. Usually cultural anthropology, especially in the United States, is thought of as having the divisions of *linguistics,* the scientific study of language; *social anthropology,* the systematic comparative study of social forms and institutions; *ethnology,* the study at first hand of primitive or tribal peoples;[2] and *archaeology,* the study of past human life on the basis of material remains excavated from the earth. The natural history museum (or the anthropology department of a general museum) shows its concern with *physical anthropology* by collecting

1. Of course, if a science and industry museum goes beyond the presentation of contemporary industrial techniques and commercial products it may, like the Deutsches Museum in Munich, have recorded, permanent collections and educational exhibits on past developments in technology. To a degree, then, it would be a *history* museum.

2. The term *ethnography* is also used. It means the description of cultures, while *ethnology* means the analysis of cultures.

human bones, *ethnology* by collecting the clothing and implements of primitive peoples, and *archaeology* by collecting the durable cultural remains excavated by archaeologists. (Such an academic field as linguistics is, of course, not a museum field because it does not have objects.)

Anthropological archaeology is prehistoric; that is, it is concerned with nonliterate cultures, such as those of the American Indian prior to the arrival of Europeans. Nonanthropological archaeology is oriented toward history and art history. Of this type, *classical archaeology* is concerned with ancient Rome and Greece (and in a broader sense of the term with ancient Egypt, Mesopotamia, Persia, and Asia Minor as well). Similar archaeology is also pursued in the areas of the high civilizations of India and eastern Asia. In Europe a distinction has been made between medieval and post-medieval archaeology. In the United States and Canada in recent years historical archaeology, which is the application of archaeological techniques to the study of history, has increased rapidly. Largely developed by anthropologists trained in prehistoric archaeology, it has a strong interest in the period of early contact between the native Americans and Europeans, and in such anthropological concerns as community structure, social interaction, and cultural change. Even so, historical archaeology is more at home in a history than in a natural history museum.

All museum objects can be thought of as *inorganic*—belonging to geology; *organic*—belonging to biology; or *superorganic* (cultural)—belonging to archaeology, ethnology, history, and art. These last four subjects are related and can be thought of as one, because all deal with the works of man. To summarize: Museums collect and are concerned with animate and inanimate natural objects, and objects made by man.

Figure 4.1 illustrates the relationships among the different types of museums. The purpose of this kind of chart in museology is to show that all fields are interrelated and that any museum object can be used in more than one way.[3] Without this kind of perspective a museum

3. Subfields along the lines connecting the major fields indicate areas of collecting and exhibiting as related to other subjects. The circles are but two examples of types of museums or museum departments related to more than one of the standard museum fields. Thus, ancient history and classical archaeology, an important and popular category, is related to history, the arts, and anthropology. Likewise, health museums are based on physical anthropology, biology, technology, etc.

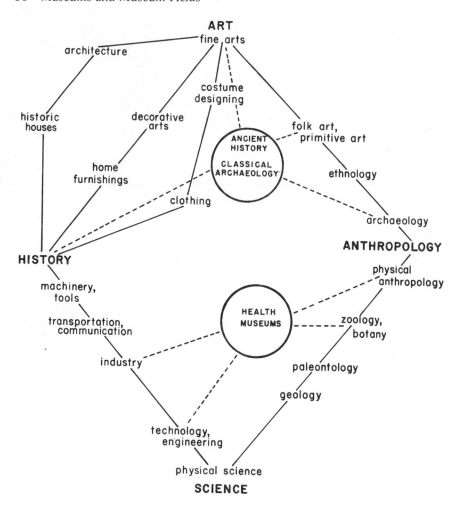

FIGURE 4.1

curator will be narrow in his approach to his collections and will fail to give full interpretation of his exhibits. A common example of this kind of failure is the treatment of ethnological materials, such as the dance masks of African tribes, in some art museums. The masks are shown only as interesting and aesthetic objects, and the cultural context in which they originally functioned is ignored, certainly to the intel-

lectual loss of the museum visitor, and, I suspect, to the detriment of full aesthetic appreciation as well. It works both ways, of course; museum ethnologists may ignore the artistic aspects of their collections and thereby deprive visitors of opportunities for aesthetic enjoyment.

A word of caution: No object entering the collections of a museum has only one potential use and categorical place. Placing it in one department or another is done on a traditional basis for the sake of orderliness and convenience (a painting by Renoir would normally be assigned to the fine arts), but the object might serve in several different ways at different times (the painting might decorate a wall in a historical room exhibit; it might be used to illustrate a step in the development of painting technique; it might be used as an example of easily transferred wealth in an exhibit of economics; it might be used for its illustration of agricultural practices at a particular time and place; and so on).

A final note: A museum need not be limited to one or two fields. There are museums that concentrate on one particular thing, such as clocks; but there are also museums of art and history, of anthropology and history, of art and science, of any other combination. Many museums embrace a number of fields and therefore are called "general" or "encyclopedic" museums. Many general museums have no limitations on their collecting, but this is usually a mistake.

EXERCISES—CHAPTER 4

1. Make an outline of all museum fields you know of or can discover. Use correct outline form; indent for subfields and indent further for sub-subfields. Try to include some areas which can be repeated in more than one kind of museum. For example, "transportation" could be a department of a history museum and also of a science and industry museum. Do not carry this too far, however. For example, art is not properly a branch of history or anthropology as museums are customarily organized.

2. An eccentric multimillionaire named Head has established a museum and named it for himself. The Head Museum collects only heads; either representations or actual heads or parts of heads. However, there is no limitation as to the subject fields by which the collections are catalogued. There are departments of different arts, history, botany, the subfields of anthropology, and so on. As a new assistant registrar in this museum, your job is to

receive incoming additions to the collections and assign each object to its proper and best department. How would you assign the following?[4]

Example: A model of a head of cabbage botany

(Note: Do not use anthropology, biology, natural history, art, or science as complete answers; use their subfields or major breakdowns. If you do not feel a particular answer is obvious, make a choice and explain why you have made it.)

A. A ceramic head in the form of a wall plaque
B. The head of a bird pickled by an Englishman in the last century
C. A piece of quartz resembling a head, donated by an Indian
D. The head of an Indian carved out of quartz by Auguste Rodin
E. The baked clay head of an animal from an Indian burial mound
F. The skull of a white girl found near the burial mound
G. The head of a Christian saint carved by a Mexican Indian
H. The skull of a dinosaur
I. A shrunken head from South America
J. A model of the human head, used in a medical school

4. This question is not as frivolous as it may sound. It illustrates the assignment of objects, collected by a museum, to specific departments on the basis of the anticipated use of the objects.

5

Organization and Support

Regardless of who owns the museum (city, state, private foundation, university, or whatever), it should have a board of trustees to whom the director reports. The director is the chief administrative officer of a museum; it is he who hires and fires and is in direct charge of the operation. The trustees' responsibility should be largely limited to matters of broad policy and of ensuring the adequate financing of the museum. It is not the proper role of the director to have to raise the money to pay his own salary. Unfortunately, however, circumstances sometimes force him to be a fundraiser, and he cannot devote his time and energies entirely to the management of the museum.

The distinction between the term "director" and the term "curator" is that the former means the administrative head of an organization, and the latter refers to a person who is in charge of a museum collection. The British term "keeper" is perhaps more illustrative of the curator's main purpose. The person in charge of a small museum with simple administrative duties should be called curator rather than director. A larger museum will have a curator for each of the major divisions, such as a curator of history, a curator of art, and so on. Since the curators are department heads, it has seemed convenient to give the same title to other department heads. Thus, we have curators of exhibits, curators of education, curators of television, etc. If a department head has an assistant, the assistant may be called assistant curator of the specific discipline.

In the large museums, subject fields are divided into as many subfields as is useful. In a large natural history museum, for example, the Chief Curator of Zoology may have under him a Curator of Mammals, a Curator of Birds, (etc.), and any number of assistants. There are just as many jobs in a small museum as in a large one, but there are

39

fewer people to do them. The generalist, or person who likes many different subjects and who enjoys variety in his work, may be happier in a small museum. The specialist, on the other hand, would fit into a large institution where the total work is divided into narrow segments. Museum people sometimes create problems for themselves by failing to recognize the difference between museums with few people and museums with many. As a museum grows, its staff must increase with it. The curator of art may then get an assistant to take over some of his responsibility, thus narrowing his job.

In a small operation, after the first person (the director or curator) is hired, the next to be added are a secretary, a janitor, and an all-around assistant. Curators are hired in the second stage; in the third, as many service personnel as the museum can afford. Service personnel are such people as receptionists and clerks, handymen and guards, registrars and librarians, exhibits technicians, and teachers (curators of education and their staffs). No rules govern this, other than the practical ones of the best management and utilization of the collections.

Museum directors should avoid the practice of hiring part-time experts to fill gaps in their staff patterns. When the funds are not sufficient to hire a full-time curator, the temptation exists to find someone who can take the responsibility on a half-time or third-time basis. At best, this is only a temporary expedient. A part-time person in a professional position, one with responsibilities and creative opportunities, will have divided loyalties. He or she may be concerned, while working for the museum, with duties and plans for the rest of the day outside the museum. There is less likelihood that this person would be involved in evening and weekend activities of the museum, and he or she can never feel (or be felt by the rest of the staff to be) completely a member of the staff. A museum staff is a team of individuals conferring, planning, and working together to make their museum successful and respected. Someone who is present only certain hours of the day or certain days of the week cannot be a full member of the team, and this diminishes his or her effectiveness. It is better to treat the part-time employment of experts like the acceptance of loans: It may be done for compelling reasons under certain circumstances for a specific, short-term purpose, which is apart from the day-to-day operation of the museum.

Most museums use volunteer help to fill the gaps in their ideal staff patterns. Sometimes a particular kind of service is left entirely to volunteers, such as classes for visiting school children, the sales de-

partment, or the registration and cataloguing of the collections. Volunteer services (which, of course, are free) are so important at many museums that without them the museums would have to curtail their programs seriously or even close their doors. Volunteers are of two main types: Those who work as individuals, directly for and under the supervision of a member of the museum staff; and those who must first belong to an officially sanctioned volunteer organization. This organization may exist solely as a volunteer arm of the museum (often called "Museum Volunteers"), or it may be an organization with a broader purpose but which includes museum volunteer work as one of its functions. An example of the latter kind of group is the Junior League, which in some cities elects to assist one or more museums for a period of time, in addition to other community service projects.

Organized volunteer efforts normally consist of guiding groups through the museum's exhibition areas and teaching visiting school classes. A person so engaged is called a docent. The training of docents should be, and usually is, a thorough preparation for all aspects of their duties. It is administered either by the museum staff or by the volunteer organization itself, or (commonly) by a cooperative effort of both. The docent receives instruction in all subject matter fields in which he or she will have to be informed, becomes completely familiar with the museum, including not only its exhibits but also its operation and philosophy, and is trained in the techniques of managing groups and of teaching children in the museum context. As such training may take months, it requires a sincere commitment on the part of the volunteer-trainee as well as conviction on the part of the museum that trained docents are an invaluable addition to the staff. Once trained, docents may donate much of their spare time for years to the educational work of the museum. Developing a training program is not a step to be taken lightly, however. The most important rule in using volunteers is that their training and supervision must not take more of the time of the professional staff than would the work that the volunteers perform.

The matter of financial income for the museum is, of course, vital. Most museums seem to be poverty-stricken most of the time. This is probably because the public expects more—and their professional staffs desire to give more to the public—than their operating budgets will buy. Although some museums feel compelled to charge for admission or to ask for donations, it is an unusual museum that can support itself in this way. If we divide the number of visitors into the number of dollars in the museum's budget, we get the cost per visitor.

This may range from fifty cents to three dollars, but for most museums the cost will probably average more than a dollar. An admission charge of 50 cents per person would then yield no more than half the funds needed, even if it did not significantly diminish the number of visitors. A large percentage of the attendance at museums is made up of visiting school classes, normally admitted free. Some museums give free admission to retired people, military personnel, members, and others. A visiting family will expect to pay a substantially lower admission charge for young children than for adults. Therefore, a museum that charges an adult one dollar for admission may receive from this source less than one-fourth of the funds that it needs for its operation.[1] A charge large enough to meet operating costs might so diminish attendance that the charge would be self-defeating.

The Museum of Modern Art, in New York City, raised its admission charge from 25 cents to two dollars in the early 1970s.[2] Studies have shown that the imposition of an admission charge goes not significantly change the pattern of attendance; that is, substantially the same people or same kinds of people visit museums whether or not there is a charge.[3] However, it is always regrettable when members of its public cannot use a tax-supported institution. There will be, inevitably, some people who cannot afford to pay an admission charge, or who object to having to pay to enter a museum which they already support through their taxes. A good solution to this problem has been used for many years by the Field Museum of Chicago (and others). On certain days of the week, admission is free and school classes and other groups are received. On other days of the week an admission is charged, and the building is quieter and less crowded. Some museums use the system of a strongly recommended donation. That is, a visitor is not forced to pay an admission charge, but most people feel obliged

1. To put this into concrete terms, imagine a museum with an annual budget of $50,000 which receives 50,000 visitors each year. (Rather, 50,000 visits, since some individuals will visit a museum many times during the year and be counted each time.) The cost per visitor (or visit) is one dollar. If 40,000 of the visits are by young children and others admitted free, the remaining 10,000 visits would have to be priced at 5 dollars each for the museum to support itself through admissions alone.

2. This was the highest charge among the major museums at that time. The trend in recent years has been for admission charges to rise and for more and more urban museums to initiate a charge.

3. For example: Hiroshi Daifuku, "The Museum and the Visitor," *The Organization of Museums: Practical Advice*, Museums and Monuments Series, No. IX (Paris: UNESCO, 1970), p. 77.

to leave a donation. In 1970, the average donation at the Cloisters (the medieval art branch of the Metropolitan Museum of Art) was 58 cents. Of course, it is higher today.

Ordinarily, the most productive source of income for the museum is public taxes, budgeted for the museum's operation by the governmental body in charge: city council, state legislature, and others. Museums augment these funds by membership fees, donations, sales desk profits, rentals, annual money-raising events, and, of course, admission fees. As stated earlier, when the level of the museum's accustomed operation is far beyond what would be supported by the annual public appropriation, the museum director may find that much of his time is required, continually, to raise money. It even happens with some museums that their major effort is simply to keep alive.

A rule-of-thumb in a healthier situation is that two thirds of the annual operating budget should be devoted to salaries. Even 75 per cent may not be excessive under some circumstances. Salaries of the professional staff should be comparable to those of libraries and schools in the area. The director of the museum should be paid at least as much as the director of the city library, the principal of an elementary school, or an assistant or associate professor at the local junior college, depending on many factors. The museum, like a library or a school, is an educational institution of great value to the community. Its staff must be as well prepared and as well paid as those of other educational institutions of comparable size and responsibility.[4] The museum staff needs not only to be paid adequately, but supported adequately as regards the operating budget. A good museum, like a good school, a good hospital, or a good sewer system, cannot be established and operated at low cost. A community cannot expect to have much of a museum on an annual operating budget of less than $100,000.[5]

4. For a detailed report on current museum salaries, see Kyran M. McGrath, *1973 Museum Salary and Financial Survey* (Washington, D.C.: The American Association of Museums, 1973).

5. Assuming $70,000 for salaries, this would allow a director, a secretary-registrar, a janitor-handyman, a curator of exhibits-assistant director, and some part-time student help (for example, for a weekend receptionist). The remaining $30,000 would have to cover insurance, utilities, shipping, postage, building maintenance and repairs, travel, purchase of objects for the collections, books and subscriptions, memberships in professional organizations, employee insurance and retirement, publicity and promotion, rental of temporary exhibitions, supplies and equipment of all kinds, etc.

Some typical staff patterns are:

A municipal contemporary art and history museum in a large city

Director
 Secretary
 Bookkeeper
Assistant Director
 Curatorial Assistant
 Guards
 Maintenance Persons
 Handymen
Curator of Collections
 Clerk-Registrar
 General Assistant
Curator of Education
 Teacher
 Audio-Visual Technician
 General Assistant
Curator of Exhibits
 Draftsman-Artist
 Preparator
 Cabinet Makers

plus occasional use of tradesmen (plumbers, electricians, etc.), volunteers, and student help as needed, as well as access to city services for publicity, publications, library, photography, etc.

A museum of art and history in a small city

Director (and Curator of Art)
Secretary-Bookkeeper
Curator of Collections (and History)
Curator of Education (and Public Relations)
Librarian (and Archivist)
Janitor-Handyman
 Assistant Janitor-Guard

plus volunteer management of the sales-reception counter, and assistance on a regular basis to the curator and the librarian.

A general museum in a small city

Director
Secretary-Registrar
Curator of Art
Curator of Exhibits
Janitor-Handyman
plus part-time help for weekend duty

The museum of a state historical society

Curator
Secretary
Registrar
Curator of Education
 Assistant Curator of Education
Exhibits Technician
 Carpenter
 General Assistant
with cleaning, maintenance, bookkeeping, guarding, library, etc., pro-
vided within the overall administration of the historical society and
volunteers used at the sales-reception counter and to assist the registrar
with the collections

A children's nature museum in a rural location

Director
Secretary-Registrar
Curator of Education
Librarian
Curator of Animals (or Zoo Keeper)
 General Assistant
Janitor-Guard
 Assistant Janitor-Groundsman
plus an active volunteer organization assisting the Curator of Education

In all cases, the various professional members of a museum staff
should have competence in different disciplines. For example, if the
director of a small general museum is a historian, the curator of exhibits
or the assistant director might be a scientist; and the curator of educa-
tion might be an artist. Even in a museum devoted to one field, such as
art, it is good to have other fields represented on the staff. One of the
most widely applicable fields is anthropology. Anthropologists are
found in museums of all kinds. Every museum staff should include an
artist, regardless of his primary responsibility.

During the 1970s, increasing amounts of money were made avail-
able to museums by the federal government. It may be hoped that this
development can continue. Grants, sometimes administered by state
agencies, have been mainly for public programs or to make the
museum's services more widely used. Money is granted to stable,
professional organizations.

While it is risky for a museum to base its operation on unreliable
funding, it has come to make sense for even small museums to estab-

lish the staff position of grant-proposal writer. Researching and writing grant proposals is skilled work, time-consuming, and often arduous. One person on a staff should be trained for it and expected to work at it at least half-time.

EXERCISES—CHAPTER 5

Imagine yourself to be the administrator (whether your title be director or curator) of a museum, and solve the following problems:

1. Your annual budget is $200,000 in a museum of art and history in a community of 40,000 people. List, with salaries, the staff positions for your museum.
2. You have the offer of volunteer help. How might you use them?
3. Your board of trustees recommends hiring part-time professionals. What is your position on this?
4. Your museum gets a lump sum cash gift of $500,000, and the board immediately starts wrangling about what to do with the money. Sensibly, they ask you for advice. What do you propose?
5. Your income consists of admission fees and an annual appropriation by the city government. Because of increased expenses you may have to fire a member of your staff unless you can raise more money. What are the possibilities? Does it matter who the museum visitors are? Does it matter whether many or few school classes use the museum? Give reasons for your answers.
6. You fall on hard times and your budget is cut to $125,000. What do you do, while trying to maintain standards and service to the public?
7. For several reasons, your income is raised by $150,000 (to $275,000), and the new addition to the museum is ready for use. What would your new salary budget be? (Assume that the new wing is adequately furnished and equipped.)
8. Suppose you, the director of the museum, are not a museologist. However, a member of the board of trustees used to be curator in a museum. What, if any, changes in the lines and areas of authority should be worked out?

6

Collecting Theory:
General and Science Museums

Museums are sometimes so busy preparing exhibits, expanding into new geographical areas and subject fields, getting publicity, and raising funds that their most fundamental job or obligation gets pushed into the background. Indeed, in some museums most members of the staff seem to ignore it. I am referring to collecting.

Museums are concerned with objects. Objects are the starting point of a museum, of a museum field, and, properly, of any activity of the museum. Objects justify museums. One determines the kind of museum he has by the kinds of objects in the collections and the uses to which the objects are put. Of all the kinds of educational, public service, and cultural institutions that exist, only the museum is founded on the principle that selecting and preserving objects is of importance to people today and in the future.

The assumption is that all objects can be fitted into some kind of museum or into a department of a museum or can be used in a special exhibition. One should categorize objects by their potential use. A collection of furniture might belong in a history museum, in an art museum, in a botanical museum (thinking of the materials of which the furniture is made), or in a museum of technology (science and industry). The value of the objects depends on how well they serve in accomplishing the goals of the museum. In an art museum the objects must give aesthetic pleasure, convey emotion, stimulate the imagination, and inspire. In another kind of museum the objects must contribute to education and intellectual stimulation.

In both cases, objects also serve these ends indirectly by attracting visitors. An Egyptian mummy may accomplish more in attracting

people, who then see other exhibits, than it does simply as an exhibit. Objects may also serve in less obvious ways, such as for research, reference, prestige, and entertainment.

Museums are firmly grounded in man's "instinct" to collect. Whatever the motivation of individuals, museums collect to preserve objects of apparent or possible value that otherwise might be lost to the future, and to bring objects together for use. These are really the same justification (public education, broadly speaking). The difference is only that a museum curator does not always have a specific use in mind for an object when he decides to preserve it.

What do individuals collect? Objects that are impressive and attractive because they are old, expensive, associated with a famous person or place, bizarre, from a remote corner of the earth (today, from the moon; someday, from another planet), the result of adventure or much labor or patience. Objects may also be collected because they are nostalgic or sentimental. What may have great value to the collector may have little or none to a museum (an arrowhead of unknown origin, a button collection sewn on pieces of cardboard, a lock of President Harding's hair, a ship model built in a bottle, a rock from Mt. Everest, a collection of matchfolders). On the other hand, a collection of ore specimens from local mines, a scrapbook made by President Harding, an authentic model of Magellan's ship that circumnavigated the globe, or a Persian rug would be of use to an appropriate museum.

The student may be surprised to learn that there is such a thing as a theory of collecting. Yet it should be obvious that: 1) Museums cannot collect *all* objects that exist; 2) collecting has to be selective; 3) it is an abstraction from the real world.

If collecting is selective (that is, if only a very few objects are selected for preservation out of untold billions or trillions of things), then the question is, "Who does the selecting?" In a way, *chance* selects what is to remain from the past. Artifacts have short lives; accidents cause objects to change or disappear. Another selector is the *donor* who selects from among the objects he owns those which he thinks belong in a museum. Other selectors, such as money, are influential, but perhaps the most important factor in selection is *popular culture*—the stereotypes of the bulk of the population (including the average museum curator) as to what is appropriate to a museum and what is not. Museum curators, as well as donors, have chosen to collect fifty-year-old wedding dresses but not overalls. (I know a museum dedicated to preserving and telling the entire history

of a whole state. The museum owns 100 wedding dresses but not a single pair of overalls. Can the history of a state be illustrated by the marriages of women but not the labor of men?)

If a museum is to have a serious purpose and be managed efficiently, thought must go into what makes the museum. The museum cannot accomplish much public education without good collections. Good collections result only from thoughtful collecting. Good collecting requires logical, intelligent planning. What a museum collects matters. The main selector of the objects should be the informed curator, who is guided by a sound collecting plan.

Museum directors and curators must know what to collect, but the general scope of the collection is not properly their decision. If they had to decide to accept or reject objects on the basis of their personal feelings at the moment, much of the time they would be wrong. The founding body, in establishing the museum, should decide on its scope. That is, it should set limitations on the collections and, therefore, on the field of interest and activity of the museum. Guthe says that this is the most important decision the board of trustees will ever make.[1]

The first limitation is one of *geography*. With what physical area will the museum be concerned? The country? The state? The original 13 colonies? The entire world? The second limitation is one of *subject*. Is the museum to be concerned only with art? Art and history? Natural history? History and anthropology? I would say that, logically, the third limitation should be that of *time*. Is your museum to limit itself to the last century? The period from 1870 to 1920? The Middle Ages? Guthe also says to consider *use*.[2] The museum should not collect an object which it cannot imagine putting to a good use. That is, if its potential educational value in the frame of your museum operation seems small at best, that object should not be acquired.

It is the responsibility of the director, and whichever members of his staff are allowed to collect, to see to it that the museum permanently acquires only objects which fit within its limitations. (For a temporary exhibition any kind of object can be borrowed for a limited time; or an object can be acquired with the understanding that it will be sold or sent to another museum.)

1. Carl E. Guthe, *The Management of Small History Museums*, 2d ed. (Nashville: American Association for State and Local History, 1959, 1964), p. 24.

2. *Ibid.*, p. 31.

What to Collect (And What Not to Collect)

It is important that the museum have an *active*, not a *passive*, collecting program. *Active* collecting is determining what the collection ought to contain, in order to do the best possible job of presenting the complete story, and then making a strong and continued effort to locate and acquire those materials. *Passive* collecting is sitting back and accepting or rejecting what is offered. This leads to collections which are largely a reflection of what the general public thinks ought to be in a museum. The potential donor's notions on this score are likely to be wide of the mark, if not downright ridiculous, in view of the museum's scope and its educational aim.

Museum collections grow through donations, purchases, expeditions and other field collecting, informal collecting by the staff (such as at secondhand stores), and by transfer, exchange, gift, and permanent loan from other institutions. (A permanent loan, contracted between two museums of professional standards, amounts to an outright gift in all but legal title. The lender has the legal right to recall the loan, but has no intention of doing so. It is a useful device for a museum which has difficulty, under the law, in disposing of surplus objects in its collections.) Two principal dangers must be avoided:

1. *Do not accept conditional gifts.* A donor may request that his gift of a number of objects be placed on exhibit, be exhibited intact —without separating the objects—and that his name be prominently displayed with the objects. Even though he does not request this, he may, because of his past associations with "museums," assume that this will be done. Only in very rare circumstances, if ever, should a museum agree to these conditions. It is best to have the donor sign a standard accession form which states something like, "I give these objects unconditionally." If you do not use such a form, you might at least explain to the donor how the collections are organized, that not everything is exhibited, and that the donor's name will be forever preserved in the records, though not in the exhibit.
2. *Do not accept loans* for an indefinite period of time or for any purpose other than temporary use. Many small museums cause their future employees much grief, wasted time, and bad public relations when they make it legally possible for lenders or their heirs to recover objects after many years have passed. Build your collections only with objects to which your museum has clear title. Often a person will want to lend something (like an antique

piano) in order to get it out of his house without giving up his ownership of it. This person is seeking to use limited space belonging to the general public as a free warehouse. Do no accommodate him.

If you are now working in a museum which has in its possession loaned or conditionally given objects, first get the approval of the board of trustees; then immediately begin correcting the situation. Separate these objects from the rest of your collections; then write to the donor or lender explaining and justifying your policy (actually, the policy of the museum) and either return objects you do not want, getting written receipts for them, or seek to have objects you do want made unconditional gifts. Once the trustees are involved, any criticism or objection can then be directed, not at a museum employee, but only at the institution itself, or, rather, its policies.

Scientific Collecting

What should a museum of science collect? (Or what should a curator of science in a general museum collect?) The goal of the science museum is to increase knowledge about our physical environment and to disseminate such knowledge to the public. Stated more simply, the museum's job is education in science. But we are speaking of education based on the study and use of tangible, three-dimensional objects. The objects that should be collected are, quite simply, those objects that can be used by that museum in an educational program. They must be in keeping with the scope of the museum, that is, within its set limitations. They must also be collectible. Microbes and volcanoes are of considerable interest to science, but they cannot be museum objects.

Collecting in science is probably easier than collecting in art or history. Text and reference books in any scientific field outline the main laws, facts, and processes that would be interpreted through exhibits for the benefit of the general public. The objects needed are those that can be used in illustration. The small, regional scientific museum will want to deal with its natural environment. The geology of the county, birds and animals of the state, flora of the region, local archaeology—all are suitable fields if they fit the museum's scope. The aim in the collecting should be first of all *accuracy* (be absolutely certain of your identifications of the specimens you collect and catalogue), and second, *completeness*. If you are exhibiting the native trees of your county, be sure you include them all, unless you can

justify a sampling; for example, to show trees of local economic importance, or to illustrate differences among large categories of trees where one representative of a category would be sufficient. Do not exhibit some trees and some animals and then imply that you are showing the total natural environment. The honesty and meticulousness of science must carry all the way through to your use of the collections. The main point is that collecting and exhibiting in the scientific fields, as in the others, should be to some larger purpose. Objects and exhibits are not ends in themselves.

Natural history museums occupy an honored position in our profession. Museums in a sense created natural history. In the latter half of the nineteenth century, collecting by these institutions and the study of the collections gave great impetus to the advance of scientific knowledge. The natural history museum deserved its great social prestige. (Today, the art museum has the most social prestige, but this was not always the case.) However, research is the activity that has shown the least progress in the last thirty or forty years. The relative importance of museums in the *advancement* of knowledge has declined (although the importance of museums in the *dissemination* of knowledge has increased). Museum research has declined in importance because it must deal chiefly with the static description and classification of things. That work is now largely done (except for dotting "i's" and crossing "t's"). Zoological research now, for example, is more concerned with natural dynamics; with observation of the relationships among living things, their adaptations to their environments, the growth and decline of populations, the utilization of "niches" in the environment, etc.

Natural history museums have been called "on the defensive" and "static, peacefully sleeping." However, with the necessity for the public to be aware of our abuses of the environment, and the dangers of pollution and overpopulation, natural history museums have as important a role to play in our culture as they have ever had. They can accomplish much good if they will rise to the task.

EXERCISES—CHAPTER 6

1. Describe the museums in your vicinity as to their scope, that is, the limitations placed on their collections. Are these limitations stated in writing? What guidance exists as to what you, as a potential donor, might reasonably offer

these museums? Are there obvious discrepancies between the publicly announced scope and the actual scope as revealed in the collections and the exhibits? Try to find out if employees are guided by a written policy in their dealings with potential donors.

2. List the different ways of acquiring scientific specimens.
3. List the ways objects may be lost to the collections (called "alienation").
4. When a curator accepts a donation, what information should he ask for?
5. What is the most important decision a board of trustees will ever make?
6. What should be the loan policy of a museum?
7. Define passive and active collecting. Use illustrations from a scientific field.
8. If a donor comes to your museum and complains that his donation is exhibited in a dark corner without his name on it and without some of the original objects, what do you say to him?
9. In general, what should a museum collect?
10. Describe an exhibit you have seen, preferably one which can be visited locally, which illustrates that the donor's idea of what a museum should contain has prevailed rather than the opinion of a scholar as to what information should be presented to the public. In other words, give an actual example of an object or a group of objects which does not contribute measurably to the official purpose of the museum.

7

Collecting Theory: History Museums

"History" is sometimes taken to mean all past events, as in "the history of the world" or "the history of man." To some people, "history" means the written record, as "It is a matter of history that Stonewall Jackson was killed by his own men." This definition allows the term "prehistoric" to be used, referring to time and events that preceded the written record. The broad and hazy separation between history and prehistory is the period of the introduction of written records of behavior. It should be obvious that the boundary between historic and prehistoric occurred at different times in different places. American Indians in the West were still prehistoric after the East was well settled by European immigrants. In remote parts of the world today some primitive tribes may properly be described as prehistoric, and even paleolithic. Museums should shy away from referring to "prehistoric animals." If the term "prehistoric times" is used, the user should be sure it refers to a period before people wrote their own records or before their literate contemporaries provided adequate written documentation.

It has been said that all museums are history museums in the sense that all preserve objects pertaining to past events and situations. This is certainly obvious when we think of collections in history, art, anthropology, and technology. It is less obvious when we think of biology. But even with this subject, the specimens *were* collected, they *did* live, the exhibits show living environments of the past (though recent). Nature changes so slowly that we cannot in our short lifetimes see most of the changes occur; museums, however, deal with these changes—mountain formation, the weathering of rocks, the evolution of plants, for example.

Let us reserve the term "history" for museum activity related to discovering, preserving, and interpreting important knowledge about past human behavior. What, then, should a history museum collect? Suppose that you are in charge of a small history museum, and a prospective donor comes in to give you something. His gift will have no strings attached, and you are free to accept or reject the offer. Would you accept or reject: 1) the wedding suit of your town's first mayor? 2) the wedding suit of your current mayor? 3) the wedding suit of an ordinary citizen of your county of a) one hundred years ago? b) twenty five years ago? c) last week? 4) one left shoe of the present day? 5) a pair of shoes with both heels missing? 6) a well-catalogued collection of birds' eggs? 7) a valuable, antique chair used in another part of the country and brought to your town by newcomers last year? 8) a painting by a great artist which has no connection with your locality? 9) a painting of poor quality of a local scene? 10) a suit of Spanish armor? 11) a magnificent, mounted moosehead? 12) an old piano used for many years by a local piano teacher? 13) a badly rusted shovel with a broken handle picked up at the entrance to an abandoned mine? 14) a miscellaneous collection made over the years by a prominent citizen of your community from his travels in different parts of the world? 15) old bottles? 16) a number of arrowheads arranged in a design on purple velvet in an oak frame? (The donor said that he had collected them from "around here" forty or fifty years ago.) 17) a family Bible? 18) the donor's great-grandmother's wedding dress? 20) a piece of cloth with President Lincoln's blood on it?

Workers in small museums have to make decisions like these almost every day. If you had trouble making up your mind, it is because you did not have a scope in mind. Now set limitations for your museum, and you will find the decisions easier to make. Not to have a clear, written policy regarding what the collections are to contain is a serious mistake. Every museum employee should know the policy. Any staff member charged with the responsibility of acquiring objects for the collections, either by purchase or by accepting gifts, must have not only a very clear knowledge of what ought to be collected, but also the assurance that his superiors on the staff and the board of trustees will support his decision.

To return to the list of offered objects, if yours is a museum of local history, and if history according to your museum continues to the present, your answer to the donor probably should be as follows: "Yes" for numbers 1, 2, 3, and 4; "No" for 5, 9, 12, and 20. Numbers 6, 7, 8, 10, and 11 might be accepted with the understanding that

you would sell or trade them. The shovel would be acceptable if you can assume that it was used in the mining operations and, of course, if the mine is located in the geographical area of concern to your museum. The traveller's collection would be acceptable only with the donor's agreement that you were at complete liberty to dispose of the objects separately as you saw fit. The collection might contain some items that you could send to other museums; other items might be sold at your sales counter; and still others might be useful in decorating staff offices. Probably none of the items would be suitable for your collections. The bottles, like the shovel, would have to be tied importantly to the life of your locality to be acceptable, unless you simply accepted them in order to sell them. The arrowhead collection has very little value without dependable documentation as to the original location of each arrowhead. If the prehistory of your region lies within your museum's scope, you might accept the arrowheads for the collections, although their usefulness will be limited. If the donor can remember very clearly the specific locations where he found certain of the arrowheads, these should be singled out immediately and properly identified. They will be of more value than the others. The Bible should be accepted only if typical of your locality, and then only if you have no more than two already in the collections. The wedding dress may be accepted if used in your locality, if in good condition, and if you have no more than two like it from the same time period. You should also ask the donor what else he may be willing to part with. The objects he has offered you may not be nearly as important to your museum as other things he has that he has not guessed that you could use (such as old wallpaper samples, for example).

At the end of Chapter 1, I referred to the Swiss National Museum in Zurich. Before it was created, the National Legislature passed a law in 1890 setting its scope and its purpose. The museum was "appointed to house important national antiquities that are historically and artistically significant and to preserve them in well-ordered arrangement." The law further declared that the museum was to be characteristic and have the greatest possible cultural and artistic value as a "testimony of our past." A few years ago the guidebooks stated that the exhibits ranged in time from "primitive times to 1920." The scope of this museum is clear. The scope of every museum should be as clear.

Another aspect of the Swiss statute is worth considering: It refers to *important, significant* objects. A good discussion of the historically significant object appears in Guthe's *The Management of Small History Museums*. This is one of the most important concepts for any student of

museology to master. For an object to belong in the collections of a museum it must signify, or say, something of importance. To what end? The museum's stated purpose. What is a historically significant object? One that can be used *educationally*. The object must be usable in teaching the visitor about life in the past. Will it help you teach the history you need to teach? Accept it. Is the object unsuitable as an illustration of your story? Reject it!

But what is the history that you ought to teach? Books will give the historical outline of your region. In most localities someone will have written a local history. But if no one has written the history of your local area, you will have to do it yourself, at least in outline form.[1] You will have to consult libraries, files of old newspapers, and other sources of information about the geographical area of your museum's interest. After you know the main facts of the history of your region, your job is still not done.

You must be prepared to present to the museum visitor the history of first exploration, early settlement, growth of industries, trade and communication, and the modern commercial situation. You will need to deal with minority and ethnic groups. But you must be prepared to go even further. H. Stuart Hughes, writing in *Current Anthropology*, said that the best definition of history is "retrospective cultural anthropology."[2] Let that be your guide. History and history museums are more and more being concerned with the lives of *all* the people, not only the rich, the powerful, and the famous. Hence, you should include the overalls of the poor laborer as well as the white tie and tails worn by the Governor at his inaugural ball; the mass-produced lithograph that decorated the two-room shack as well as the imported oil painting from the rich man's home; the toys of the Indian child as well as the ceremonial sword of the famous general. As an educator, you are concerned with truth and completeness. Leave the aesthetics to the art museum and curiosities to the circus and remind yourself, every day, that a public institution is for *all* the people, all the time. It is not easy. Historical collecting is the hardest of all. Is it not especially unfortunate that we do not yet have enough trained people for all the history museums?

1. Write to the American Association for State and Local History, 1315 Eighth Avenue, South, Nashville, Tennessee 37203, and inquire about publications that would help you. (Incidentally, AASLH Technical Leaflets, which members receive with *History News* and which can be bought separately, give much valuable information on a wide range of topics.)

2. Vol. 4, No. 2 (April 1963), p. 141.

An Associated Press wire service news item of December 1967 illustrates the way many community history museums get started:

Haconda, Georgia—Because he has always been interested in history, Tatum Bedsole has been collecting articles representative of early American life for more than 30 years. An old log cabin, which he moved piece by piece from his family's farm to his own yard, houses hundreds of items such as Indian relics, arrowheads estimated to be 5,000 years old, a cane mill, churns made of gourds and a hand-made rope bed. Bedsole, a rural mail carrier for the past 47 years, said, "Steadfast courage, determination and hard work built our country and we should always remember it. That's what the things in this museum say to me—and that's what I hope they say to the people who come here to visit."

This beginning could serve as the nucleus of a public museum of local history.

Newspapers outside the large cities often print feature articles on local collectors and the collections they have built up over the years. Sometimes the collection is specialized, such as one of antique bottles. Collections are displayed in homes and places of business, and the newspaper stories refer to the 20 to 40 years spent in accumulating them. Some antique collections are thrown open to the public as "museums." Through incorporation as public institutions and subsequent professional management, some of these may one day be able to dispense with the quotation marks.

Of course, not all worthwhile collections fall into public hands. The syndicated column "Dear Abby" published a few years ago a letter from a woman whose grandmother had left her "her most prized possession"—a valuable collection of 338 antique clocks. The woman signed herself "Prefers Cash" and indicated her desire to sell them; Abby supported her. The clocks are now, no doubt, scattered once again and private hands. The grandmother's many years of work in bringing the collection together, and her special knowledge, were lost. It is possible that she would have preferred to donate the collection to a museum had she known that her granddaughter would not keep it.

On the other hand, not all collecting engaged in by amateurs is of interest to history museums. I shall give several examples to illustrate this point, because amateur collectors assume that they are in competition with museums. Museums sometimes help to foster this point of view by showing collections as collections and not in historical context. (For instance, a display of all the pressed glass goblets the

museum owns.) The market price of some objects is a deterrent. In the fall of 1972, a 17th-century flintlock was sold at auction for $300,000. No gun could ever be worth that much to a history museum.[3]

Another kind of object that is collected is the rare stamp or coin that results from a manufacturing mistake. In 1847 on the Indian Ocean island of Mauritius, the British colonial administration issued a one-penny stamp which bore the words "post office" instead of "post paid." Only 14 examples of this engraving error are known to exist. Two of these stamps were bought in 1897 for 50 pounds sterling. Their value in 1954 was estimated to be $75,000. They were sold at auction for $380,000 in 1968. In 1971 a sheet of 100 U.S. eight-cent stamps of the Flag and White House issue was discovered to have no perforations. A philatelic auctioneer said the eight-dollar sheet might be worth $50,000. Later in the year, another purchaser discovered that a sheet of eight-cent stamps showing the exploration of the moon had the horizontal perforations running above the words at the bottom of the stamps rather than below the words. A well-known collector expressed the opinion that this eight-dollar sheet might be worth $100,000. Clearly, such oddities are of no interest to museums as collectors' items, even if the museums could afford to compete at auctions for them.

Sometimes the "rarity" of an object is due to where it has been, rather than what it is. In 1965 an old coin, a 1793 large cent, was secreted aboard a Gemini 7 spacecraft which made a 14-day orbit of the earth. Removed by the flight surgeon who had placed it aboard, the coin was sold for $15,000 and now, according to a coin dealer, might be worth as much as $100,000.

Amateur collecting may have emotional or psychological value instead of financial. The Beer Can Collectors of America hold an annual "canvention" (sic) at which more than 100,000 empty beer cans are on display and offered for exchange. A private hobby might be of more general interest and still not be of much significance in a museum.

For example, a western couple whose hobby is leather tooling had spent more than three years in fitting out the interior of the cab of their pickup truck, including the dashboard, with hand-tooled leather and figured that the cost in time and materials was more than $10,000,

3. This was a French fowling piece made for Louis XIII and sold by the American collector William Renwick at Sotheby's auction house in London to London dealer Frank Partridge, November 20, 1972.

according to a newspaper article. They were quoted as saying that when the truck was at the end of its life span of usefulness, it would be given to a museum with all leather intact. Such a curiosity would be of limited interest to a real history museum.

A popular movement of more concern to museums is the public's greatly revived interest in recent years in the odds and ends of yesteryear. Interest in quality furniture, glassware, silver, spinning wheels, and such materials useful in interior decoration has always existed. Now, however, cast-iron toys, advertising posters, beartraps, tobacco tins, and almost any relic of the past is in demand. "Old fashioned" restaurants and bars use sewing machine cabinets as tables and decorate their walls with what would have been carted to the dump not very long ago. An article in *Time* showed a woman ladling soup from a chamber pot at the dinner table and quoted an antique dealer as saying, "It has some age to it, maybe 15 or 20 years."[4]

What is it all about? Nostalgia. A kind of homesickness for an imagined past as a retreat from the frightening and puzzling world of today. In the May 3, 1971, issue of *Time*, Gerald Clarke's essay "The Meaning of Nostaliga," refers to the popular clichés which constitute the average person's understanding of history. "At a certain distance," he says, "vision fades and imagination takes over. Try as they might, imitators never succeed in exactly reproducing the past. The eye of memory takes in 1936 and the elegance of an Astaire dance or the froth of a Lubitsch comedy; it is blind to Depression breadlines. It catches the shapely legs of Rita Hayworth in 1944's hot pants but neglects the 500,000 U.S. war casualties of that year. It is amused by the crew cuts and slang of 1953 but forgets the anti-Communist hysteria and the fear that followed the detonation of Russia's first hydrogen bomb."

The history museum must not be an institutionalized representation of fads, hobbies, and myths. What concerns the private collector and the entertainment-seeking public should not necessarily occupy the attention of the historian, except as he observes and records the passing scene. The museum must be devoted to the serious occupation of discovering, preserving, and interpreting the forces that created human behavior and the concrete results of that behavior. It must tell *all* the story and do it in proportion; that is, each part of the story must be told in relation to the other parts. To exhibit wedding dresses but no overalls is to lie about history (unless the limitations of

4. "Antiques: Return of Yesterday's Artifacts," May 2, 1969.

your museum require that you collect only female ceremonial attire, which should then be officially stated and publicized).

A history museum can err not only in regard to its view of history, but also as to the temporal limitation placed on its operation. A museum may be so naively founded and administered that the board, the staff, and the general public have no common understanding about its scope. When a closing date or upper limit is set for a small museum of local history, it is usually 50 years or more before the present. Such a museum may be accepting objects of the World War I era but refusing donations of the 1920's. In the 1980's they may accept objects of the 1920's and 1930's. In the year 2020 they will begin to accept the objects with which we are familiar today. But why should a museum give its collecting program a 50-year handicap? The curator, in effect, says "Yes, 50 years from now the clothing we are wearing, our furniture, our pots and pans will be of great value to the historical museum. However, we shall allow most of these things to disappear through accidents of time, and then 50 years from now our successors will search attics and secondhand stores to see what they can find that is still usable." Museums, in theory, go on forever. Just as we are interested in objects of the past, museum curators of the future will be interested in what we have today. Might we not consider collecting objects of today that will be historically significant tomorrow?[5]

In general, objects of the past are harder to come by if they are very old, were made of perishable material, were never very plentiful, were not highly valued in the past, or are highly valued today (by private collectors). The history curator needs to be skilled in locating such objects and in getting donations of them. Might not he save the curators who succeed him unnecessary trouble by collecting objects now while they are plentiful, reasonably priced, and in good-to-perfect condition? The important objects in a history museum are the commonplace, typical, popular, and once-plentiful artifacts of every-day living, but it is precisely this kind of material that is least likely to be stored away in a trunk in the attic eventually to be offered to the local museum.

Progressive history museums today accept two somewhat radical ideas: 1) the best history includes a strong measure of anthropology, and 2) collecting from today's world for tomorrow's makes sense.

5. I developed this idea more completely in my article "Active Collecting in History Museums," *Museum News*, 45, No. 7 (March 1967).

The Oregon Historical Society has established eighty or more location points for continuing, periodical documentation photography. Photographs are taken several times a year from the same viewpoint, making a record of the changing scene. Local historical societies choose the points and make the photographs. The state society stores the negatives and supplies prints. The University of Alaska Museum reported on its Modern Alaskan Native Material Culture Project in the *Western Museums Quarterly*.[6] L. J. Rowinski, Director, described in detail the program for photographic documentation and for collecting objects from Eskimos and Indians in the present day. L. Thomas Frye, Curator of History at the Oakland (California) Museum has interested young people in his city in collecting and donating everyday objects from their environments pertaining to "work, family, and play." The collection is for the year 2069, 100 years after the project was begun. One further example: the Smithsonian Institution stirred up the press a few years ago with an announcement of plans to reconstruct a slum dwelling, a simulated tenement, and more recently got newspaper notice when it added miniskirts to the costume collection.

Collecting only impressive objects of the past without a serious intent to be engaged in social science is antiquarianism. Collections must be useful in an active program of public education. Deadwood must be cleared out. No museum has so much space that it can afford to store objects that are not historically significant. Collections are sometimes improved not only by accessioning but by deaccessioning. Indeed, this "deliberate alienation" (see Chapter 6, Exercise 3) may be temporarily more important to a museum than collecting.

Items to be eliminated from the collections are those that: 1) lie outside the defined scope of the museum; 2) are not significant and which cannot be used for research, exhibition, or loan; 3) are so badly damaged or deteriorated that they are of little or no use; 4) would accomplish more good in another museum; 5) are duplicated many times—and so on.

Items may be returned to the donor, destroyed, sold, or transferred to another museum. "Legal considerations and public relations will determine the method of disposition. Disposition should be decided by the board."[7]

6. Journal of the Western Regional Conference of the American Association of Museums, VIII, No. 1 (December 1971).

7. Eugene F. Kramer, "Guideposts for Collecting," AASLH Technical Leaflet No. 6 (Nashville: American Association for State and Local History, 1970).

EXERCISES—CHAPTER 7

One of the most important concepts in museology, one that tends to separate the real museums from the curiosity collections, is that of the historically significant object. It can be applied to other fields, of course. One might also speak of the "geologically significant object," the "ethnologically significant object," or even "the artistically significant object." The purpose of this assignment is for the student to grasp the theory of historical collecting, or, to put it simply, to understand what he should add to the collections of a history museum if he were given this responsibility.

1. Define the following terms: souvenir; antique; relic; heirloom; collector's item; nostalgia; sentiment; hobby.
2. What does age have to do with historical collections? What is the relationship of age to worth? Are old things of more importance to a museum than new things? (You may answer this as a single paragraph which includes the points raised in these questions or answer the questions individually).
3. Discuss the importance of the commonplace. What about the unique, one-of-a-kind object?
4. What are the categories of objects in a historical collection? (In regard to condition, documentation, and the like.)
5. What is a history museum?
6. Look about you. List 10 to 20 objects that you can see in the room from where you sit. Now think of preserving these objects for use in an appropriate museum 100 or more years from now.

 Categorize the objects on the basis of historical significance. Which of the objects you listed would you consider to be the best illustrations of life today? Which of lesser value? Which would be of doubtful use or of least value?
7. This one will require a good relationship with several other people or sneakiness on your part. Look into and make inventories of the contents of four or five refrigerators in as many different homes. Safely back at your desk, compare these lists to arrive at similarities and differences. Make up a composite list of average items that would be found in a typical refrigerator in your neighborhood at this time. Leave out unusual items, and do not add anything which you think should have been present, though it was not.

 This list of items would be of great value to a curator of history a hundred years from now. Add any instructions he would need on how to place the objects within the refrigerator.

8

Collecting Theory: Art Museums

In the first chapter, we defined "art object" and "art museum"; now we must define "art." First let us consider what artists do.

All humanity has a drive for beauty. Even the most primitive peoples decorate their simple possessions and their own bodies. They also make representations of real and imagined elements of their environments, such as carvings of animals, or masks portraying supernatural beings. In the Mediterranean civilizations, statues representing gods and people were often painted in bright colors. Pictures were painted on walls and boards and woven in cloth. Representation of what is real to the artist continues to our day. The fine artist's creation that results in a material object is called *sculpture*, whether carved wood, chiseled marble, modeled clay, or whatever. The creation that results in a flat, two-dimensional picture or design may be

Author's Note: A word of explanation may be in order regarding the nature and length of this chapter. My purpose has not been to write a treatise on aesthetics, or about art in general, but rather to provide for the majority of persons using this book an introduction to the kinds of objects collected by art museums—and the kinds which are rejected—and the traditional attitudes of art museums toward these materials. Most of the museums of the United States and Canada include objects in one or more of the art fields but without having anyone on their staffs who is familiar with these fields. Most beginners are not prepared to cope with the confusion that often exists between a historical and an artistic attitude toward things of the past. Furthermore, it is basic to an understanding of museology to grasp the philosophical difference between art museums and other kinds of museums. It is the aim of this chapter, therefore, to place art collecting in a larger perspective.

Persons who have had training in the fine arts may find some of the explanations elementary and some of the illustrations repetitious. They may also regard my interpretation of the complex world of art as biased. Be that as it may, I ask all readers, whatever their prior acquaintance with the arts, to think seriously about the issues raised in this chapter.

called *graphic art*. This includes drawings, prints, paintings, and photography.[1]

The liquid in paint is called the vehicle, since it carries the pigment until it is applied to the surface being painted. When the vehicle has evaporated, we say the paint is dry. The vehicle determines the name of the medium: oil for oil paints, water for watercolors. The term "acrylic" is used to refer to a painting made with acrylic resin-based paints. Paint can be applied to a variety of surfaces, so that a "painting" may be a wall, an eggshell, a board, a sheet of masonite, a sheet of plastic, or a piece of canvas stretched over a wooden frame (called a "stretcher"). A print is a picture, design, or image made by a printing process, much as a book is printed. There are four main printing methods, which can be used separately or combined:

1. *Relief Printing*. This is the oldest method for making prints. It is based on cutting away part of a flat surface so that the image required is left to act as a printing block. Examples are *woodcuts* and *"lino cuts"* (linoleum block prints). If raised surfaces are created on the printing plate, the result is an *embossed print*.

2. *Lithography*. This is based on the fact that oil and water will not mix. On a flat stone (or zinc plate) a drawing is made with a greasy crayon. The plate is moistened; water will not adhere to the design. Ink is rolled onto the plate; it adheres to the design but not to the wet stone. Paper pressed onto the stone picks up only the image.

3. *Intaglio Printing*. The image is cut into the printing surface and filled with a greasy printer's ink. The surface is wiped clean, leaving ink only in the grooves of the design. Dampened paper is pressed onto the plate, picking up the ink in the grooves to print the design. The oldest intaglio process is *engraving*, in which the design is scratched into a metal plate with a sharp tool. In *dry point* a furrow with raised edges is made, and the raised edges catch the ink to make the print. In *etching* the plate is covered with an acid-resistant substance, which is scratched away to make the design. The plate is dipped into acid, which eats into the metal plate where the

1. Of course, the decorative arts such as silversmithing and weaving result in objects of beautiful form or beautiful surface design. The main distinction is that the fine arts tend further toward the ideal of "art for art's sake," while the primary purpose of the decorative arts is utility; art, if it exists at all, is a secondary characteristic.

protective coating has been removed. The plate is then cleaned and used for printing, as in engravings. The *aquatint* process is the reverse of etching; the acid is used to remove areas instead of lines.

4. *Serigraphy. Silk screen printing* is the common form of this process. A piece of silk held in a frame is prepared by blocking out all the surface that is not to be used for printing. The resulting stencil is placed over paper, and ink is squeezed through the areas of the silk left open. For color printing, each color is printed by a separate screen.[2]

Obviously, a number of prints can be made from the printing plate or plates prepared by the artist. Because of the progressive deterioration of successive prints through the wear of the plates, artists usually destroy the plates after a certain number of prints are made. (Of course, the economics of scarcity also come into play.) The prints are often numbered (for example, No. 32 of 200). The lower the number, the better the print, generally speaking. A work of graphic art can be reproduced by photography and a printing process, as illustrations in art books are made. When produced individually for framing or matting, these reproductions may also be called prints. To avoid confusion and to establish a standard, the Print Council of America has defined the term *original print* as follows: 1. The image must be created by the artist himself on the plate, stone, woodblock, or other material from which the image will be printed. 2. The prints must be pulled by the artist or under his supervision. 3. The finished prints must be approved by the artist.

Most artists cannot or will not define "art" in words. For museum purposes, definitions are useful, however; therefore I shall attempt one. We might say, briefly, that *art is the deliberate creation of aesthetic sensations*. Art is a work of a human being, not of nature. It is not accidental. It produces something that is perceived through the senses and results in a personal emotional experience. This experience was commonly understood in the past to be a recognition and appreciation of beauty. In recent years, some artists have deliberately created ugliness with the avowed aim of shocking the viewer rather than of giving him pleasure. Artists and art museum people are not in full agreement on whether these creations are art, or whether a new

2. Condensed from Luis Edwards, "Prints: A Glossary," *The Art Gallery* (November 1966).

definition of art is needed. How to deal with much of contemporary art is a problem that we shall put aside for the moment.

A longer definition of art is that it is the conscious, deliberate production of an event or object of beauty (or emotional import) by a human being, employing not only the skill of the craftsman, but, in addition, an element of creativity—original, inventive, instinctive genius. An art object is an aesthetic artifact, deliberately created. The key idea is that of creativity. Art actually lies in the act of creation, not in its result. Therefore, the expert copier of another person's painting may be just as good a technician, and the painting copied may be a work of art. However, the copy is not a work of art (but a copy of a work of art), and if the copier never created a painting of his own he could not be called an artist. A skilled pianist may or may not be an artist. It depends on whether he or she merely reproduces the composer's creation or, in playing, creates something new; a personal interpretation. A cook may be an artist (in his cooking). A painter, in his painting, may not be. A sunset may be beautiful, but it is not a work of art. A photograph of the sunset, even though less beautiful, may be a work of art.

Every museum must be involved in art, even if it is only to recognize that art objects in its collections must be protected from deterioration and that exhibits of all kinds must be artistically prepared. Even science museum curators need to have an understanding of art as it relates to museums. All museum professionals must understand why a museum of science (or natural history) will commonly have a hall of African or Oceanic Art, yet to find a hall of African or Oceanic science and technology in an art museum would be rare indeed.

Let us consider the basis of art. A few years ago the Detroit Zoo auctioned off paintings by chimpanzees. Paintings by monkeys and apes have been sold and even entered in art exhibits, sometimes reportedly winning prizes. This delights the average person because he is convinced that there is nothing of value in modern abstract paintings by humans. Desmond Morris became interested in paintings by apes and decided, after a study involving both human children and monkeys and apes, that only six principles apply to picture making as a whole, covering everything and everyone from Leonardo da Vinci to Congo (a gorilla). They are: 1) *Self-rewarding Activation*. The production of a picture must be pleasurable and satisfying. 2) *Compositional Control*. Steadiness, symmetry, repetition, rhythm, a positive reaction to order rather than chaos. 3) *Calligraphic*

Differentiation. A slow process of pictorial growth, covering the de- velopment of marks and lines into distinct shapes. 4) *Thematic Variation.* A pattern selected from erratic exploration chosen as a theme and repeated with variations. The simple replacing the com- plex as a reaction. A familiar, repeated theme replaced by another and then returned to. 5) *Optimum Heterogeneity.* The point at which the picture is finished. One mark less and it would be unfinished, one more and it would be overworked. 6) *Universal Imagery.* Picture- making by children and by uninhibited, untrained adults is similar regardless of culture. This depends on: a) The muscular factor; certain movements of the hand and arm are more pleasing than others. b) The optical factor; certain visual arrangements are more acceptable to the optical apparatus than others. This is related to the spacing of the eyes, the fact that it is more comfortable to look from side to side than up and down, and other factors. The ratio of height to width that is most pleasing to most people is 1:1.618. It is called the *Golden Number*, and can be represented by a rectangle of these dimensions. It can also be expressed by the proportion, width is to length as length is to length plus width. c) The psychological factor; strong undercurrents at work concerning relationships of elements in the picture.[3]

Morris says that any rules that are basic enough to be applied to several related species rather than one species or (as is more often the case in art history) to one epoch of one species, must indeed be fundamental to the activity concerned.

If art has a biological basis, we would assume that all people, at all times and places, share in this drive for expression. Anthropologists agree that art is a universal aspect of culture. It is the aesthetic compo- nent of objects and acts in which the art museum is interested. A canoe paddle to the ethnologist is a tool with a significance for mobility, that is, for the extension of the sphere of activity of the people concerned. If the paddle is decorated, or has a pleasing shape, it may be collected by an art museum and exhibited as an aesthetic object. Why is it that some primitive peoples are more noted for their (folk) art than others? All cultural manifestations, including art, can be understood as satis- fying the needs of the society, such as relieving tension. A. W. Wolfe, making a study of this question, concluded "that art develops in those societies where the men of a local community are divided by impor-

3. Desmond Morris, *The Biology of Art* (New York: Alfred A. Knopf, 1962).

tant social cleavages."[4] In other words, art serves ascertainable practical needs.

The contribution that art study can make to history is probably too obvious to mention, but other fields may profit as well. For example, Mr. Xavier de Salas, Assistant Director of the Prado Museum in Madrid, has pointed out that the works of minor artists can be revealing for sociological study. While the great masters were usually highly innovative (even radical and individualistic), the artists of lesser stature were more subject to the influence of their situation, and, therefore, produced work more truly reflective of their times.

Is education, then, the proper role of the art museum? It probably is, especially if the museum belongs to an educational institution. The campus art museum or gallery shares the educational aim of the college or university of which it is a part. Its curators should not be content to engage in repetitious exhibition of the same kind of art but should show art in all possible forms and expressions from all countries and all times. The aim should be a broad education in art history and art appreciation for all of the students. The gallery should introduce students to modern fine arts and strive to engender standards of taste and beauty. The average student may not come to enjoy nonobjective (abstract) painting, but at least he will have seen it; and any assistance in eliminating billboards, utility poles, and automobile graveyards by making future adult citizens aware of the ugliness around us is surely a good thing.

This is not to say that the viewing of art, in itself, will accomplish much. Art museum people are forced to recognize that mere exposure to good art is not enough to teach good taste or an appreciation of art. Docents (guides and lecturers), trustees, volunteers—educated people voluntarily associating with and identifying with an art museum and *exposed constantly to good art*—often do not become literate in art. Gallery guards may be exposed to great art eight hours a day for years, yet still retain the tastes of their social class and educational level. Therefore, because exposure to art is not educational or molding in itself, the art museum that desires to educate or raise standards must embark on a deliberate educational effort.

Art museums in general spare themselves the pain and frustration of such missionary travail and are content to serve only the aesthetic needs of their visitors. Indeed, many art curators and direc-

4. Alvin W. Wolfe, "Social Structural Bases of Art," *Current Anthropology*, Vol. 10, No. 1 (February 1969).

tors will flatly deny any obligation to educate in the usual sense and will maintain that art museums, unlike other museums, are not educational institutions. Philip Johnson, an architect of high and well-deserved reputation who knows a great deal about the functioning of art museums, answered Francine du Plessix' question "Do you regard the museum's role in our society as mostly education?" by saying "Horrors no! I do not believe in education. I hate the thought of all those tots being dragged around in museums, being shoved all that information they can't begin to assimilate. I only believe in *self* education, in the individual going *to* art if he needs it. The function of the museum is to satisfy a deep natural want, as deep and natural as sex or sleeping, for looking at pictures."[5]

You have realized by now that we have been talking about three kinds of "art": 1. The traditional fine art hanging on the art gallery walls (and the decorative arts of high quality), called "art"; 2. Popular or mass art hanging on the walls of the gallery guard's home, called "Kitsch"; 3. Primitive or tribal art as represented by the carved canoe paddle, usually lumped together with traditional rural (peasant and pioneer) crafts under the name "folk art."

All art originated with primitive or tribal art, in the sense that all mankind was in a precivilized state during most of his existence. As culture develops to more complex forms, elite art emerges. This depends on the creation of an artist class which exists to symbolize the high status of priests and rulers. The artist class forms a court or patrician style of art that differs from the tribal or plebeian style. "Domination of the culture by any particular class will always be reflected by art."[6] A few years ago in Europe the bulk of the population consisted of peasants, producing food on the land and supporting a parasitic elite segment of society. The elite were the nobility, the churchmen, and, later, the middle class. Art was then divided into fine art—the art of the aristocrats—and folk art—the art of the common people. With the growth of towns and especially after the Industrial Revolution, an urban lower class developed. Its culture can be called "mass culture." This mass culture of the towns is the ancestor of the popular culture of today, just as true art or fine art is the descendant of

5. *Art in America* (July–August 1966). Note that people involved in the arts and in art museums frequently refer to art museums simply as "museums," as though other kinds of museums do not exist.

6. Herta Haselberger, "Methods of Studying Ethnological Art," *Current Anthropology*, Vol. 2, No. 4 (October 1961), 351.

the art of the nobility. Such folk art as exists in the present goes back to peasant origins.

Figure 8.1 may make relationships clearer, though it must be understood to be hypothetical and only suggestive as to scale and relative proportions of areas. The key to understanding the difference between true fine art and the other kinds of art is the expression "art for art's sake." It refers to an act or an object that has been created solely, or at least primarily, as art. This is characteristic of art in recent times (in the last few hundred years) and appears to be more and more true as time goes on. That is, an example of modern abstract art that does not depict anything real is more truly art for art's sake than is, for example, a portrait by Gainsborough, which is not only a work of art but also a kind of historical document showing how a certain real person looked and dressed. Without meaning to quarrel with those who say that the work of the giants of art history, such as El Greco and Michelangelo, can communicate with all ages, since great works of art have universal and timeless appeal, remember the continuum from the utilitarian object of the tribesman to the work of pure art. Fine art developed out of tribal art as a representation of something that was

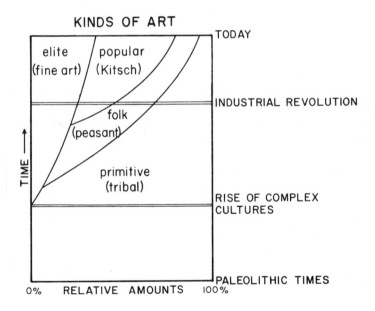

FIGURE 8.1.

real to the culture (like ancestor spirits, not necessarily real to you and me). Art in the Middle Ages served religion and the nobility; a painting was primarily an object useful in religious instruction or as a focus for veneration. Later, landscapes and pictures of people and animals were items to amuse and were appreciated for their subject matter. The radical French Impressionists departed from a realistic technique, and the abstract painters who followed them went even further. Good modern art is less utilitarian (serving a practical, nonart purpose) than was the good art produced in the past, and therefore, many would argue, more truly art.

If this seems hard to swallow, ask a good artist why he does not paint or sculpt in the style of Michelangelo. If he is honest, he will tell you that his style of art is better; or he will say that he does not want to use Michelangelo's style or that he can achieve more satisfaction working in the modern way—which is pretty much the same thing.

Some scholars object to the statement that primitives do not have true art (art for art's sake). Haselberger[7] points out that Himmelheber reported finding in a village on the Ivory Coast nonfunctional items enjoyed as art objects by the natives on festival days. Examples were sword grips without openings for inserting the blades, salve containers that could not be opened, and signal horns that lacked mouthpieces. Thus Haselberger concludes that tribal peoples occasionally do create art for art's sake. However, she seems undisturbed by the fact that the objects started out to be or were made in imitation of real, functional objects. The situation cited is perhaps a transitional one. We may have here an instance of a tribal people taking a step in the direction of art; yet our thesis, I feel, is still valid. Generally speaking, art as art is characteristic only of civilized society. The term "folk art" as applied to ethnological specimens collected and shown by some art museums can be misleading.

Another distinction between primitive or tribal art and true or fine art is this: the former expresses group sentiments, and the latter expresses individual (that is, the artist's personal) sentiments. Returning to our definition of art as an individual creation of genius, primitive art that so rigidly adheres to traditional forms that all the people of a village decorate objects in pretty much the same way hardly qualifies. Anthropologists tell us that individual differences are not ordinarily encouraged among primitive or folk societies. In such an envi-

7. *Op. cit.*, p. 345, citing Hans Himmelheber, *Negerkunstler*, (Stuttgart: Stecker & Schroeder, 1935) p. 49.

ronment the so-called "folk artist" may produce objects of beauty and emotional impact without being an artist. He may lack the conscious intent to produce art (as art), or he may be merely a skillful renderer of traditional forms, rather than an innovator who adds his personal creativity to his work.

In an interesting article that appeard in *Life* magazine during the summer of 1969, Robert Phelps dealt with Governor Nelson Rockefeller's collection of objects from New Guinea and elsewhere, which was then on display at the Metropolitan Museum of Art in New York City. Mr. Phelps pointed out that we ordinarily equate "primitive" with "crude," "unschooled," "unintelligent," and the like, but that the objects in this collection of primitive art show great beauty and power. "All the same it is *art*"; he says, "that is, in every piece there is human feeling as well as human craft." He admits, however, that while "The artists were acknowledged by communities, it was as *makers*, not inventors of original feelings. The emotions expressed are family and tribal." One may conclude that although primitive art may have the outward characteristics of art, it is art of another dimension, much as a folksong may be beautiful and well constructed, though molded by the many over the years—not a one-time creation by one person. Rather, the culture has created the art; and the artisan who makes the object that is involved is not the artist but the expert copier of a creation not his own.

The beginning museologist need not be quite so philosophical about the Indian baskets which he has to exhibit. Perhaps more to the point is the distinction made at Cooperstown[8] between the formal and the folk arts; that is, between fine arts and history. Museums use objects according to how they can best serve. Folk arts and tribal arts may be more useful for history and anthropology. If, however, an art museum wishes to call our attention to the aesthetic properties of an object which had a practical function, this is by no means an improper use of the object.

Let us now consider popular art. Confusion arises out of the failure to recognize that two separate kinds of art exist side by side today. One is traditional fine art: the other is popular art or Kitsch. The practical aspect of the problem for the museum worker has to do with the difference of opinion between the museum and the man on the street as to what kind of picture is worth looking at. Mail-order houses

8. New York; the excellent museum-training program of the New York State Historical Association.

and furniture stores stock and sell paintings and prints that are popular with the masses. A reputable art museum would not hang one of these. Why not? Is not the art museum an institution existing to serve the aesthetic needs of the public? Is not the successful furniture store a reliable guide to popular taste? I am not suggesting that an art museum collect and display the kinds of pictures that the public, which it serves, would most want to see. I do hope, however, to throw some light, for the beginner, onto the nature of the conflict.

Fine art directs our attention to its own character or existence; Kitsch directs our attention to pictured concepts, events, and objects. We respond to the *subject* of an example of Kitsch, not to the painting as an object of value in its own right. Fine art is created as an end in itself: the painter wishes the viewer to be aware of the painted surface as a painted surface and to respond to the style, form, and color employed. Kitsch is designed to entertain, to divert, to persuade, or to propagandize; the painter wants the viewer to look through the painting "as if it were a window into nature" and respond to the subject matter.

Norman Rockwell's paintings provide an excellent example of Kitsch. An advertising leaflet for a book about him and his work refers to him as a chronicler of nostalgia who spent half a century finding humor and pathos in the daily trivia of American life.[9] Rockwell would have us join the family gathered around the Thanksgiving table. The true artist, dealing with a similar subject, would hold us back so that we would appreciate the two-dimensional object that he had created, rather than become vicariously involved in the scene depicted. The kind of popular art created by Rockwell has been said to represent a visual counterpart of the anti-intellectualism which characterizes other facets of American culture. When the viewer cannot immerse himself in the subject matter of the painting, he is brought up short. He is forced to see an abstract by Picasso as a painting, not as a device to allow him to daydream about a baseball game, a "date," or a Thanksgiving dinner, and he becomes puzzled about contemporary art.

Kitsch, like everything else, changes. It feeds on fine art; and as fine art develops new styles, popular art picks up the old ones. This phenomenon is observable in other kinds of human behavior. When the stylemakers who glory in setting themselves apart from the masses

9. Thomas S. Buechner, *Norman Rockwell: Artist and Illustrator* (New York: Harry N. Abrams, 1970).

discover that the general public is imitating or taking over their distinctive symbols—whether clothing, furniture, or seaside resorts—they abandon the old symbols and take up new badges of their superiority. The elite classes passed sumptuary laws a few hundred years ago to prevent the peasants from imitating them. The common man, however, lags behind. It takes him a while to become accustomed and to risk braving the scorn of his peers before he adopts a new hairstyle or a new manner of dress. Maintaining status and self-esteem is a continual struggle for most people: they want to avoid the appearance and label of being old-fashioned or a "hick" but not to forge so far ahead as to be called a "kook" or a "weirdo." "The public, thinking it is going along with the modern movement by accepting Picasso, Miro, or Chagall, merely indicates that it has caught up with these art forms that have been with us for a half-century," said Alvin C. Eurich.[10] Eurich pointed out that the artists of any period are inventing new forms of expression, and a great artist may not be completely or enthusiastically received in his own time. "A highly regarded music critic, a contemporary of Beethoven's, wrote 'poor Beethoven, he is so deaf he does not hear the discords he writes.' A patron of Mozart, hearing some new tonalities developed by Mozart, became so furious that he rushed to the music stand and tore the music to shreds. A group of established artists in France ran a now historically famous ad in a newspaper publicly denouncing the French Impressionists as a group of idiots who had banded together to show their art. An established art magazine of the time carried an article stating that Cézanne did not know how to draw straight lines. All of these examples lead to a conclusion that is abundantly clear: any new development in any art form will probably be denounced by the established artists in that form. This is understandable, because a new direction is an indirect attack on the validity of what they are doing."[11]

Conservatism exists, even among artists. A museum curator must not be misled if an established artist of good reputation speaks out against the kinds of art being produced today. These radical forms are not necessarily bad. The art museum might well consider adding contemporary pieces to its collection, but problems may arise immediately. Leaving aside monstrosities like a half-mile of ocean cliff

10. President of the Aspen Institute for Humanistic Studies, speaking at the Governor's Conference on the Arts and Humanities, Boise, Idaho, November 15, 1966.
11. *Ibid*.

wrapped in canvas, many modern pieces are so large that they cannot be moved through the art gallery's doors; or they may be meant to take up a great amount of floor space. A 1970 exhibition by Joel Shapiro at the Paula Cooper Gallery in New York City included a work entitled "38 1/2 lbs. 1970." It consisted of 38 1/2–pound beams of aluminum, steel, and mahogany aligned parallel across the floor. The wood stretched out to a length of about fourteen feet.

The old categories of art are no longer exclusive. Today, paint and materials are combined in three-dimensional forms which are not exactly paintings and not exactly sculpture. Perhaps they might best be called "constructions." Other works of contemporary art are trans- itory in nature—not intended for long existence. I have seen a plastic sheet blowing in the breeze of an electric fan, several bucketfuls of sand spread around on the floor, and crumpled colored paper thrown against a wall. Similarly, some public performances, called "happen- ings," are transitory. One might argue that all such examples demon- strate creativity in the performing arts, rather than the fine arts—that they are theatrical events or stunts.

The first problem that the collector of contemporary art faces is what *can* be collected? The second is what *should* be collected? In *Rebels of Art*, George Slocombe says that at any given moment between 1870 and 1900 approximately 40,000 professional easel painters were work- ing in Paris. Allowing for a turnover of most of this number every few years, the total number must have been at least a quarter of a million. If only 20 Impressionists are significant (worth collecting today), we must conclude that, conservatively, only one in 10,000 makes the grade. Using this ratio, we may assume that of the 25,000 art majors in California colleges and universities at this time, only two or three may be expected to achieve lasting, international reputation. Douglas M. Davis predicts an even smaller number. He says that the vast majority of the art objects currently being produced are "surely trash and will never be heard from again. We shall be fortunate if from this decade, so fertile and exciting in its productivity, one or two genuine artists emerge."[12] At the same time, he pointed out, "It is grossly unfair to compare the collective work of the new painters with selected giants from the past, as is frequently done—with Michelangelo or Rubens or Cézanne. We forget that what we know of the art of the past is highly filtered. Thousands upon thousands of bad landscapes, bad portraits,

12. *National Observer*, January 9, 1967.

bad Impressionists, bad Cubists have been winnowed out by museums and textbooks, giving us a considerably warped view of the past as a collective whole."[13] Art museums are faced with a two-horned dilemma. The old, established art is so expensive that most of them cannot afford it, and who knows what to buy of relatively inexpensive contemporary art? What to do? The art institution can avoid collecting problems by not being a museum. The so-called Museum of Contemporary Art in Chicago, established in 1967, intends to avoid collections. The Museum of Modern Art in New York for years maintained a policy against permanent acquisitions. A Middle Western art museum recently sold its collections in order to have money to support an activities program. But remember that institutions without collections are not museums. They are art centers, theaters, libraries, research institutions, or something else. Art museums, except for the wealthy ones that can hold their own at auctions, must depend on the generosity of donors for the works of established artists of the past (what might be called "historic" art) and buy contemporary art carefully.

Buying contemporary art which has not yet become established in our culture (that is, buying kinds of art which are not widely collected for decorative use, or buying the works of an "unknown" artist) presents a philosophical problem for the art museum of serious purpose. The inclusion of a work of art in the collections of an art museum and the exhibiting of the item is tantamount to a statement by the museum's professional staff that it is more than an aesthetic object—that it was of importance in the lives of people, or is representative of a kind of art that had such importance; that, in other words, the object had relevance to the cultural milieu in which it was produced. Therefore an art museum must be cautious in acquiring brand new art, as from the artist's commercial outlet (the gallery which sells his work for him). A more extreme example is the purchase of a work of art created by an artist *for* a museum, to be transferred directly from the artist's studio to the museum's exhibition halls. The painting or sculpture should first have had some use. It should have been accepted and successfully employed as an art object; in other words, it should have played a role in our culture. Then, as a cultural object, it would be eligible for preservation by a museum, *whose reason for existence is the preservation and use of significant cultural and natural specimens.* One can, of course, imagine an exception: Similar to the

13. *Ibid.*

undocumented object in the history museum which has significance because it is typical and representative of a class of objects of documented importance, a museum may consider collectible a painting by a contemporary artist of established reputation, even without an intermediate owner. That is, if the paintings of this artist have won recognition, if they are the product of significant forces in our culture, are illustrative of our times and so on, the museum may buy a painting from him while it is still wet on his easel and transfer it to an exhibition gallery.

In this view, art provides not only high-level entertainment (aesthetic experience) but illustrates cultural history as well. An art museum staff which is so set against the use of their collections for public education (which is the prime necessity for all other kinds of museums) that they flee in the opposite direction and ignore the cultural connections of the objects of art cannot be defended. Not only do they decrease the potential use of their collections (and therefore decrease their collections' worth), they run the risk of having their works of art but a step removed from any accumulation of curiosities, and their museums but a step from any enterprise that merely panders to the superficial and momentary pleasure-seeking of a mentally lazy public.

In collecting the art of today, the art museum curator must try to recognize examples of creative genius. He should also try to select objects that are representative samples of our time and culture, not idiosyncratic oddities. In collecting the art of the past, the chief problem is cost.

Lately, the demand for art has reached enormous proportions, and the number of available art objects is decreasing. As time goes on, of course, objects of the past become scarcer. Fire, war, and natural disasters take great toll of historic art. The floods in Italy in the fall of 1966 were the worst in hundreds of years: more than 8,000 paintings in the Uffizi Gallery in Florence were under water, to cite but a single example. Another cause of scarcity is the museum itself. When a museum acquires a piece of sculpture, it is permanently removed from private hands. Each year, fewer great works of art are available for purchase by individuals. There is more affluence today, however, and art is a socially acceptable form for excess wealth, perhaps more so than private railway cars and ocean-going yachts. It all adds up to high prices paid to dealers and at public auction for works of art.

The prices of items at auction suggest that the value of an object is not the cost of producing it or what the owner paid for it but what it

will bring at auction. Market price is tied less to beauty or appearance than to the name of the creator. One of the largest and most respected of the auction houses, Christie's of London, put a price of $280 on a painting, *The Judgment of Paris*, when they thought Lankrink had painted it. When they decided that it had been painted by Rubens, they announced its value as more than $225,000. Why is it that the same painting is worth 1,000 times as much if painted by one man than if painted by another? It can only be that the dollar value of an object is determined by what someone is willing to pay for it. Most museums cannot compete with the people who are willing to pay astronomical sums. With notable exceptions, great art that hits the market today is more likely to wind up in private than in public hands.

Art museums, however, continue to do the best they can. They maintain contacts throughout the world so they can keep abreast of what is becoming available on the world art market. The director often travels to inspect a work of art and decide whether it meets the standards of his museum and will be an important addition to the collections. For example, will it fill a gap? The actual purchase may be handled through an intermediary so that competing bidders cannot judge their competition.

Market prices have expanded even beyond the expectations of the experts. A porcelain teapot worth $3,200 in 1961 sold for $10,640 five years later. A set of seven Chippendale chairs sold for $2,987 in the spring of 1966. Six months later they brought $4,480. Mischa Elman sold in 1972, for $34,800, a Stradivarius violin he had bought in 1907 for $1,200. Old Master original prints multiplied in value 37 times from 1950 to 1970. *Seated Odalisque* by Henri Matisse sold for $350 in 1960 and $4,000 in 1970. Picasso prints increased in value 120 per cent in 1968–69. One of his linoleum cuts, *After Cranach*, worth $600 in the early 1960's, went for $35,000 in 1970.

The "big money" is reserved for oil paintings. To date, the most paid for a painting was the $5,544,000, which won *Juan de Pareja* by Velasquez for the Metropolitan in 1970. This painting, done in 1649 just for practice, is not regarded as Velasquez' best and would probably win no popularity contests for beauty. The highest amount previously paid for a painting at auction, also by the Metropolitan Museum of Art, was $3,285,000 in 1961 for *Aristotle Contemplating the Bust of Homer* by Rembrandt. The highest price ever paid for a painting in a private sale was more than $5,000,000 paid to the Prince of Liechtenstein in 1967 for *Ginevra dei Benci* by Leonardo da Vinci. The painting went to the National Gallery of Art in Washington, D.C.

French Impressionism and paintings of related styles are enjoy-
ing a vogue now. They are said to have increased in value one
thousandfold from 1893 to 1970. A few examples: In 1867 Claude
Monet painted *La Terrasse à Sainte Adresse* and sold it not long after for
$80. In 1926, Theodore Pitcairn of Bryn Athyn, Pennsylvania, bought
it for $11,000. In 1967, Pitcairn sold it to the New York Metropolitan
Museum of Art at an auction in London for $1,411,200. Renoir sold his
Pont des Artes for $77. In this century it was once sold for $40,000. In
1968 it brought $1,500,000 at auction. A small (only 15" X 19") painting
by Georges Seurat, *Les Poseuses*, was sold in 1970 for $1,033,000. In the
early 1900's, when Modigliani could not pay his room rent, he settled
the small bill with a painting of his landlady's daughter. That same
painting was sold in 1968 for $300,000.

Figures like the foregoing seem unreal to most of us in museum
work. The director of a small art museum or the curator of art in a
general museum will be concerned about the few thousand dollars
needed to keep his work going for the coming year. Not every art
museum or department has a sizable amount to spend on acquisi-
tions. But any amount used to purchase permanent additions to the
collection must be spent with great care. Uppermost in the mind must
be the purpose and scope of the museum. Precisely what is its area of
interest and activity? What do you hope to accomplish by the use of
your collections? How can the collections be improved so that you can
accomplish more?

If spending millions of dollars on a painting strikes you as im-
moral, you are not alone. Is it not legitimate to inquire how much
public good is accomplished by one more painting hanging with
endless rows of other paintings on an art museum's walls? Might not
even the smaller amounts spent by less pretentious institutions be
questioned? They have been and are being questioned. The art
museum itself, as an institution, is under attack.

The common man has held the art museum in awe but felt it was
not for him. Members of disadvantaged segments of society, disil-
lusioned youth, and many artists are more blunt. They see the art
museum as a flagrant example of the Establishment's disregard for the
needs of society. The typical art museum is not relevant to our times,
they would say. Barbara Gold, a columnist for the *Baltimore Sun*, has
criticized the museums of her city. She says that they seem committed
to a suburban elite even though located in the middle of one of our
major cities, and that the three major museums of Baltimore seem to
feel little responsibility toward the city, even though they are city-

supported. This is far from being a unique situation. Even the small museums in small communities must be aware of the current reaction to the traditional role of the art museum. It must, more than ever, be responsible to the needs of its community.

Robert Hughes, for one, is offended by the participation of large public museums in the art market. He asks what the function of past art ought to be in present culture, and refers to the rapacity that impelled the Met's director to spend more than $5½-million on the Velasquez.

The American museum still tends to be an institutional parody of the robber baron's castle, staking its prestige more on acquisitions than functions. The Metropolitan speaks with politic sincerity of "bringing art to the people"—though this did not deter it last October from slapping what amounts to a tax on art education by reinstituting an admission fee for the first time in 30 years. But these declarations are apt to be gutted by the display of a now old multimillion-dollar painting. For what will *Juan de Pareja* on its draped wall in the Metropolitan mean to an intelligent 18-year-old from Spanish Harlem when he sees it and remembers the price? (As well he may, since the Met is not inclined to disguise the market value of its major acquisitions.) His probable reaction will be fury at the wrong priorities that spending $5,000,000 on a painting involves. Who can say that the boy would not be right? In a city that has a Harlem and a Bedford-Stuyvesant, and is already stuffed to superfluity with exceptional works of art, pride in acquiring yet another multimillion-dollar painting is merely an index of fetishism and decayed conscience.[14]

EXERCISES—CHAPTER 8

1. Read and report on two articles from periodicals dealing with art collecting. Pay special attention to references to the art market, what art museums are trying to acquire, and the kinds of objects receiving publicity.

2. Discuss what kinds of museums and kinds of museum activity are most relevant to our times. Should a natural history museum have exhibits on the preservation of the natural environment? A health museum exhibits of birth control, the population explosion, drugs, etc.? A history museum on the contributions of minority groups to the building of America? What is the role of the art museum in American culture today? Are Guthe's four obligations of a museum still valid? (Treat these not as individual questions to be answered

14. "Who Needs Masterpieces at Those Prices?" *Time*, July 19, 1971. Reprinted by permission from *Time*, The Weekly Newsmagazine; copyright Time, Inc., 1971.

but as suggestions for material to be covered in a short essay—at least 300 words.)

3. You are the director of an art museum and have $100,000 per year to spend on building the collections. Would you spend it all each year on a famous name—even if it means a drawing instead of an oil painting? Would you save it from year to year—and every four or five years buy one famous painting at auction? Would you buy several paintings each year by relatively unknown, lesser artists? What effect on your answers would the existing collections of your museum have?

4. Michael Levey, Keeper of the National Gallery, London, said, "One masterpiece is worth more in aesthetic significance than twenty minor pictures, all with some historical interest." Comment, assuming "historical" to mean "art historical," and then comment further, assuming "historical" to mean simply "historical" (nonart).

5. Your art museum has a department of decorative arts and no limitation as to time period. What might you collect from today? (Be specific and justify your choices.) Would you collect objects typical of the lower classes? Why? This question is not as simple as it might first appear. You must keep in mind the nature of the typical, traditional art museum.

6. Let us say your art museum has established a new department of popular art. How would you go about collecting?

7. Look at the pictures on the walls of your own home and describe them. Are there prints? What kinds (techniques)? Are there reproductions and originals? Are they of popular art? Fine art? Folk art? Primitive art? How is each enjoyed? (That is, analyze your enjoyment or nonenjoyment.) The purpose of this assignment is for you to describe a collection of art with which you are familiar according to manufacture, style, function, etc. You may limit yourself to one room, and, of course, the collection does not need to belong to you or to your family. You should be familiar with it, however.

8. Assuming that your museum has within its scope the collecting of contemporary art, how will you deal with the following? (That is, would you accept it in the first place, and, if so, how would you store and exhibit the piece?) In each case explain your decision or how you would cope with any problems you might anticipate.
 A. A fragile construction of thin tree branches, dried grasses, and birds' nests?
 B. A 15' x 15' x 15' inflatable plastic animal?
 C. A very heavy construction of metal plates twelve feet square and eight feet high?
 D. A pornographic painting?
 E. A painting of revolting subject matter, worse than spilled garbage?
 F. A painting advocating the revolutionary overthrow of our government?
 G. A construction of partially burned wagon wheels with an arrow sticking in one of them, lying in a tray of loose dirt about six feet square, with plants, small animal bones, and a buffalo chip or two?

H. A pottery vessel by a college art student?
I. The blue ribbon winners from the fine arts division of your local county fair? (Produced by largely untaught or self-taught "artists".)
J. A painted copy of a painting?
K. A piece of sculpture of high quality lying outside the scope of your museum?

9. Keeping in mind that popular art is mainly illustration, a means to present visual background for a mood or a story and not an end in itself, as fine art is, try this exercise: in a furniture store, in magazine advertisements, on television, on your own bedroom walls, or wherever illustrations may be found, select an example of popular art and an example of fine art. Both examples may be copies or reproductions. Describe, compare, and contrast the two. Try to detect the quality of artistic merit that would lead an art museum to display one and not the other.

9

Registration and Cataloguing

Even though he understands the nature of museums, the purpose of his own museum, and what the collections of his museum should include, the museum curator is not ready to collect until he knows how to make the records that preserve information about the museum objects under his care. To this point we have discussed the first of Guthe's four obligations of a museum, the obligation to build and maintain good collections.[1] The second obligation is that of records, without which the collections are worth little.

Records enable the museum worker to identify and locate all the objects in the collections. As an object is added to the collections, therefore, complete information about it must be obtained from the supplier and previous owners. The best time to identify the object is when it is being registered and catalogued. It is important to have a good reference library dealing with the subjects that fall within the museum's scope.

Registration is the assignment of a permanent number to an accession.[2] *Cataloguing* is the classification of each object in the accession by subject. Just as a library may catalogue a book according to title, author, and any number of subjects dealt with in the book, a museum may make any number of reference cards to refer to the subjects or areas of interest that a given specimen may illustrate. The numbering system used can be any one that seems efficient for your particular museum operation. A museum which has had its collec-

1. Carl E. Guthe, "Epilogue," *So You Want a Good Museum* (Washington, D.C.: American Association of Museums, 1957, 1973).
2. Remember that an accession is the acquisition of one or more objects from one source at one time. It is one transaction between source and museum, or the objects acquired in the transaction.

tions recorded and numbered for many years may still be using one of the older systems. A typical one would use only large, bound books and have one series of numbers for accessions and other series for objects by category, designated by a prefixed letter. Thus A2172 would indicate the two thousand one hundred and seventy second object catalogued in the A category (art, anthropology, archaeology, animals, or whatever that particular museum has chosen A to mean). The full number would include the accession number, ordinarily given first, and the object number by category. 14/H212 would mean the two hundred and twelfth object in the history (let us say) category, which is part of the museum's fourteenth accession.

Many museums today favor the system recommended by the AAM and explained by Guthe and others. It is simply to assign a number for the year, a number for the accession within the year, and a number for the object within the accession. 50.12.3 means the third object of the twelfth accession of 1950. The museum that wishes to avoid confusion among 1850, 1950, and 2050 will place an 8, a 9, or a 0 before the five. If an object has two parts, such as a bayonet and scabbard, the more important, if there is a choice, is called "a" and the other "b." The scabbard, therefore, would be 50.12.3b. (Or 50/12/3b, 50-12-3b., etc.) Each object of the collection will have a number written on it or attached to it, if possible, and for each object there will be one or more written records bearing this number.

The various techniques for attaching or applying numbers to objects have been described many times in the literature (for example, in the books by Carl E. Guthe recommended in the bibliography). In general, the numbering must be permanent without damaging the object, inconspicuous but logically placed and easy to find, small but legible, and protected from wear. A typical example of numbering involves, first, brushing a small amount of white paint onto the object; second, using a small straight pen to write numbers onto the dry paint with permanent drafting ink; and third, coating the numbers with clear lacquer (like clear nail polish). Other methods are used for objects which should not be painted or written on. To number a shirt, for example, print the number on a short strip of cloth tape and sew the tape to the inside of the garment near an edge—either inside the neck band or on the tail at the front.

There will be several kinds of records or files. Commonly, a museum will have an *accession file*, which may be in the form of a bound book or of cards (preferably locked in the drawer with a rod through holes in the cards, as with library cards). This record is

arranged numerically. A museum should also have a *donor* (or *source*) file, arranged alphabetically by name of the source. This might also include donors of funds, or even members of the museum's association. Such a file might be kept by a membership secretary or public relations officer, though it must be easily available to the entire professional staff. Another indispensable file is for *accession documents*. Ordinarily, it consists of large envelopes or folders in letter- or legal-size file drawers. The document file includes supporting records such as news clippings, letters, previous owner's written records, publications or references to publications, photographs, research reports, etc., which pertain to individual accessions. Not every accession will have an entry in the document file, and it is not necessary to number a folder for an accession until there is something to put in it. An object may appear in a newspaper photograph with an accompanying story years after it has been accessioned. If no folder exists for its accession, the accession number should be written on a folder, the object number should be written on the newspaper clipping, the clipping placed in the folder, and the folder inserted in the file at the proper numerical location.

The donor file, mentioned above, is normally on cards, as is the *catalogue* or *object file*. This file is arranged alphabetically by name of the object or other name, such as material of which it is made, its historical period, famous person with whom it is associated, Indian tribe which produced it, geographical provenance, or whatever.

Not every object needs a number. For example, if archaeological excavations yield thousands of pieces of broken pottery, scraps of bone, and flint chips, the time and money spent in writing numbers on each piece and filling out thousands of catalogue cards would not be productive in most cases. In such an instance a decision will have to be made as to how to maintain the identity of the objects without unnecessary labor and cost. One accession number might be assigned to all the objects from one season's field work at a site. Individual numbers could be assigned to the most significant objects, including all those described and shown in publications. The remaining items could be assigned numbers by lot. That is, all the potsherds from a particular part of the excavation (a dump, a level, a house floor, a storage pit) could be given a number and stored in a box or drawer bearing that number.[3] Another example can be taken from biology. It

3. The museum point of view; the archaeologist in charge may want additional numbering refinements. Whatever cataloguing, numbering, cross-referencing, etc., are

would be folly to attempt to catalogue individual insects in a collection of several hundred thousand, or the thousands of sheets of plant specimens in a herbarium. Since such collections are filed systematically, it is a simple matter to find any wanted specimen, and a catalogue is unnecessary. It might even be said that the collections and the catalogue coincide in such an instance, adequate identification being on tags, sheets, or containers with which or in which the specimens are filed.

The *accession file* entry, of course, describes the accession as a whole and answers the questions: What was obtained? When? From whom? How? etc. The *donor file* gives the name and address of the source and lists the accessions by number from that source. The *catalogue* describes the individual objects rather completely. A catalogue card will include the number of the object, its source, its name and description, its location in the museum,[4] photographs taken of the object, value, date catalogued, etc. Sometimes a sketch of the object directly on the card will aid in the description. Some museums attach small photographs to the catalogue cards, and others print photographs on heavy paper the same size as the catalogue card, on the back of which the form has been printed. The reverse side of the catalogue card itself is thus a photograph of the object. Photographs should be taken of the most important objects in the collections and the negatives filed numerically, either using the catalogue number or a separate numbering system. Prints can be filed separately or placed in the document file.

"Value" on the catalogue card is sometimes confusing. Even though the real value of a museum object lies in its educational potential, the word in the catalogue refers to money and has to do with insurance. There are three ways of arriving at a dollar value for an object: 1) the purchase price; 2) replacement cost on the market; 3) a consolation figure. A date should be given for the second, since market values change with time. The last kind of valuation is applied in the case of an object that is unique, irreplaceable, literally "price-

called for by the archaeological reference and research requirements can be incorporated into the museum's record system. The same can be said for any of the scientific research areas.

4. This may be written in pencil so that it can be erased when the location is changed, or it may be entered on the back of the card so that changes in location can be added without removing previous entries. This has the advantage of giving the complete history of the use of the object.

less." If your museum should lose such an item, how much money would it take to console you for the loss? We shall discuss insurance in a later chapter.

The description should include the measurements of most objects. It might be well to do these in the metric system in order to avoid conversion of the figures later when the English system is abandoned.

Examples of record cards will be useful at this point. The forms shown here are in use at the University of Idaho Museum. They are not necessarily better than hundreds of other forms used elsewhere, but they will serve to illustrate the characteristics of good collections records.

Any number of cards in the catalogue may be used for a single object. Each card is filed alphabetically, under a category which is considered to be important in the organization of the collections. Cards may be added at any time, and categories may be changed as the collections grow.

The records must be kept safe. They should be locked up, kept in as fireproof a location as possible, and made available only to au-

UNIVERSITY OF IDAHO MUSEUM, Moscow, Idaho
registration card

Acc. no. _74-12_ Source _Troy Trading Post_
How acquired _purchase_ When _April 12, 1974_

Description of accession _broadaxe (head only, no handle), forged iron, 15 cm x 20 cm_

Cost, origin, details, remarks _$5.00, made and used in Northern Idaho, badly pitted_

this record made by _Arthur White_ date _April 20, 1974_

THE REGISTRATION CARD OR ACCESSION CARD (the file of these cards is the *register* or *accession file*) Filed numerically.

```
                  source  Troy Trading Post
                  address        812 Spruce Street
                                       Troy, Idaho  83871
                                 (formerly Jim's Junk)

                  accessions from this source:
                  number      description              date rec'd
                  71-14      Women's clothing, framed  Aug. 12, 1971
                             pictures, churn
                  73-28      blacksmith's tools        Nov. 5, 1973
                  74-12      broadaxe                  Apr. 12, 1974

                  if continued on another card, check here_____
```

(vertical text at left:) UNIVERSITY OF IDAHO MUSEUM, Moscow, Idaho
source card

THE SOURCE CARD (since most objects in most museums are acquired by donation, the file of these cards is commonly called the *donor file*) Filed alphabetically.

thorized persons. All records should not be kept in one location. Ideally, a duplicate set should be in another building. At least try to keep the accession file and the catalogue in different locations so that a disaster that ruins part of your building will not ruin all your records of the collections.

No entirely satisfactory system has yet been devised for the classification of all historical objects. Several systems for certain kinds of materials are included in the bibliography at the end of this book. The time is not far off when numerical coding for museum objects will open up the use of computers in the recording, storing, searching for, and exchanging of information about museum collections. Eventually, we may hope for central information banks on the holdings of all recognized museums. Any museum can then learn in a few seconds where museum objects of a particular kind may be found, anywhere in the United States and Canada—or even the entire world.[5]

5. Those interested in this matter are referred to *Computers and Their Potential Applications in Museums* (New York: Arno Press, 1968) and Robert G. Chenhall, *Museum Cataloging in the Computer Age* (Nashville: American Association for State and Local History, 1975).

UNIVERSITY OF IDAHO MUSEUM, Moscow, Idaho
catalogue card

name of
category Hunter, John M. source Troy Trading Post

object no._71-14-5 date rec'd Aug. 12, 1971

other no(s)._432 (previous collector's number)

description of object apron, muslin, 105 cm x 55 cm,
waist ties, dyed blue, pocket on right side
(drawing on back or card). Made and used in
Troy, Idaho about 1910. Handkerchief no.
71-14-6 found in pocket at time of purchase.

value $8.00 (1971) condition good photo(s) 513, 514
remarks belonged to Catherine Thomas, wife of
John M. Hunter. She was born in England.
this record made by Alice Johns date May 23, 1972

PUT LOCATION OF OBJECT ON OTHER SIDE OF CARD

UNIVERSITY OF IDAHO MUSEUM, Moscow, Idaho
catalogue card

name of
category_ clothing, women's source Troy Trading Post

object no._71-14-5 date rec'd Aug. 12, 1971

other no(s)._432 (previous collector's number)

description of object apron, muslin, 105 cm x 55 cm,
waist ties, dyed blue, pocket on right side
(drawing on back of card). Made and used in
Troy, Idaho about 1910. Handkerchief no.
71-14-6 found in pocket at time of purchase.

value $8.00 (1971) condition good photo(s) 513, 514
remarks belonged to Catherine Thomas (Mrs. John
M. Hunter) who was born in England
this record made by_ Mary Wittin date Sept. 18, 1971

PUT LOCATION OF OBJECT ON OTHER SIDE OF CARD

THE CATALOGUE CARD (together, these cards make up the *catalogue* or *object file*) Filed alphabetically.

For the time being, most museums will continue to maintain their records according to systems they have adopted. The most we can hope for is that each museum will have, and use, a copy of the principal reference book on the work of the registrar, *Museum Registration Methods* by Dorothy H. Dudley and Irma Bezold Wilkinson.[6] If you do not feel qualified to describe and classify some categories of museum objects, call on experts in those categories to assist you. You may be able to get the short-term services of a volunteer who has special knowledge of guns, sea shells, prints, weaving, or some other subject and will catalogue all the objects in your collections that lie within his area of special competence. He will enjoy the opportunity to put his knowledge to public use and to study your collections.

Temporary inventories of shipments to and from your museum are also very important. This applies to accessions, temporary art exhibitions, loans to schools, and any other movement of objects to or from your museum. Packing and unpacking must be done under the direct supervision of an authorized person who is responsible for the inventories. The safeguarding of objects is the museum's prime function.

Presented here is the simplest approach to the registrar's job. Two additional points should be raised. The first concerns the conceptual basis of organizing information about objects (cataloguing) in the three major kinds of museums. In *science museums,* collecting and cataloguing are done according to genetic relationships, the systematic ordering of the natural world by the geological, biological, and anthropological sciences. Such work is so specialized that it is done by curators, the registrar discharging administrative and legal responsibilities by maintaining the records, or copies of them, in central files. In *history museums,* the key concept is the social context of the object, the most important consideration being the object's function. This is the basis for the standard system for cataloguing historical collections described by Robert G. Chenhall in his *Nomenclature for Museum Cataloging* (Nashville: American Association for State and Local History, 1978). In *art museums,* neither function nor relationships are issues. Key concepts are uniqueness and production. Medium is the main consideration. Art objects are catalogued by what they are and the way they are made; that is, medium, vehicle, support, size, creator, title, and so on. A trained registrar can do the cataloguing in both history and art museums; a specialist is needed for cataloguing in science museums.

6. Third ed., rev., Washington, D.C.: American Association of Museums, 1979.

The second point is that, as we enter the electronic age, all record-making, information storage, and information retrieval will be accomplished through computers. Museum administrators should understand the basics of using typed cards for these purposes, but should be moving as fast as possible toward computerization. Computer equipment for all the museum's information-processing needs (membership lists, finances, correspondence, publications, research, and collection records) is now within reach for all museums with professional staffs and aspirations to accreditation. Each museum staff should include at least one computer operator; ideally, each museum staff professional will do much of his or her work electronically.

EXERCISES—CHAPTER 9

1. Let us assume you have found the following written on an object in a museum storeroom: 875–1–2a 2/G691. What can you tell about the museum and the object from the number alone? (Also, what would you speculate?)
2. How should the number be physically applied or attached to the object: a. if G stands for geology? b. if G stands for garment? c. if G stands for gun? d. if G stands for Georgia history?
3. Choose a category (art, history, or whatever) to describe the museum you are working at or the kind of museum you would like to be associated with. List at least six, and preferably more, books you should have for reference in order to catalogue the collections. If you were able to expand this reference "shelf" into a reference "library," what kinds of books would you buy? (If you do not feel competent to do this part of the assignment, get help from your local librarian. The purpose is to get you to understand the kinds of references that would assist you in identifying and classifying objects in your chosen field.)
4. Look around you, wherever you are, and choose four different and dissimilar objects. Make out records for them, preferably on 4 x 6 cards, inventing details when needed to complete the cards. Be sure to include complete descriptions, so that someone else could distinguish each object from others that are similar. Your cards should have all the information that you would expect to find on such cards in a museum.
5. Assuming that you have access to at least two museums, describe their record systems. Try to get sample forms, fill them out enough to show you understand how they are used. What files do the museums have? What kinds of files (pertaining to the collections) do they lack? Who does the accessioning, the cataloguing, etc.? Evaluate the systems.

10

Care of Collections

Caring for collections is part of the definition of a real museum. Since the collections make the museum and the museum is supposed to last indefinitely, the collections should be given meticulous care. "Collections-filing rooms" or storerooms must be provided, and the collections must be organized and accessible. Collecting wisely and preparing good records would hardly make sense if the collections were then allowed to deteriorate or disappear. The first obligation, the adequate management of the collections, involves preservation, the subject of this chapter, and security, the subject of the next.

Any good museum will have more museum objects than it exhibits at one time. The objects on public view may actually constitute less than half of the total collections.[1] The museum has the responsibility to care for and to use all of its objects, whether being exhibited or not. This means that it should provide good and adequate space "behind the scenes" for the organized storage of the collections. As a rule of thumb, the museum should have at least as much space for the collections as for the exhibits. The well-known proportion, 40-40-20, means that of the total amount of space in the museum, 40 percent should be for collections, 40 percent for exhibits, and the remaining 20 percent for everything else (offices, rest rooms, hallways, janitor's closets, lobbies, auditoriums, lunchrooms, workrooms, receiving rooms, carpenter shops, elevators, etc.). Obviously 20 percent may not be enough for all of this. A more reasonable proportion might be 30-30-40. The main point is that at least as much space should be

1. The Field Museum of Natural History, in Chicago, exhibits less than one percent of its total collections at any one time.

devoted to the collections that are not on exhibit as is in the public area where the exhibits are located.

The word "storage," as applied to the collections, must be used with care since it has the bad connotation of things not in use. Guthe prefers "filing" and speaks of the "filed collections," comparing them to the stacks in a closed-stacks library. Daifuku distinguishes between "live" and "dead" storage.[2] Each object should be easy to find and to remove. A one-word characterization of proper storage is "accessible."

Three related faults are typical of nonprofessional museum management. Because of an overemphasis on exhibits, the amateur will put all or nearly all of the collection on display. This results in poor exhibits, too little space for the storage of collections as they grow, and poor management of the stored collections. That storage will be "dead" to some degree. At the worst extreme the objects will be piled in attics and corners of the basement and tied up in unmarked boxes and stacked in out of the way places—essentially lost to the museum operation. Even in apparently good museums, objects may be stored beneath exhibit cases behind panels screwed in place, and the catalogue cards may not show the locations of the objects.

Let us follow the progress of an object as it enters the collections. A donor brings it to the museum and to the director's or a curator's office. Or the donor may have invited the director to send a member of his staff to the donor's home to get the object. The staff member, while talking to the donor, should get as much information as possible about the object. Many museums have accession worksheets which the staff member fills out at that time. He gets names and addresses and the answers to such questions as "What is it? How was it used? Where was it used? Who used it? Where was it made? How much did you pay for it? Did other people in the same locality use the same kind of thing?" and so on. The object is examined and its condition noted, with remarks that might be useful later in handling and cataloguing the object. Once in the museum, the object is assigned a number (registered) and placed in a secure location awaiting cataloguing, cleaned and repaired, and possibly photographed. When catalogued, which should be within a few weeks,[3] the object is placed with other

2. Hiroshi Daifuku, "Collections: Their Care and Storage," *The Organization of Museums: Practical Advice*, Museums and Monuments Series, No. IX (Paris: UNESCO, 1960), p. 124.

3. Some museums set aside a certain day each month, usually the last or the first, for cataloguing all accessions of the previous month.

objects of a similar nature where it can be well cared for and will be easily accessible for future reference and use.

All materials deteriorate; and since the museum is devoted to permanent preservation of its collections, it must maintain the best possible conditions for the longest possible life of each object. Before discussing preservation conditions, however, let us return to the matter of cleaning.

To clean or not to clean is not always a simple question. There are many reasons why we clean an object:

1. *Practical* reasons: removing dirt, foreign matter, material that obscures the surface and form of the object; to prevent deterioration of the object (rust and corrosion must be arrested; fly specks, acidic or alkaline substances on the surface, or substances that absorb water from the atmosphere may cause steady damage). Since the primary requirement in the care of an object by a museum is its preservation, this must be the first consideration in cleaning.
2. *Aesthetic* reasons: to give the object a more pleasing appearance or for psychological effect.
3. *Educational* reasons: to reveal more about the object to the person studying it for research (e.g., the curator) or to the person viewing the object as exhibited (e.g., the visitor).

A decision whether to clean, how to clean, and how much to clean must be based on the use determined for the object. (An object has real value only in terms of its use by and for human beings; that is, in terms of its contribution to human life.) Recognize that one use may preclude another; conflict exists especially between the aesthetic and the educational—or between art and science. The aesthetic approach may sometimes be that of the professional collector, whose attitude toward objects may not be the same as that of the museum curator. For example, a coin collector may value the patina which a coin has acquired over the centuries and feel that the commercial value of the coin would be diminished by cleaning. The curator might feel that more detail of the coin's design would show if the overlying patina were removed and that, therefore, cleaning would enhance the coin's educational value. He should keep in mind, however, that cleaning should not be undertaken if more might be lost than gained. He must be careful not to remove identifying marks or features; to abrade soft metals, such as pewter, or otherwise to destroy evidence concerning the history of the object. In seeking the "original" appearance of an object, we must be clear in our minds as to what that is. Do we want to

portray an unused tool fresh from the hardware store? A farming machine, clean and brightly painted? A child's toy not yet played with?

Philosophically, we might think of such items as unborn artifacts. Does the cultural object take on significance when new and perfect or when adopted and used? It is the commonplace, everyday importance of objects which earns them a place in the collections of a history museum. It is their relevance to the life of the people at large. Therefore, it is an object that has been used and is typical that is important. To erase all clues of such use is in a way to create an artificiality and to make the object something of an abstraction. A brand new saw is the *idea of a saw*. It becomes a real saw after a man has sawn boards with it to build a house. The signs of wear, the rusty spots, the patina of age, the chipped corners are evidence that this was a real object in a real world. What you would remove by cleaning is an important part of the real object. To put it another way, the real object is not a saw but a saw that was used by human beings living real lives.

This question of cleaning down to the bare metal or bare wood and then refinishing or repainting relates to the restoration of historical objects. Should a historical museum replace missing parts? Reupholster the sofa? Rebuild a missing building? Make a new handle for the tea cup? We have to refer to the earlier statement that the use to which the object is to be put must determine our answer.

If the use is *aesthetic* (related to art and beauty)—if the object is to be enjoyed for its appearance—then the art, the artist's original creation, must be allowed to come through unimpeded and unimpaired. Keep in mind that art is the creation, the intention of the artist rather than the art object itself. Realize, too, that weathering and oxidation may be part of the art, part of the artist's or maker's intention for the object. If the use is *entertainment*, to create nostalgia or a feeling of awe, the appearance of age may be desired. (Examples are distressed wood furniture, artificial worm holes, beating with chains, "antiquing" furniture, wearing old silver plate down to the copper base.) If the use is to be primarily *educational*, as in a good history museum, but with some attention paid to aesthetic values, a patina acquired through time may be desirable. The ravages of time may lend authenticity to the object, attesting to its history.

How do we know whether to clean, how to clean, and how much to clean? No answer will apply in every case. Judgment must be based on reason, and the answer will depend on the use to which the object

may be put. In general, be conservative. Clean too little rather than too much.

While cleaning is a deliberate effort to change an object or at least its appearance, preservation is, in a way, the reverse. It is defensive rather than active, the aim being to prevent changes from occurring. There are several causes of change: 1) *Human loss*—theft, vandalism, careless usage, accidents; 2) *environmental damage*—fire, leaking roof, leaking pipes, dirt, fumes; 3) *climatic damage*—extremes of temperature and humidity, and rapid changes in temperature and humidity; 4) *radiant energy*—chiefly ultraviolet light; 5) *biological damage* —insects, rodents, fungus; 6) *faulty procedures*; 7) *disasters*.

Preservation consists of techniques to prevent undesirable changes from occurring. Storage rooms should preferably be air conditioned and temperature controlled. Some kinds of materials require a higher relative humidity than others. Some kinds of materials are more susceptible to damage from changes in humidity than others. Each kind of material—leather, wood, paper, metal, glass, etc.— should be kept under the conditions that are best for it.

The beginner may, logically, be confused as to how much technique he needs to master at the beginning of his museum training. If he is actually working in a museum, he is naturally expected to master his job, whatever is involved, as quickly as he can. The student or the administrator, on the other hand, without such urgency, is advised to master theory first and then such techniques as he may need for specific jobs. A common mistake of the amateur and the beginner is the assumption that preparation for work in a museum is merely the learning of a certain number of techniques in order to perform museum functions. My attitude is quite the opposite. I feel that an introductory museology course, that is to say, basic orientation for all kinds of museum work and for a broad understanding of museums, must deal with such matters as purpose and organization. Technical matters need to be introduced, but not explored in detail.

All persons who will be handling the collections must practice a few basic principles of conservation: Do not use rubber bands, paper clips, unpadded wire hangers, adhesive tapes, paper of high acidic content, and do not fold textiles or store them tightly crammed together. Avoid extremes of temperature and humidity and rapid changes of these. This usually means not using attics and basements for museum storage. Never allow sunlight to fall on museum objects subject to fading. It is best to keep the light level at a minimum, to omit

windows or skylights in storage rooms or exhibit halls, to avoid placing lamps close to objects, and to interpose glass, at least,[4] between flourescent lights and museum objects. Specifically, do not use un- shielded fluorescent lights inside exhibit cases and do use low wattage incandescent lamps (bulbs) in storerooms. Such rooms should be kept dark, of course, except for short periods when someone needs to work there.

A common mistake made by amateurs in museum work is to view potential damage to museum materials as they would view potential damage to clothing, furnishings, butterfly collections, and paintings in their own homes. They forget that while they may expect an article of clothing to last two years, a rug five, a butterfly collection ten, museum collections are theoretically meant to last forever. The light, the fumes, the humidity, the wire hanger, the creases in the table cloth, which cause no observable damage in a short time, will destroy the material in fifty years (or less).

In extreme cases, lack of proper care may become obvious to the public. For a donor to feel that your museum is not adequately preserv- ing the treasured objects which he gave you is a source of bad publicity at the very least. Early in 1967, an Associated Press dispatch reported that Avery Brundage had "threatened to take back the $30 million collection of Oriental Art he donated to San Francisco." Though it was housed in the principal art museum in a special wing built at a cost of $2.75 million, Brundage's statement that he was unhappy at the *care* given the collection received national publicity.

The recording of collections is the responsibility of the registrar. The care of collections—beyond the routine care that all members of the staff exercise—is the responsibility of the conservator. A small museum may have to combine both functions in one position, perhaps to be filled by a "curator of collections." There is so much work that, whatever the organizational arrangement, someone on the staff must be skilled in at least the fundamentals of conservation. Conservation includes *study of the physical nature of objects and an understanding of ways to protect them from deterioration.* It includes knowledge of the proper ways of handling and cleaning objects in the collection, apply- ing preservation measures, repairing and restoration, packing and shipping—a responsibility perhaps shared with the registrar—and

4. Better is a plastic material commercially available which filters out most of the harmful radiation. This is made into sleeves which fit over the fluorescent tubes.

responsibility for periodic examination of all objects either on exhibit or in storage, to guard against the collection's deterioration. An important part of the conservator's job is assuring the best possible storage conditions, to protect the collection from any kind of damage or loss, whether caused by biological or environmental attack, earthquake, employee carelessness, or other mischance. Since the maintenance of the collection is of prime importance, the position of conservator should have high priority in any staff-building program.

EXERCISES—CHAPTER 10

1. What are the issues (what problems or controversial matters) are involved in cleaning: old coins, badly rusted gun parts, delicate textiles, oil paintings, animal hides? (This question does not ask for recommendations as to techniques. It is a philosophical question; that is, it is more a museological than a museographical question.)
2. Name various categories of museum objects on the basis of the nature of the materials of which they are composed, and the different kinds of care which these categories must have.
3. Discuss metal shelving in relation to the storing of tea cups and paper.
4. How would you store oil paintings? (See Daifuku, note 2.)
5. Give examples of the effect of humidity on materials.
6. What is fumigation?
7. What examples of deterioration (and/or fading) resulting from light have you observed, perhaps in your own home or in a museum with which you are familiar?
8. Estimate the amount of space devoted to exhibits, to collections storage and to all other purposes in a museum that you would judge to be well run and in one that you would judge to be the opposite. How do the proportions compare? If you cannot compare one museum with another, at least compare the exhibit space and the collection storage space in one museum. How far from being equal are they?
9. If you can get into the collections-filing rooms (storage) of a museum, criticize the organization of the collections and their care.
10. How does the care of the collections (including organization, cleanliness, amount of space, and preservation techniques) relate to the worth of a museum?

11

Security

Security is the most important consideration in the administration of *any* museum. (Next is cleanliness).[1] Security embraces the protection of the museum buildings, its contents, its staff, and its visitors. It includes the care of the collections, insurance against severe financial loss, and physical security (protection against theft, fire, and vandalism).

Museums, by their very nature, must be security conscious. Insurance is a poor substitute for preventive measures because the value of museum collections cannot really be expressed in financial terms. In guarding against theft, carelessness, and vandalism, the museum is placed in an awkward position because good public relations are so important to it. The museum wants to welcome all kinds of people in great numbers and to make them feel "at home." While being friendly and hospitable, the museum must also prevent any damage and disturbance the visitor might cause.

Some museums feel unjustifiably safe from potential dangers. This is partly because not all losses to museums are publicized, certainly not nationally. Yet Joseph Chapman pointed out that in 1964 there were "daily between four and six thefts of art items valued at $5,000 or more."[2] As art values rise, thefts will probably continue to increase. Newspapers frequently carry stories of thefts of art from private collectors and from museums. Almost every issue of a museum periodical carries notices of thefts. Directors of small museums in remote locations cannot reassure themselves that such thievery occurs

1. Douglas A. Allan, "The Staff," *The Organization of Museums: Practical Advice,* Museums and Monuments Series, No. IX (Paris: UNESCO, 1960), p. 63.

2. Caroline E. Keck *et al., A Primer on Museum Security* (Cooperstown: New York State Historical Association, 1966), p. 1.

only in cities. It is worldwide and becoming steadily more serious. Museum thefts have nearly doubled in recent years.

Thieves are removing ancient statues and paintings from the temples and museums of India. A story in the *Los Angeles Times* in the spring of 1969 stated that foreign collectors and tourists are removing stolen goods from the country. Police arrested an American professor and his wife as they were taking aboard ship 37 rare miniature paintings stolen a few months earlier from a $2 million collection in the museum of the Maharajah of Jaipur. The professor said that he had purchased the items in good faith at the residence of the curator of a museum. One hundred sixteen pieces of ancient jewlery were taken from the National Museum in New Delhi, according to the story, and statues of gods as tall as 30 feet were sawed out of their niches.

According to the Ecclesiastical Insurance Office, a church in England is robbed or desecrated every day. Authorities believe that organized crime syndicates are shipping silver, armor, and other kinds of antiques to the United States, where they bring high prices. Organized thievery is rampant in Italy, where churches are being robbed almost daily of art treasures. In the first three months of 1972, 1,598 art objects were stolen from churches and museums, and each year an estimated $10 million worth of archaeological objects are removed from the country. Vandals have raided the Villa Doria Park in Rome, hacking off the heads of ancient Roman statues and removing Etruscan tomb carvings and the artworks of the Caesars. One European travel poster said "Visit Italy Now, Before the Italians Destroy It." In November 1969, a New York art dealer who had taken great precautions to protect his gallery suffered a half-million -dollar loss while he was attending a meeting of the Art Dealers Association of America. The topic discussed at the meeting was current art thievery in New York City.

Germain Bazin[3] said that from 1957 to 1964 fifty museums and seventy churches suffered severe losses from robbery, and that some 900 important pieces of art had disappeared from documented collections. There is hardly a museum of any size anywhere that has not suffered losses. If a museum staff does not take preventive steps, the question is not *"Will* they get by with it?" but *"How long* will they get by with it?" Embarrassing as it is to the profession, internal theft also occurs. A museum must protect itself against its own employees as well as outside agents. All who are connected with a museum share in

3. *The Museum Age* (New York: Universe Books, Inc., 1967), p. 8.

the grave responsibility of security. The problem will not go away; it cannot be ignored.

Vandalism is also a serious problem. The Statue of Liberty became so marked by lipstick in recent years that it had to be coated with a special lipstick-resistant paint. A telephone company in the United States announced recently that vandals put some 11,000 pay phones out of commission every day. According to an official report, an average of 90 public telephone booths is destroyed *every day* in the Irish Republic, which, in proportion to the population, is about twice as bad as the same problem in this country. Signs and markers will probably be eliminated from the Boise National Forest in Idaho because the cost of replacing those destroyed by vandalism has become prohibitive. Museums are not immune. Vandalism heads the list of dangers within museum buildings, says Richard Foster Howard, Director of the Birmingham (Alabama) Museum of Art.[4] We have long had the problem of the individual vandal who slashes a painting or sets fire to a trashcan, but many museum administrators have become concerned with vandalism en masse. Because of changes in their cities, some museums now find themselves in or near slum areas. Participants in race riots and other civil disturbances in the neighborhood of a museum may find it a relatively defenseless symbol of the "Establishment."

William A. Bostick, Administrator and Secretary of the Detroit Institute of Arts, discussed riot security in an article outlining a recent survey.[5] Stanley D. Sohl, Museum Director of the Kansas State Historical Society, spoke on security at the national convention of the American Association of Museums in New Orleans in May 1968. He covered such matters as placing fire extinguishers near windows where Molotov cocktails might be thrown in, outdoor floodlighting of the building and grounds, bars on ground-floor windows and doors, and drawing the blinds over windows at night so that snipers cannot kill the staff. This is not to suggest that the public is the museum's enemy. Up to a point, visitors in the museum prevent theft and vandalism.

A common mistake is to equate security with law enforcement and museum guards with policemen. There is a basic difference:

4. *Museum Security* (Washington, D.C.: American Association of Museums, 1958), p. 2.

5. "What is the State of Museum Security?" *Museum News*, Vol. 46, No. 5 (January 1968), 13-19.

security is prevention; law enforcement is reaction. Museum security measures should be directed toward preventing loss of any kind from any source. Howard speaks mainly of dealing with people.[6] However, measures of different kinds can supplement the guard force. Smoke-sensitive and heat-sensitive devices can set off fire alarms. Acoustical devices can detect movement in a gallery after the building is closed. Burglar alarms protect windows, doors, and skylights. Closed circuit television will allow the supervision of a number of separate areas from one guard post. Delicate electronic devices will sound an alarm if a painting is moved or a floor stepped on. Watchdogs may patrol buildings and grounds at night.

Smaller museums, at the very least, need fire extinguishers of more than one kind. The alkaline-acid type that sprays water is not suitable for electrical fires. The dry powder kind that smothers a fire by excluding oxygen is useful, but the carbon dioxide extinguisher may be the best for most situations that can be handled by the museum staff. It has the obvious advantage that it does not give rise to poisonous fumes and does not leave water or chemical powder on museum objects.

Since museums differ so greatly in their collections and their physical plants, no specific security plan would apply to all of them. I recommend, therefore, that the staff of your museum confer with the fire department, the police, and any other security agencies (do not forget your insurance company) regarding your own situation. The fire department, especially, will be glad to inspect your premises, make recommendations regarding fire extinguishers, and instruct your staff in their use. Remember that the excitement of an emergency is not conducive to reading printed instructions. The person on the spot must know immediately what to do.

One rule of thumb might be in order. Do not have fire hoses or sprinkler systems in exhibit areas and collection storage areas, because the water damage might be greater than damage by a fire that can be extinguished by other means. You should also alert your local fire chief to the damage that his hoses might create in your museum. He should be prepared in advance to treat a fire there with special care. Naturally, museum collections should be in fireproof surroundings, as much as possible. If your museum must be a frame building, try to store the unexhibited collections and the records in a separate fireproof building.

6. *Op. cit.*

The museum guard or night watchman is the most valuable security device the museum can have. There is no substitute for a human being who is alert to possible dangers and prepared to act. Protective precautions must take into account human vulnerability, however. In December 1973 an armed gang overpowered the night watchman at the Fogg Museum of Harvard and made off with $6 million worth of Greek and Roman coins. Howard's contention that the guard force should be organized on military lines and should be in uniform was formerly universally accepted, and this advice may still be correct for most museums. The presence of uniformed guards, however, may aggravate the recent antimilitary sentiment of young people, especially if some of the guards give the impression of being hostile. Conventional street attire with an identifying mark, such as a badge or an armband, may be better for your museum.

Cleanliness cannot be overemphasized as a deterrent to theft and vandalism. Good housekeeping shows that someone cares very much about the museum and that any disturbance will be quickly noticed and resented. Should vandalism occur, repair the damage immediately. One destructive act breeds another. The noncreative mind can be led into repeating what someone else has done. A museum had a statue of a person with hands outspread and fingers separated. The statue was allowed to remain where it was, and one after another, the fingers were broken off.

Insurance is part of the security picture, since a relatively small annual cost will prevent a financial disaster. The museum must protect itself from being wiped out at a single blow. In general, the museum will have a blanket "fine arts" policy which will cover damage and loss to the collections from any cause. This can be in any amount; that is, the museum can buy protection from any degree of loss. The individual objects need not be itemized, but very important objects should be singled out for special mention in the policy. Remember that specific dollar values for the most important items as well as the total amount of coverage should be reviewed regularly. Replacement costs for most categories of expensive objects are increasing. You may also need public liability insurance (who pays the bill if a visitor trips over a potted palm in your lobby and breaks a leg?), and employee-fidelity coverage, too (what if the secretary runs off with not only the bookkeeper, but her typewriter, the cashbox, and the painting in the director's office?).

Two particular points might be mentioned because they are traps for the uninitiated. One is that *when payment for total loss is accepted,*

title passes out of the museum's hands. If you feel that the object is a total loss and put in a claim for full value, the insurance company may pay you, take the object, repair it, and sell it. Or if you accept reimbursement for a stolen object which is later recovered, it belongs to the insurance company, which might then sell it for much more than they gave you for it. The answer to this problem is to have your policy so written and the values so listed that you get full, current market value in the event of total loss, with the right to buy a recovered object back from the insurance company for what they paid you for it.

The second point has to do with subrogation, the legal substitution of one creditor for another. In a museum situation it would work like this: Your museum borrows something from another museum, and it is destroyed while it is in your possession. You notify the lender with regrets, he assures you that it was insured, and proceeds to collect from his insurance company. You breathe easier, but the blow falls when the insurance company sues you to recover the amount paid to the lender. It does this on the grounds that your museum is responsible for the financial loss the insurance company has suffered. The way to protect yourself from this pitfall is to obtain written proof, when you borrow an insured item, that the insurance company has waived the rights of subrogation or that your museum is named as an additional insured party with the lender.

As with other aspects of security, the insurance needs of each institution will differ from those of other institutions. The museum director should select a good insurance broker and discuss with him the total requirements of his institution.

One staff member should be made security chief—in a small operation, perhaps the director or the deputy director for administration; in a larger organization, perhaps the building superintendent. The security chief should hold and issue all keys, keep a check-in and check-out ledger for weekends and after-closing hours, supervise the guarding of exhibit galleries, be on good terms with the police and the fire department, and receive extra training in security matters. Much help can be gained through electronic devices such as motion detectors, smoke detectors, closed-circuit television surveillance, electronic door locks (opened with coded plastic cards), and many others. Most museums should hire a professional security company to plan and install defenses and train the staff, at least. Loss from various causes is so common and so disastrous for a museum, with its irreplaceable collections, that a maximum security effort should take precedence over any other aspect of the program.

EXERCISES—CHAPTER 11

1. Imagine yourself the curator of collections. Consider different requests coming to you from a board member, the curator of education, and others, for the use of objects and historic buildings under your jurisdiction. Describe potential dangers and your responses.
2. Why is sharing a building with the municipal library preferable to sharing it with the city government?
3. Name three different kinds of museums that may have three different security risks. (The purpose is to get you to think of problems in relation to the museum's own special situation—location, kinds of visitors, kind of staff, kind of collections, etc.)
4. Review a museum's insurance coverage. Be specific, but do not name the museum.
5. Discuss photography as a security measure.
6. How does the museum guard against the loss of equipment and supplies which are not part of the collections?
7. Describe what a small museum with a small staff and a small budget can do to make its collections secure.
8. Look at the museum from the standpoint of the visitor. Where may he go and what may he do in the museum, and what may he not do and where may he not go?
9. A historic house museum is entered by a woman wearing spike heels, sun glasses, and a bulky coat, carrying an umbrella and a large handbag, smoking, and leading a large dog and a small child eating an ice cream bar. As an attendant at the entrance, what do you do? ("Have a cardiac arrest," while reasonable, cannot be accepted as an answer. Think first of all of the potential security and safety problems created and try to deal with them.)

Part II

Interpretation in the Museum

12

Use of Collections

Now that our hypothetical museum is well organized and has good, documented, well-cared-for collections, we must face the problem of how to use the collections to accomplish the museum's purpose. Other institutions teach, entertain, dispense information, provide hospitality to visitors, and so on. Only the museum is dedicated to the use of the real object for the public good. How, then, can the collections be used?

If everything the museum owned were on exhibit, except for a few inferior items piled somewhere out of the way and ignored, the phrase "uses of the collections" would be meaningless. To the amateur only one use exists—exhibits. A prospective donor may offer something to a museum with the words, "Do you want to put this on exhibit?" If you accept the item, it is with the understanding that you will put it out as quickly as you can; the donor may drop around the following week to see where you are showing "his" item.

The real museum has a very different attitude. Objects are collected because of their educational potential as specimens. The museum worker must force himself to think of the worth of the collections apart from their exhibit value, even though exhibition may be the chief use to which the collections are put. The distinction is basic, and as much as anything separates the good museums (and the good museologists) from the bad.

Since its creation in the last century, the educational, public museum has been devoted to research. The world's largest museum complex, the Smithsonian Institution, was founded by the will of an Englishman, James Smithson, who upon his death in 1829 left money to establish a museum for the "increase and diffusion of knowledge among men." James Brown Goode reiterated in 1895 that museums

exist for "the increase in knowledge." Thus the museum's mission is the study of its collections for the edification of mankind.

Guthe explains that the records constitute a research facility.[1] The researcher goes from the records to the collections and works with both. Daifuku speaks of research as pursued in the different kinds of museums.[2] The museum's input is research based on the objects that it has acquired; its output is public education. If museums are to claim the prestigious title of "educational institutions," they must study their collections in depth and interpret them, not merely show what they have collected. *All* museums must do research, for each musum has things that no other museum has; and each museum is unique, also, being concerned with a region, subject matter, or public with which no other museum is concerned in just the same way.

The study of the collections may yield practical results other than the advancement of knowledge. Mummies in the Cairo Museum, X-rayed in December 1970, revealed gold arm bands and jewelry still in place beneath the undisturbed wrappings. Dr. James Harris of the University of Michigan, head of the scientific team that did the work, said, "This is the first discovery of royal Egyptian artifacts since the discovery in 1922 of the tomb of King Tutankhamen."[3] Microscopic examination and technical tests sometimes reveal that museum objects are not what they have been assumed to be. This, of course, requires a thorough mastery of original techniques and materials.

Coupled with the large trade in antiquities, mostly illegal, is a thriving forgery business. *Interamerican*, a newsletter distributed by the Instituto Interamericano, alleged that Professor Spyridon Marinatos, Inspector General of Greek Archaeological Services, believed the gold treasure on exhibit at the Boston Museum of Fine Arts to consist of modern fakes; and on July 30, 1971, *The Times* (London) carried a story by Norman Hammond headlined "Tests show forged Turkish prehistoric pottery in many world museums." According to the article, the British Museum, the Metropolitan Museum of Art in New York, and the Ashmolean Museum at Oxford, among others, have purchased fakes in the last ten years. Technical methods developed in museum research have led to this discovery.

1. Carl E. Guthe, *So You Want a Good Museum* (Washington, D.C.: American Association of Museums, 1957, 1973), p. 4.

2. Hiroshi Daifuku, "Museums and Research," *The Organization of Museums: Practical Advice*, Museums and Monuments Series, No. IX (Paris: UNESCO, 1960).

3. Associated Press dispatch, Lewiston (Idaho) *Tribune*, January 14, 1971.

Even small museums should be concerned with research. Advanced degrees, large budgets, impressive collections, and luxurious surroundings are not required. But some small museums are not so engaged. Why? The word "research" may frighten the staff, who may not feel capable of research. Surely the curator must be capable, or he should not be a curator, in name or in fact. There may not be time for research. The lone curator or the small staff with large ambitions may be devoting all available time to other activity, such as publicity and peripheral programs. The staff may even be overbalanced with clerks, guards, receptionists, teachers, librarians, registrars, guides, public relations people, and so on, to the exclusion of real scholar-curators. Robert Shalkop, Director of the Anchorage Historical and Fine Arts Museum, notes that "careful scrutiny of the staff lists of many museums reveals an astonishingly small number of professionals," relatively few people who are "generating the program, as distinct from those who disseminate or publicize it."[4] He reminds us of the common observation that in our national economy advertising is often more important than the quality of the product.

Perhaps saddest of all is the case of the institution which could engage in research (and which may have done so in the past) but whose director is not a professional museum worker. Such a person may actually be hostile to serious museum work and may downgrade, if not actually eliminate, research. Shalkop puts it this way: "If a director is hired specifically for his public relations skills, he may have even less sympathy for the research program and de-emphasize it for ideological as well as budgetary reasons. Thus the museum finds itself directing an increasing proportion of its efforts toward selling its educational product, and a decreasing amount to creating it."[5]

Research creates knowledge, and museum curators must become authorities on the kinds of materials collected by their museums. Assisting the general public to identify objects is one of the museum's public services. Research done over the years should make this relatively easy, and usually enjoyable, for the curator. He will have to refuse, tactfully, the common request for the "worth" of an object. Most people brought up in our culture regard price as an attribute of all things and will regard any description of an object as incomplete without a pricetag. Since museums deal in objects, people automatically assume that any curator worth his salt will be able to say how

4. "Research and the Museum," *Museum News*, 50, No. 8 (April 1972), 11.
5. *Ibid*.

much an old family Bible is "worth," for example. Even though no one ever offered to buy the Bible from the family that owned it, to them it would still be "worth" a certain amount of money. This unrealistic attitude appears when a visitor asks a museum employee how much an object on exhibit is "worth," and when he brings in something of his own to show the director or a curator. Often he expects a dollar offer and to haggle over the price, then to sell the object. The museum curator can usually sidestep this problem by explaining that museums ordinarily receive their accessions through donation, that museums have no knowledge of market values since they only rarely buy and sell things, that he already has similar objects in his collections, and that he has no money (or very little money) to spend on purchases. Of course, if he wants to buy the object he may do so, but he might still look into the possibility of getting such an object donated. He should at least check with a reputable dealer to find out the going price.

If the visitor to the curator's office is requesting corroboration that he has an object of great value, the curator must, again with great tact and genuine concern, do what he can to help. A member of the public that employs him is requesting his expert knowledge, and the curator must not give in to boredom or annoyance. Good public relations is the museum's lifeblood. Fortunately, skill in dealing with these matters comes quickly. For instance, no Stradivarius violins are lying around in attics waiting to be discovered by eager heirs. "Strads" have been copied through the years, even to the maker's label inside the sound box. (I once got one free with a set of violin lessons.) Nevertheless, it is always possible that a visitor will bring in something of importance, and you do not want a disdainful reception to cost your museum a valuable accession, or, perhaps, a valuable friend.

A relatively new use of the collection has come about with the advent of television. I once put on weekly programs dealing with museum objects and exhibits through a local television station. It was a reciprocal arrangement. I would occasionally lend the station objects to use on other programs and commercials (usually with credit given to the museum, which created publicity and good will) and the station co-operated admirably with me in putting on the museum program. Preparing and presenting this program every week required a considerable amout of time and work, but my staff and I became convinced that it was worth it when we compared program viewers with museum visitors. More people saw *one* half-hour television presentation than had visited the museum in ten years. If you measure your success, not by the banging of the turnstile at your front door, but by

the amount of contact you are making with human minds, you must be impressed by the potential application of television to museum work.

Objects may be lent to schools, other museums, and stores. Displays in downtown department store windows have the same justification as television programs. The timeworn expression is "bringing the museum to the people." Hundreds or thousands of people who have never been in your museum will walk down Main Street and see your objects. Your spinning wheel and antique clothing will enhance the store's display, but a sign will give credit to the museum. Such incidents may not accomplish much solid education, but they do create good—and free—advertisement. Incidentally, an anniversary celebration of a store or other business is an opportunity for the local history museum to get in on the act. If they do not think of you first, call them. However, do not ever forget what is more important than great publicity: the safety of the objects.

Objects from your collections may often illustrate the presentations of reputable public lecturers, and you may find such loans worthwhile. In addition, special public demonstrations, such as an antique car in a garage, or an ancient musical instrument used in a concert, may use your objects.

Reference is an important use for any collection. Ned Burns recommended thinking of the museum collections as two series, one for exhibition, the other for study.[6] The first series requires attractive specimens in good condition; irreplaceable items are kept in the second. According to Burns, the value of the collection is not in its size but in its utility.

Biological collections illustrate the usefulness of the collection for reference—for comparison and identification. For example, in the identification of animals, insects, or plants the scientist refers to standard descriptions and to the range of actual specimens on file. When a new species is first described, the "type specimen" is safely deposited in a museum (or museum-like facility) if possible, where it can be consulted for comparison with other related examples under study. The analogy with the iridium meter bar at the National Bureau of Standards is inescapable.[7] When a farmer brings in a creature that is

6. Ned J. Burns, *Field Manual for Museums* (Washington, D.C.: National Park Service, 1940).

7. Since 1960 the meter has been defined in terms of radiation wave lengths of the element krypton.

eating him out of the south forty, the expert can tell him exactly what it is by consulting the reference collections. The farmer is hardly different from the antique collector who wonders about the origin of his tole coffee pot.

We have seen that the collections may be used for reference, for store displays, as visual aids in public lectures and in schools, and for television programs. A principal use is research—the study of the objects in their contexts by the staff and by outsiders. Such research leads to new knowledge, new sources of materials, the avoidance of fakes, and the greater skill and knowledge of the staff. Another obvious use of collections is in exhibits, both permanent and temporary, which will be discussed in the next two chapters.

EXERCISES—CHAPTER 12

1. Explain:
 a. "the two faces of a single coin," preservation and interpretation,
 b. importance of a museum library,
 c. dichotomy between research curators and interpretive curators, (if a curator must interpret, should he give up research? Should a curator engaged in research be divorced from interpretation?)
 d. museum conferences as research.
2. If you are keeping a scrapbook of clippings about museums, is there a story in it related to forgery or museum research? If so, give a short review of it. If not, what do you recall reading recently in this regard?
3. What kind of museum spends the most money on research? Why?
4. Discuss museum television programs pro and con. Should museums concentrate on this use of their collections? Should a museum become a "prop room" for a television station?
5. List four to six different kinds of businesses, professions, or other occupants having sidewalk windows in downtown areas of heavy pedestrian traffic. Imagine and describe window displays based on objects borrowed from a museum. Be as specific as you can, and if you are familiar with a museum, use that museum's collections in your imagination. Relate kinds of displays to kinds of businesses.
6. This assignment deals with research by the small museum. Discuss the possibilities for research in a small musuem with which you are acquainted. What kinds of research projects can you imagine? How would the community benefit directly? How would the exhibits be improved by research? If possible, discuss this with a member of the staff of a museum.

13
Permanent Exhibits

A distinction was made in the first chapter between a display and an exhibit. To put it in other words, an exhibit is a display plus interpretation; or, a display is showing, an exhibit is showing and telling. Therefore, an exhibit should not be thought of as a single object, like a piano in a historic house, but rather as a deliberate interpretation of a subject or a grouping according to a theme—the entire, furnished parlor or the whole historic house is the exhibit. The term "exhibit" carries the connotation that something has been added to the object or objects shown (interpretation) in order to accomplish something of importance (education, in the broad sense). The techniques of exhibit planning and construction assume their proper perspective only with this end result in mind.

While exhibits are the obvious, public aspect of museum work, and while visitors judge the worth of the museum on the basis of its exhibits, much needs to be done well, "behind the scenes," before the exhibit program can be of high quality. The museum worker needs to be aware of the basic techniques of good exhibit production, but he also needs to understand the needs and behavior of the museum visitor—the customer who comes into the museum to get its product. (Or what the visitor regards as its product. Remember that what he wants to get and what museum professionals most want to give him are not necessarily the same.) The museum worker, in other words, must see exhibits from both sides.

Probably the greatest museum of science and industry (technology) in the world is the Deutsches Museum in Munich. Although one thinks of the variety and quality of its exhibits rather than of their sheer mass, their total size will help to make a point. The Deutsches Museum has more than twelve miles of exhibits. A visitor moving at

the rate of 20 feet per minute, which is not extremely slow, would take 53 hours, or 21 visits of two and a half hours each, to see all the exhibits. Visiting once a month for two hours and 15 minutes, which is about the limit for a visit (not only do the feet get tired, so does the mind), moving at the ideal rate of speed—the one exhibit designers hope the visitor will use—*a person would need two years to see the exhibits in this one museum.* (Munich, incidentally, is a "museum city." It has many museums worth careful and leisurely visiting.) We have all heard someone say "You can't see everything in that museum in an afternoon. I could spend two or three days there." Actually, two or three weeks would be more accurate, if one is speaking of one of the larger museums.

What does this mean for the exhibit designer? In practical terms it means that he does not have an easy job. He cannot expect every visitor to appreciate fully every exhibit. Designers in large museums must recognize that each visitor will see only a fraction of the exhibits. Curators and exhibit designers should post signs where they will see them every day. The signs should read:

> *A visitor is a pedestrian whose feet hurt, who is tired and preoccupied, and who is on his way to somewhere. An exhibit must stop this person, hold him, and improve him while making him feel good.*

An exhibit that does not do this does not justify the salaries of the people who made it.

Kinds of Exhibits

According to purpose or intent, exhibits may be classed as aesthetic or entertaining—to show objects that people enjoy looking at; factual—to convey information; or conceptual—to present ideas. They may be classed according to the organization of the material as systematic—organized according to similarity of the objects and their "genetic" relationship to each other; or ecological—organized according to area, "habitat," or living relationship to each other.

In Figure 13.1 the examples from history and science, equating the period room and the habitat group, are clear enough. Obviously, the period room is also an important kind of exhibit in art museums, where the fine arts and the decorative arts are combined in rooms representative of the life of wealthy people (whose furnishings and

	SYSTEMATIC	ECOLOGICAL
Art	French Impressionist paintings exhibited together in the same gallery.	Paintings, drawings, sculpture produced in the same social milieu, representing the response in different media to the same forces.
History	The evolution of home lighting with candles, oil lamps, incandescent lamps.	A period room with clothing, furniture, reading matter, etc., representing a real room typical of a specific time, place, and economic level.
Science	Birds of the same and related species arranged according to a closeness or relationship.	Birds, animals, plants shown in a natural setting illustrating the sharing of an ecological niche, a diorama.

FIGURE 13. 1

interior decoration were created by artists). The examples given for art, while not as simple as the example of the period room versus a single kind of art, are meant to suggest that even within the fine arts the exhibitions may be organized in quite different ways.

Characteristics of a Good Exhibit

A good exhibit, regardless of what kind it is, will have certain characteristics:

1. *It must be safe and secure.* It must provide for the protection of its objects, the museum, the staff, and visitors. (An exhibit of nitroglycerine would be questionable, as would be an exhibit of silverware on an unprotected table.)
2. *It must be visible.* The exhibit must be lighted, unobstructed, and shown with a minimum of inconvenience and distraction. Those who have visited regional museums and had to lean over a hay rake to see what was behind it and decided to bring flashlights on their next visit will understand this. (Exhibits near unblocked windows usually suffer because of the glare in visitors' eyes.)

3. *It must catch the eye.* An exhibit that visitors pass by is a failure.
4. *It must look good.* A dirty, crudely made, tasteless exhibit will repel the visitor.
5. *It must hold attention.* An exhibit must educate, stimulate, produce emotion, entertain, or whatever. To accomplish its purpose requires time—long enough to get its message across (naturally, some exhibits require more time than others). Usually, this means the exhibit must stop the visitor for a few seconds to a few minutes.
6. *It must be worthwhile.* When the visitor stops and gives the exhibit his attention, he has entered into a contract with the museum. The museum must not betray his trust. It must give the visitor something of value in exchange and justify his faith that the exhibit is worth stopping for.
7. *It must be in good taste.* Taste must be defined for each museum and each kind of visitor, but the designer must endeavor not to offend. He must respect public mores, accepted standards of decency, the sensitivity of minorities and ethnic groups, religious beliefs, and similar areas of concern to museum visitors. This does not mean that nude statues must be draped, that science exhibits must omit references to human evolution, or that Leif Ericson cannot be mentioned if the museum is in an Italian neighborhood. Shock, used judiciously, may even have value. One cannot accurately describe life without including some unpleasant topics, but like a dash of hot sauce in the beans, a little goes a long way. The museum administrator, his staff, and the board of trustees must be in tune with the times and their community. Their job is to elevate the public, but with the public's consent. Museum work is as much an art as a science.

To summarize, the good exhibit uses significant objects, has an important purpose, and is well planned.

Good planning involves certain fundamentals. Ordinarily an exhibit, whatever its type or size, should have: 1) Good labels, including an easily visible and legible short title, a more detailed subtitle, one or more additional labels giving necessary information, and captions on objects where needed (like a newspaper story). 2) Harmony between objects and labels—they should appear to belong together, both con-

tributing to the same goal. 3) Good design, including layout or arrangement, good use of color, typography, lighting, etc.

Properly done, the planning adds up to a good result, giving the visitor education, information, inspiration pleasantly and in good taste.

What is a good result? A museum is like a business—it invests and expends capital to produce something. Our capital is money; it is also space and the energy and enthusiasm of the staff. Museum workers are paid to spend this capital efficiently. *Efficiency* is the key word. An army that is not efficient loses battles. An inefficient body is ill and may die. An inefficient business goes bankrupt.

Before the efficiency of a museum, or of an exhibit, can be determined, the desired end result must be known and measured against the cost (in money, time, energy, space—whatever the capital expended). We know how much money we spend and how many hours our people work, but we do not know what we are accomplishing. This is the big problem, yet we museum people tend to ignore it while concentrating our attention on the little things. In other words, we may expend much time and effort toward discovering exactly the right kind of adhesive for attaching labels, but we do not concern ourselves with whether or not visitors are actually learning anything from the exhibits.

An exhibit should be designed so as to produce a particular result. To decide *what* to exhibit, *how*, and *where,* without first deciding *why*, is questionable procedure. Just as a museum should have a purpose, an exhibit should have a purpose.

Often the actual reasons or the motivations behind exhibits may be to fill an empty case; to occupy an empty location; to avoid storing something attractive; to please an individual, such as a member of the board of trustees or an egocentric donor; to pursue the hobby of a staff member; or simply to add another exhibit. The only worthwhile justification, however, is to contribute to the education of the visitor—to teach something. But teach something *to whom*? People vary in many ways—in age, sex, size, social class, religion, education, experience, nationality, intelligence, temperament, talents, interests, values. They vary in environment—whether they live in the country or in the city, whether they were brought up in one region or another—in attitudes—whether they are conservative or liberal, old-fashioned or modern, mentally healthy or not, whether they are "folk" in the anthropological sense or whether they participate deeply in international culture, whether they are rich or poor, secure or insec-

ure. Some people are color blind, others do not hear well, some are illiterate or not accustomed to reading. Thinking of museum visitors as "the general public" and assuming that they are all pretty much alike is an ignorant or a lazy escape from thinking of visitors as representing many "publics" or as being individuals. Museum visitors are—to a greater or lesser degree, depending on the museum and its location—heterogeneous rather than homogeneous.

The next question is "Teach *what*?" (in the few seconds that you have the visitor's attention). A paragraph of technical information? An obscure fact unrelated to the preceding exhibit or the next? The exhibit planner should decide what is to be accomplished; plan the exhibit so as to achieve this goal; then evaluate the results to learn how well the exhibit is fulfilling his intention. Only in this way can he achieve efficiency.

The end is not the collections, the museum, the exhibits, or even the viewing of exhibits by visitors. These are all means. The end is the change brought about in the minds of people. This is what museums exist for, and the measure of the success of a museum is how well the aggregate of these mental alterations serve the goals and purposes of the museum. Just as the efficiency of a machine is determined by measuring the amount of work done for a given expenditure of the energy required to operate it, the efficiency of a museum is arrived at by comparing what it accomplishes with what it spends. Unfortunately, though we know what we spend, we do not know what we accomplish.

Studies have attempted to discover what particular exhibits in a particular museum are looked at most and longest, and some museums have even distributed self-testing questionnaires to measure how much information a visitor has acquired in a particular room or exhibition area. These, however, are but the beginnings of the recognition by serious museologists that an exhibit (or a museum) is not necessarily an effective educational instrument simply because it is there. If museums are to justify the spending of public tax moneys, they must give serious thought to what they are actually giving the public in return.

Watching visitors in their museums should be required of all professional employees. Not only will they learn where visitors appear to be disoriented and, therefore, need direction in the form of signs and arrows, but they will find out what attracts visitors and holds their interest. They will discover that certain exhibits are more successful in holding attention, and they should then undertake to

learn why. Perhaps the appeal of one exhibit can be re-created in others. The exhibit designer should create exhibits and arrange them in a logical—and educational—progression. The designer is a storyteller. He must be concerned with structure, drama, suspense, climax, relief, humor, and whatever else a good storyteller employs. He must help the visitor to avoid viewing exhibits out of sequence, skipping essential labels, and otherwise failing to get the most out of his museum visit.

How does the designer go about planning an exhibit? There are several approaches to the problem:

The "Open Storage" Approach

As objects are acquired, they are put on exhibit immediately: 1) with no organization at all; 2) together with similar objects; 3) with other objects from the same donor, locality, or time period; 4) in some combination of the foregoing.

In this approach, labeling is either absent or spotty, giving unnecessary information, such as "oil lamp" or "donated by Mrs. Elmer Judd." A "museum" with such exhibits will commonly have a guest register, a conspicuous donation box, and perhaps an attendant who is not well informed. The name "open storage" implies that objects have not been selected from the collections for display as much as that the exhibits are the collections and vice versa. It is a serious criticism of a museum to say that its exhibits have the appearance of "open storage." The object approach is a step up the ladder.

The Object Approach

The exhibit is planned, and the objects are taken from the collections. The intent is to produce an educational exhibit. The objects are 1) selected; 2) arranged in a case; 3) researched; 4) labeled; and 5) lighted. The object approach may be the result of an unintellectual idea or a scarcity of ideas; in the extreme, it may result in a display of objects with little informational content.

Thirty or 40 years ago an advance in exhibit theory called the "Idea Exhibit" was born. It emphasized concepts rather than objects.

The Idea Approach

Concentrating intently on the educational mission of his museum, the curator 1) decides what story or idea should be pre-

sented; 2) decides how the story can best be put across; 3) selects needed objects from the collections, acquires them for the exhibit, or uses photographs, drawings, or models; 4) plans the exhibit so as to teach, emphasizing the concepts or ideas with various techniques; and 5) installs the exhibit as a unit. The idea approach may, in the extreme, result in a textbook-type presentation with many words, some pictures, and no objects. It may be the result of a scarcity of objects.

Both extremes are bad.

The philosophical questions are, on the one hand, whether the displaying of objects in itself is justifiable, and, on the other, whether museums should be so compelled to impart information that they do so in such abstract fields as mathematics and psychiatry.

The best solution, as a general rule, is the combined approach.

The Combined Approach

The curator selects both objects and ideas at the same time —based on 1) the significant objects in the collections (what is worth showing), and 2) the purposes of your museum (what stories or ideas that should be put across).

To repeat what was said earlier, an important consideration is that exhibits should be grouped in some reasonable order. Just as an exhibit should not contain a hodgepodge of objects, a gallery should not contain a hodgepodge of exhibits. At the same time, avoid monotony—row on row of the same size case, the same artistic techniques and styles, the same methods of organization. The result of these faults is Victorian classification, merely raised from the level of the object to that of the exhibit.

There are so many different kinds of objects to be shown and ideas to be imparted that it may not be possible in a few words to explain how to create a good museum exhibit. Perhaps most museologists would agree, however, that an exhibit represents an important part of the "story" the museum has to tell. It is a measurable aspect of the museum's scope. Most exhibits, then, are a grouping of objects, labels, and pictorial and electronic aids which together are meant to accomplish something. The typical exhibit will have a large sign saying what it is about (the main label). One or more additional labels will convey essential information. The exhibit will contain carefully selected objects, each with an identifying caption, and a longer, detailed label will be available for the viewer who has the time

and interest to read it. Photographs, maps, and diagrams, if these will help to explain the subject matter, may be included. In an art exhibit, large letters on the wall of the room may say "France, 17th Century." This is the main label. Individual paintings will be identified as to title, artist, and the years of the artist's life. Somewhere in the room one or more labels may help to explain the style or styles represented, the development of technique, and even something of the social context of the art works. In some art museums the labeling is largely in the form of a guidebook which the viewer carries with him, or plastic-protected labels mounted on wooden paddles. The visitor uses one of these while he is viewing the exhibit and returns it to a holder as he leaves. In European museums these are commonly available in several languages.

Summary of Ten Exhibit Types: *According to intent or intellectual content:* (1) aesthetic or entertaining; (2) factual; (3) conceptual. *According to interrelationships of the objects, two extreme forms:* (4) systematic—either "horizontal," a detailed treatment at one moment in time, or "vertical," showing development through time; (5) ecological. *According to the planning process:* (6) open storage with no organization; (7) open storage with some logical arrangement—by type of object, source, etc.; (8) object approach; (9) idea approach; (10) combined approach.

EXERCISES—CHAPTER 13

Every now and then a review is beneficial. What is a museum? A permanent, public, educational institution that cares for collections systematically. What is its basic ingredient? Collections. What is its purpose? Education. How is education accomplished? Through the use of the collections. What does good use require? Records, preservation, live storage. What is a major use of the collections? Exhibits.

This assignment is in two parts: answers to questions about exhibit matters, and the actual study and observation of exhibits and of the public in relation to them. It will be assumed that you have access to a museum where you can spend several hours as a student and as an observer. If you are located too far from the kind of museum where this kind of work would be possible, you may substitute a store. It should be one that has a sizable number of customers and good window displays such as a department store in a town or small city. You will have to get the manager's permission to "loiter" and observe the behavior of customers. You will have to be discreet and as inconspicuous as possible. Offer to give the manager a report of your observations. He will probably appreciate learning what product displays seem to be most attractive to customers.

Part One
 1. Define diorama and describe one.
 2. An important rule in exhibit making is "art should conceal art." It means that the exhibit designer should be clever enough to keep his cleverness from being obtrusive; that is, that the techniques used in the installation of an exhibit should not distract the viewer from the purpose of the exhibit. Describe an art exhibit, a history exhibit, and a science exhibit in each of which the advice "art should conceal art" was ignored to some degree. (These can be hypothetical, rather than actual exhibits.)
 3. Write label copy for a sample of surface material brought back to Earth from Mars. In the exhibit you will have one or more scale models and photographs. Include all the labels you would use in your imagined exhibit, and also a simple sketch if this would be helpful.
 4. Discuss exhibit cases in relation to exhibits. Why have them? What do they do? How should they be designed? What is bad about them?
 5. It has been suggested that art museums should not ignore the historic, human, and social aspects of art, and that other kinds of museums should not ignore the aesthetic qualities of their objects. Discuss.
 6. Make an estimate as to the relative efficiency of two museums of your acquaintance and explain how you arrived at your conclusion.

Part Two
In a museum (or store, but explain why you had to select a store):
 7. For two hours, observe visitors entering an exhibit hall or some other busy place where one must make decisions. Record visitors' movements and note what appeared to attract and hold their interest.
 8. Stationed inconspicuously, observe about twenty-five visitors to one or two reasonably good exhibits. Report length of time visitors spent, what was looked at most, what least, what visitors seem to have got from the exhibit on the basis of their remarks and reactions. From that, try to decide how successful the exhibit is.
 9. Choose an exhibit and evaluate it on the basis of the characteristics of a good exhibit.
 10. Find and describe an example of each of the ten exhibit types.

A human "habitat group" helps to explain the early contact between the Indians and white traders of the upper Great Lakes region.
Courtesy, Milwaukee Public Museum

American colonial domestic life is the subject of the lesson taught in this special "classroom" for visiting school children.
Courtesy, Milwaukee Public Museum

Spanish colonial art in South America shown in a simulated room setting.
Courtesy, Milwaukee Public Museum

Good storage: tray 7, cabinet 6, aisle V. Recessed hasps will take padlocks, but
are out of the way. Doors swing back. Aisle, of sufficient width, has no floor
obstructions. Fire and intruder detectors are on the ceiling. Fluorescent lights,
turned on only as needed, have ultraviolet screening. There is a Halon fire-
suppression system. Tray height is adjustable; cards give contents; slips indi-
cate temporary removals. Pressure strips on doors keep out dust and insects.
Courtesy, Lowie Museum of Anthropology, University of California, Berkeley

An exhibition, like an individual exhibit, should have organization and interpretation. Here, the entrance to a major portion of the museum's exhibit area bears a main label, "Africa," photographs, a map, secondary labels, and three-dimensional objects to prepare the visitor for the exhibits he is about to see. Courtesy, Milwaukee Public Museum

Visible storage serves learning in the Object Gallery.
Courtesy, Florida State Museum, University of Florida.

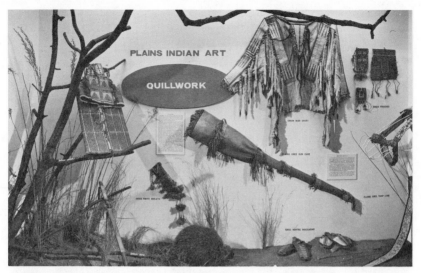

An exhibit on a single topic, the craft of quillwork among the Plains Indians. The main label, or title, is "Quillwork," and the exhibition of which this exhibit is a part, "Plains Indian Art," is named as well. A porcupine is shown in a suggestion of a natural setting, and individual objects decorated with quills are identified. A long label explains the subject, and an additional label on the right discusses Cree Indian quillwork in particular.

This simple format can be used effectively, even by small museums with limited budgets.

Courtesy, Milwaukee Public Museum

Additional details on exhibited guns are available by computer in the room where the guns are shown at the Winchester Museum.

Courtesy, Buffalo Bill Historical Center. Photograph by Sheri Hoem

14
Temporary Exhibits

Much of the material covered in the previous chapter applies to this chapter as well. Exhibits are exhibits whether they are expected to last for three weeks or ten years. Some museums today object to the term "permanent" as applied to exhibits, because it conjures up ugly pictures of installations in static museums that have obviously not been changed in many years. Such exhibits are often dirty, faded, and show signs of neglect, to say nothing of revealing outmoded information. Some museums prefer to consider all exhibits temporary and expect to renew them in the course of, say, five years. Not all museums, however, have the staff and money to effect such a rapid turnover, desirable though it may be.

The temporary exhibit, or exhibition, differs from the permanent exhibit in a number of ways in addition to the matter of time. For one thing, it ordinarily employs a greater measure of what I shall call "show business."

Show business is entertainment with a flair; organized, "slick" gratification of the senses. It is drama and opera—and going over Niagara Falls in a barrel. It is conspicuous, noisy, sometimes gaudy and superficial, but universally appealing. Show business may employ the fine arts, but its aim is at mass audience. It uses sound, color, movement, excitement, animals, sex, suspense, and strange and skillful behavior to entertain and to produce a favorable response in its audience. It may be used to promote sales, win votes for a political candidate, to propagandize or to sell entertainment: for example, Smokey the Bear, Macy's Christmas Parade; a rodeo; the "Magic Kingdom of Walt Disney World."

Showmanship in a butcher shop is dressing all the butchers and clerks in flat straw sailor hats and sleeve garters. Meat markets in

Germany often provide bread and mustard and sell small amounts of sausage to people who want to make sandwiches and eat them on the spot. There it is business. The same thing in the United States would be *show* business, because of the entertainment factor, the publicity, the novelty. A pizza restaurant is using showmanship when it places its kitchen up front where the work can be observed from the sidewalk through the large window.

"Show business," as related to museums, is the use of techniques to attract and hold attention, stimulate interest, provide entertainment, and create a favorable image. It is not "showing," *i.e..* not *exhibits*, but "showmanship"—the use of color, lights, artwork, motion, and entertainment *in* exhibits. Showmanship appears in other contacts between the museum and the public. It is the totem pole on the museum lawn, a distinctive letterhead, floats in parades, exhibits at the county fair, Christmas parties for children, and continuous short motion pictures in rest areas. "Show business" is fountains with colored lights shining on them; piped-in music; landscaped grounds; a striking building, illuminated at night; billboard advertising; free balloons stamped with the museum's name; an attractive sales desk with an attractive receptionist; distinctive uniforms for the guards; unusual dishes in the lunchroom; interesting newspaper stories. All of these are not educational in themselves, but they serve to attract people, to get them to take advantage of the museum's services, and to do so in a receptive frame of mind.

The big problem the museum faces, in designing good exhibits, is in reconciling the statements *"If you're not in show business, you're not in business,"* and *"The business of a museum is education, not entertainment."* Both statements are valid, and museum people should accept them. The problem is to achieve a proper balance between the two in the activities (including the exhibits) of the museum. The visitor comes to the museum primarily to be entertained, yet the museum exists primarily to inform. The museum must attract visitors and give them a pleasant experience while educating them. The entertainment aspect must be neither too much nor too little. It must be appropriate to the kind of museum, the kind of visitors, the kind of subject matter.

It is possible to entertain and educate at the same time, or to do neither. At one extreme the result will be a midway or carnival, at the other a mausoleum. A good museum combines education and entertainment.

"Show business" may play a larger role in temporary exhibits

than in the permanent installations because of the first characteristic of temporary exhibits—the rules are suspended. A temporary exhibit offers much more freedom than a permanent exhibit. The latter must be part of the overall plan; restricted to your fields and purposes; carefully researched, prepared, and installed. It must be economical of space yet justify your investment of time and money. It must be important; it must present a big idea. The short-term exhibition, on the other hand, can be experimental, not limited as to subject matter, quickly and inexpensively installed, and not so serious or important. *It affords the opportunity for going beyond the ordinary scope of your museum and doing so without investing much time, energy, and capital.* A temporary exhibit provides a rare opportunity for visitors and staff to see and to study material which is ordinarily not available. The common example is that of privately owned works of art, ordinarily seen by only a few people, put on temporary public view at the museum.

A temporary exhibit is often rented or borrowed. Called circulating shows, traveling exhibitions, etc., temporary exhibits are available in a variety of fields from a dozen or more sources. They consist of photographs, copies or original art, museum objects, working demonstration machines, etc. Sometimes the cost is only for shipping, usually one way, so that the expense to the museum may range from a few dollars to several thousand dollars. The sources are too numerous to list here, but the Traveling Exhibition Service of the Smithsonian Institution (Washington, D.C. 20560) offers a wide range of subject matter. As one might expect, most traveling exhibitions display contemporary art; however, a few exhibitions in history, anthropology, natural science, and other fields are available.

A temporary exhibit may be borrowed from another museum, a commercial organization, or from a local individual. Single items or entire collections may be borrowed; but the borrowing must be only for temporary use, not on an indefinite basis. A local hobby club or craft group, such as a weaver's guild, a rockhound club, or a garden club, may supply an exhibit. The temporary exhibit provides the opportunity for local group participation; it enables individuals and groups to do something in and for your museum. Becoming involved in your operation makes them more interested and makes them feel more responsible. It is good for the people in your community to say *"our museum."* A variety of locally produced exhibits will attract a varied attendance, perhaps some persons heretofore unreached.

The museum may prepare a temporary showing from its own collections. This may include photographs, documents, and objects

which for one reason or another are not part of the permanent exhibits. For example, a science museum may own some art objects. A history museum may have an extensive collection of cuckoo clocks, of which only a few representative specimens are permanently exhibited. An art museum may own the private papers of an important collector and donor.

The cost of a temporary show might be borne by a local industry or business. This might take the form of an annual Christmas gift to the community.

The temporary exhibit usually has a definite opening and closing, with dates that can be announced in advance for publicity. It is sometimes tied to an event that everyone knows about, such as an anniversary celebration, a presidential election, the inauguration of an irrigation project, a popular motion picture, or the arrival of a foreign exchange student. The temporary show can demonstrate a timeliness that will increase community interest and result in much more publicity. A special ceremony, a party, or private preview might be held at the beginning.

The temporary exhibit is often light and entertaining. It might be aimed specifically at children, or it can be simply amusing, with no great educational content. Suppose, for instance, you collected examples of doodling done by the prominent and best-known men and women in the community, mounted and matted them, and hung them as works of art. This would be a trivial thing, but it might result in much friendly feeling toward your museum or society. Naturally, anything like this would have to be handled with good taste and extreme care not to offend anyone. Your local psychiatrist should be asked not to comment publicly.

The temporary exhibit might use a large amount of space, even to the point of seeming wasteful, in order to help establish the mood. An example of this approach would be a photographic exhibit of life on the plains; a large photograph of a farmstead surrounded by miles of flat emptiness might be suspended on wires from the ceiling in front of, but not touching, a completely empty wall with nothing on either side of the photograph for ten feet or so. You would then be surrounding it with empty space as a kind of frame—or rather the absence of a frame—to help create the impression of vast distances.

Special kinds of temporary exhibits need not be confined to the museum building. They may be installed at a county fair, in a store window, a hotel lobby, in a school, or at the airport. By spreading its location the museum reaches out for a larger audience. Like the

museum-produced television show, the exhibit is taking the museum out to the people and, thereby, becoming an even more important part of the community life.

Almost all museums need publicity. We need greater attendance and greater public support. Today museums have to compete with television, the automobile, and the many other demands on the individual's leisure time. We want—and desperately need—stories, notices, and photographs in newspapers, announcements and programs on radio and television, and all the other devices for getting the public to be aware of us and interested in visiting our museums. *One of the best means for achieving repeated public announcements of a kind to* *arouse interest throughout the community is the temporary exhibit.* Since it is temporary and tied to a particular time span, it is news. It is an event, not a permanent community asset. It has human interest appeal, variety, associations with people in the community, the element of civic pride, and a certain urgency. A temporary exhibit program over the months and years can probably be justified in terms of its promotional value alone, though its educational value as an extension of the permanent exhibits will be very great indeed.

Museums of all kinds are increasingly using temporary exhibits as they seek more publicity and as they attempt to reach out to a wider audience. Any subject field will lend itself to this treatment; however, a general rule should be kept in mind. The temporary exhibit is at its best when it presents a simple idea or a unity of objects. Objects that require lengthy explanatory labels, technical matters above average understanding, and anything too complex and obscure to be grasped quickly by a walking visitor should be avoided.

EXERCISES—CHAPTER 14

The distinction between the temporary exhibition announced in the newspaper and on a billboard in front of the museum and the scholarly and expensive permanent installation is a real one for many reasons. This assignment is intended to help the student to appreciate those distinctions.

1. Imagine and list different kinds of temporary exhibits for different kinds of museums.
2. What would you assume to be ten or twelve different sources for temporary exhibits in your community? List sources and describe the exhibits.

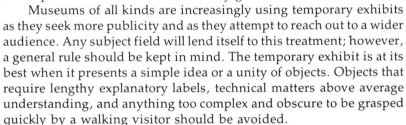

3. Give examples of "show business:
 a. as seen in local stores;
 b. as seen in local museums, or museums you have visited.
4. Describe two or three temporary exhibits you have seen in your local museum or in the community outside museums (banks, store fronts, schools). How did these examples illustrate the characteristics of temporary exhibits as set forth in Chapter 14?
5. Two related concepts were introduced in Chapter 14. They are the balance between show business and serious education in the museum, and the greater freedom in temporary exhibit work as compared with permanent exhibits. Discuss these in the context of a specific museum; either the one you are now associated with or another museum with which you are familiar.

15
Visitors and Interpretation

Museums collect, record, and preserve in order to interpret, or increase understanding. Some of the interpretation, as the result of research, reaches the public indirectly in the form of publications. Other interpretation is direct—through exhibits, through guides, through lectures, and otherwise. Interpretation is basic to the concept of the educational museum. The objects alone—without explanation, organization, selection—would not support the educational aim of the modern museum.

Interpretation does not exist in a vacuum. It is communication between the museum staff (as students and teachers) and the public (as consumers of the museum's product). Just as a wise merchant comes to know his potential customers, the museum must know its visitors. Carrying the analogy further, the museum must attract and please its visitors, and leave them satisfied. "Ask the man who owns one" used to sell cars. The museum should so deal with its customers that they will become its public relations ambassadors and recommend its product to others.

The most striking thing about visitors is that there are so many of them. No longer are museums catering to a select few. Coping with throngs of tourists more accurately describes what many museums do today. Not only in our own country are people on the move. Tourism is becoming more and more popular; and money, time, and a breakdown in provincialism are making travel more possible throughout Western civilization.

In 1965, 115 million tourists traveled outside their own countries, throughout the world, and the rate of increase at that time was 12 per cent per year. Scotland receives as many tourists each year as it has permanent residents (more than five million). Foreign visitors to the

United States are increasing. A few years ago the number was re-
ported as a million, double that of only three years before. One airline
flying in and out of Denver reported that during August 1964 two-
thirds of its customers were foreigners.

Tourism is the largest industry of some of our states and ranks
very high in many others. The state of Virginia spends more than a
million dollars a year to promote travel. Even so, the economic impact
of tourism is difficult to conceive. In 1968 campers spent more than $50
million for sleeping bags alone. Camping trucks and travel trailers cost
more than $700 million; the ski business accounted for $1 billion, and
the total leisure market was estimated at $150 billion in one year's
time.

In 1970 the National Park System had 172 million visits, including
more than 24 million to the Blue Ridge Parkway and the Natchez Trace
Parkway. In 1969, 200 million persons visited the National Forests,
and on one day, July 4, 1969, 160,000 persons visited the 19 National
Forest visitor centers. It would be natural to expect large numbers of
visitors to museums, and such is indeed the case.

The Metropolitan Museum of Art reports more than six million
visitors per year. During the school year, one thousand school chil-
dren come each weekday by appointment. Attendance at the Smith-
sonian museums in Washington, D.C., was given as 10 million in
1966, and estimates for museum attendance each year in the United
States range as high as 600 million and even higher. It is interesting
that in spite of this astronomical figure—three times as many museum
visits as there are people in the United States—museum visiting is still
not regarded as important by the common man, or as reflected in our
mass culture. The news media are much more preoccupied with
attendance at sports events, and sports occupy a much more promi-
nent place in conversation in a wide range of social gatherings than do
museums.[1]

Museum attendance has increased because of increased popula-
tion; higher educational attainment; increased sophistication in
museum fields on the part of visitors; increased use of museums by

1. On the other hand, the Stanford Research Institute reported in the early 1960's
that theatergoers outnumber boaters, skiers, golfers, and skindivers combined. Twice
as many people attend concerts as see major league baseball and football games. There
are more piano players than fishermen; as many painters as hunters. The growth in
spending for "culture" was twice as fast as that for sports recreation and more than six
times as fast as the growth of spending on spectator sports.

public school classes; increased leisure time; increased mobility; increased desire to travel—curiosity about the world outside one's home environment; increased popularization of approach by museums (for example, simpler and more attractive exhibits). Whether or not greatly increased attendance is a good thing is another matter. While almost everyone would agree that large segments of our society would profit by more exposure to museums (a recent survey showed that 43 per cent of Americans had never visited an art museum), many people would prefer to see less of some visitors. In August 1965 the Providence (Rhode Island) Redevelopment Agency took a public stand "against having a museum in the proposed Roger Williams National Memorial because of the traffic it would draw. Agency members say they would rather forego a possible $693,000 in Federal money for the memorial if the National Park Service insists on a museum."[2] In an Associated Press wire service story that appeared in Montana papers in the fall of 1969, William A. Worf, chief of the recreation and lands division of the Northern Region of the National Forests, reported that vandalism was increasing. "In developed recreation sites," he said, "the vandalism rate was double the national average." In regard to overuse of nature trails, a museum man seriously proposed keeping their location secret from the general public, so that only a few persons would find them and use them. His hope was that these few would be the ones who could benefit most by the experience—whose interest was sufficient to cause them to seek out such park and forest offerings. On the other hand, others might argue that the throngs of city dwellers who know the least about preserving our natural environment are the people who most need what the nature trail has to offer.

Visitors who are principally seeking recreation still demand interpretation; they want informed people to explain things. Many visitors to museums with quite adequate labels still prefer guided tours. They prefer being told to discovering on their own. As Guthe says, preservation of the collections and interpretation of them to the public go hand in hand.[3]

Part of the museum curator's job is to abstract, simplify, and make interesting the important information about the objects he shows. He does not attempt to tell all; he should not dwell on unimportant details. He should render into simple, standard English what should

2. *Rocky Mountain News* (Associated Press), August 29, 1965.

3. Carl E. Guthe, *The Management of Small History Museums* (Nashville: American Association for State and Local History, 1959, 1964), p. 51.

be said. Labels, electronic devices (tape players, radio guide systems, etc.), publications, or human docents can convey the message. This is the most obvious kind of interpretation, though the selection of objects, the layout of exhibits, and other kinds of museum work are also part of interpretation.

Museums are becoming increasingly active in the out-of-doors. For example, a children's museum, a science museum, or a general museum might install a nature trail. A nature trail—a marked path through a natural area, with identified plants, geological outcroppings, animal burrows, and viewpoints—is a self-guided sampling of the natural environment. Outdoor interpretive trails need not be limited to natural science. A historical society might mark a route through and near the community, singling out places of historic interest. An art museum might do the same for buildings of architectural interest. The visitor may receive interpretive leaflets, or cassette tapes, which are played either on the visitor's own portable or automobile machine or on a unit rented from the museum. Such electronic devices are coming into increasing use.

The quality of the interpretation is an important matter. An Associated Press news item of July 1971 said that Lester B. Dill, Director of Meramec Caverns, a commercially operated cave near Stanton, Missouri, had ruled out the possibility of hiring geology students as guides. "They are too technical when they conduct tours," he said. "Tourists would prefer to hear about how Jesse James used the cave to elude the law." But the serious visitor should not be denied the opportunity to learn. Some years ago I visited Mammoth Cave National Park in Kentucky and participated in the guided underground tour. My guide was an unlettered local man who knew or cared very little about geology or geological explanations. His interpretation of one of the world's great natural marvels consisted of giving cute names to formations ("slab of bacon," "setting hen") and telling Methodist-Baptist theological jokes. The issue here is again the question of entertainment versus education. The *museum* does not exist to provide light entertainment for an uneducated clientele. It must balance show-business techniques with education.

We have discussed the visitor in regard to what we hope he will not to do us (security) and what we hope to do for him (education). Now let us think how we can make his visit smooth and pleasant.

In the first place, the museum must be accessible. You can have the best museum of its kind in the world, but if potential visitors do not know about it, do not know when it is open, do not know how to

get to it, are afraid to come to its neighborhood, cannot afford your admission charge, or are not well received, yours is not a successful public museum. The visitor must be able to reach it by public transportation, by walking from a downtown location, or by private automobile. If he drives, he must find a convenient and safe parking lot near the entrance.

The entrance should be impressive, easy to find, and to get to. The visitor should not have to walk around the block trying locked doors. If you have an admission charge, post it conspicuously at the parking area and outside the front door. If your building has doors that are not open to the public, have plenty of signs directing the visitor to the proper entrance. That door should say "Welcome," which should be echoed by the friendly tones, smiles, and helpful attitudes of the members of the staff the visitor sees upon entering. A surly guard at the front door can quickly counteract all that the director does to be pleasant.

The lobby is a reception area for visitors. It should be large enough for the marshaling of school groups but pleasant and comfortable enough for friends to meet. The lobby is also a distribution point. From here visitors are sent directly to wherever they most want to go at that moment: restrooms, which should be modern and immaculate; lunchroom; lounge area; offices; sales rooms; auditorium, etc. Signs, directional arrows, directory boards, "you are here" orientation diagrams, announcement boards, and a drinking fountain should be in the lobby.

Immediately adjacent, if not actually in the entrance lobby, should be a reception desk for information and the receiving of groups. Here, too, should be a checkroom for umbrellas, coats, parcels, and briefcases. Hooks on the wall and a sign saying "The museum is not responsible for stolen articles" are not enough.

Places to sit down should appear throughout the public areas of the museum. Seats should be comfortable, with a view not facing a blank wall or the restroom door. The building should have elevators, escalators, gentle (not steep and narrow) stairways, and ramps where needed. It should not be necessary to negotiate a wheel chair or child's stroller up and down steps anywhere between the parking lot and any part of your building.

Rest areas, such as lounges, lunchrooms, and the lobby, should have windows where the visitor can lose the shut-in feeling he may get from windowless exhibition halls.

Museum personnel should be prepared to give the tourist any kind of information he is likely to need: maps of the city and region, names and locations of other nearby museums, restaurants, motels, service stations. Your sales counter should have publications related to the exhibits: not only guidebooks, suggested short tours through your museum and the like, but good quality books on the subjects dealt with by the museum, hobby kits for children, reproductions of your art works, postcards, and in some locations such travelers' needs as photographic film.

A lunchroom is an important feature for almost any museum, especially for a museum not located near good restaurants. Amenities of many European museums are a bar and a dining room where one may get wine or beer with his meal. It would be rare, indeed, were this to occur in the United States because of our attitude that alcohol is sinful and teaching is holy. Rarely do the two get together, except as a special privilege for members. One might argue that even this does not reconcile the two, since the uplifting of the masses is not the primary purpose of a champagne preview.

Interpretation, such an essential element in the present-day professional museum, can hardly be overemphasized. When George Brown Goode of the U.S. National Museum said what he said about labels (see page 12), that is what he was talking about. Exhibits in an art museum may be given little or no interpretation, because of the museum administration's belief that that would be an intrusion into the viewer's private act of enjoyment, art appreciation being considered a matter of personal taste and personal emotional involvement. Some interpretation on the part of the art museum staff does enter into the situation, however, since staff members choose the display frame or pedestal for showing each object, place the object spatially in relation to architectural details of the building and other exhibited objects (or their absence), set the lighting, and pipe in music, even if they do not provide the visitor an explanatory leaflet, a conducted tour, or a long label near the object viewed. At what point *interpretation* may be considered *intrusion* is somewhat subjective.

Increasingly, outdoor history museums in the United States are using diversified interpretation—ranging from guided tours to "living history" techniques in which the museum's interpretive staff dress in period costume, adopt authentic accents, and recreate past human cultural behavior. Two extreme forms may be observed—at Plimoth Plantation in Massachusetts, where the interpreters pretend to be authentic pilgrims actually living in the 1620s; and in a historic house at Yorktown, Virginia, where visitors in groups are conducted through a

succession of locations about the house, while, at each location, professional actors present dramatic skits illustrating events that might have occurred there during the history of the house and the town. The museum exhibit becomes the interpretation, in a way, the objects merely illustrating the "talking labels."

The American emphasis on education and interpretation seems excessive to Europeans, while the meticulously researched and beautifully maintained historic buildings of Europe, in their attractive parks, seem to Americans as if they are empty, crying out for actors to illustrate past life.[1]

EXERCISES—CHAPTER 15

In previous chapters we have looked at museums from the inside. In this chapter let us look from the outside, from the point of view of the person who is visiting the museum.

1. The description of facilities for visitors given in this chapter was not complete. Such facilities as were listed apply to a wide range of visitors. Put yourself in the shoes of each of the major categories of museum visitors, adding any additional kinds that the readings left out, and describe what you, as a museum visitor, would want in the way of services and conveniences. What would make your visit more enjoyable and more profitable? Are there some special kinds of museums that should be mentioned?

2. Discuss the matter of charging for admission: 1) to the museum, and 2) to a special exhibition, wing, or performance within the museum. Include in your discussion the possibility that a charge is discriminatory.

3. "Applied museography" is the term given to the deliberate use of museums and their activities in order to effect specific changes in attitudes in the public; that is, propaganda. Does it occur in American museums? Give illustrations of how it might be used in different kinds of museums. How does it relate to such political issues as nationalism, totalitarianism, consumerism, etc.?

4. Discuss the role of the museum in broadening the horizons, uplifting the public, and the like. Is there a connection with different roles for different categories of museums (small local, larger regional, and national)?

5. Discuss traffic patterns in exhibit areas and the design of exhibit installations in reference to visitors' behavior. (Such matters as the location of an exit influencing whether visitors pass up certain exhibits in a room, for example). The aim here is to think of where the museum staff wants the visitor to go, in relation to where the visitor might want to go or might accidentally go.

1. For a fuller discussion of this matter, see G. Ellis Burcaw, "Can History Be Too Lively?" in *Museums Journal* 80, no. 1 (June 1980): 5-7; and a subsequent exchange of letters in *Museums Journal* 80, no. 3 (December 1980): 168.

16

Education and Activities

The reader may well wonder why I have taken so long to get to specific mention of education, when that is the whole purpose of all museum activity. The fact is that we have been discussing education all along. The word as used in this chapter has a special meaning. Museum people speak of their "education staff," "education department," and "curator of education." What they refer to is their work with visiting school classes, loan exhibits to schools, and related activities, which sometimes include guided tours. What makes it so easy for many museum people to use the word "education" in this restricted way is the old view that education is what is accomplished by someone standing in front of a blackboard with a piece of chalk in his hand.

I once lived in a large city where I served on a committee to coordinate public educational opportunities. The committee first compiled a list of all sources of education in the community, other than schools, and included public service agencies, the Anti-Defamation League, and dozens of others. When I suggested listing television stations and newspapers, blank stares told me that my definition of education did not coincide with that of the majority of the committee. Some museums prefer to use the term "school services" for the department, even though its head is called the curator of education. The point of this discussion is that the beginner should be aware that, even in a good museum, the term "education" is often used in its limited sense.

We have previously discussed Guthe's first three obligations. The fourth is activities. Since many activities are for children and are managed by the education staff, the two areas of interest are often grouped together. A related topic is children's museums.

The children's museum is an example of categorizing by type of visitor rather than by subject matter. Physical equipment and installations, as well as exhibits and activities, are scaled down to the size and mental capacity of elementary school children. Often, these museums are operated by the public school district and staffed with certified teachers. The parallel with the children's library is obvious, and such museums usually do not lack public support and volunteer help.

Special techniques have been developed to reach and stimulate the immature mind of the child visitor. Exhibits relate to his own world of experience, and interpretation is more provocation than instruction. An interesting example is found at one of our city zoos where two identical monkey islands were built. Each had the complete complement of climbing and swinging installations that monkeys use in a zoo. Monkeys were placed on one of the islands, and the other was turned over to the children. As a reverse of "monkey see, monkey do" the children imitated the monkeys in climbing, swinging by their arms, and jumping, if not in other activities, and thereby, one would imagine, gained a small measure of humility.

Ordinarily, regular adult museums do not construct special exhibits for children. An interesting exception is the Civic Center Museum of Philadelphia (formerly the Commercial Museum). Here a large portion of one floor is devoted to two classrooms, the education office, an auditorium, the storage room for teaching aids, and a half dozen or more open lesson areas with chairs facing an elaborate "exhibit" on which the lesson is based. Actually, each area is more like a theater with three-dimensional objects. Visiting school classes are also taken to the public areas of the museum where examination of the general exhibits supplements lessons. The public school system provides two teachers; the museum, one.

The key word in the previous paragraph is "lesson." The up-to-date museum prefers to make the visit of the school group a truly educational experience, not merely a holiday from classroom routine. Organized lessons on single topics deal with important aspects of the museum. Museum teachers (either professionals or volunteers) show and explain exhibits, and the children handle real objects. The visit is ordinarily limited to an hour, and several lesson visits are necessary for a child to see the entire museum. The Colorado State Museum in Denver, devoted to Colorado history, offers "Fur Trade," "Cattle, Land, and Water," "Indians of Colorado," etc. The teacher of the visiting school group must make reservations in advance, and he is encouraged to prepare his class ahead of time in the subject matter and

to recapitulate the salient facts of the lesson after the museum visit. The teacher who calls a museum and inquires about a "tour" may not be aware that good museums today offer much more.

There are opposing points of view regarding who should conduct the museum lesson—the school class's own teacher or a member of the museum staff (or docent). The principal arguments are that the teacher knows his or her children; the museum person knows the subject. Controversial, too, is the question as to where to conduct the lesson —in the exhibit areas where the presentation may be over the children's heads (in both senses) and where the lesson may be a nuisance to other visitors, or in a special classroom where the experience for the children may not be much different from remaining at school. Even the children's museum has been criticized for segregating its curators and its visitors from the greater collections, exhibits, and expertise of the adult museum. Beginning museologists can profitably discuss all three of these issues. As with many controversies, the best solutions appear to be combinations and compromises.

I might mention in passing that some museums use their education departments as a crutch. Since teachers and docents interpret exhibits orally, curators and exhibits designers sometimes take the easy road and allow their exhibits to rely on the oral interpretation. In other words, they may not interpret the subject matter fully by good exhibit techniques—such as adequate labels. For some purposes, of course, there is no substitute for the live, sensitive, and informed guide, interacting with an audience.

Activities include all offerings and services to the public beyond the maintenance of collections and exhibits. Some of the most common are publications, guided tours, field trips, lectures, art classes, hobby clubs, concerts, motion pictures, other special events, and membership services. These activities stem from the museum's desire to give its community as much as it can, consistent with the limitations of its staff, facilities, and scope. A danger lies in overemphasizing activities to the point where the museum's more basic obligations—collections and records—suffer.

EXERCISES—CHAPTER 16[1]

Again, it will be helpful if you can relate your reading to real museum operations. Of the museums you can visit, or with which you are familiar (a specific visit to examine "education" services will be of most value to you), choose the one that has the most active education department.

1. Interview the director or curator of education (or both) and make a report as to that museum's school services and other activities for children. Include brochures and other published information.
2. Observe a school class visit and evaluate it in detail as an educational experience for the children. Criticize constructively the adults involved. Include your own recommendations for improvement of the program.
3. Interview a grade school principal and a middle grade teacher as to the school's attitude toward their local museums as community resources and specifically toward "your" museum's offerings. Interpret what you find out.
4. Referring to your reading, as well as to whatever firsthand experience you may have had, discuss the following, pro and con: (that is, give all the arguments for and against, regardless of what you, personally, may favor).
 a. Having the lesson in the museum conducted by the class's own teacher, as opposed to a member of the museum staff.
 b. Teaching the lesson to the visiting school class in a special classroom rather than in the public exhibition areas.
 c. The concept of the children's museum.
5. Discuss group visits to the museum, including main purpose, size, frequency, organization, etc.
6. List all the "activities" of three or four museums of your acquaintance.
7. Decide whether activities occupy too much or too little staff time and resources in a museum with which you are acquainted. Discuss.
8. Discuss the contribution of museums in general to solving present day educational and social problems.

1. Molly Harrison, "Education in Museums," *The Organization of Museums: Practical Advice*, Museums and Monuments Series, No. IX (Paris: UNESCO, 1960) is especially pertinent to some of these exercises.

17
Architecture

To this point we have discussed the nature of the museum and its operation. Only now can we take up the matter of proper housing for the museum. The architectural maxim that "form must follow function" is the paramount consideration in planning a museum building. The building must be created for or adapted to the needs of the museum operation. Too often the converse is the case; the functioning of the museum often must be adapted to fit the building. Remember that a museum is not a building (except for convenience in colloquial usage). It is a dynamic, organized operation involving specialized needs and activities. The building that houses the museum is just a vehicle or tool to facilitate the museum's operation.

A person who says "The old courthouse (post office, city hall, high school) will be vacant next year. Wouldn't it make a good museum?" is showing his ignorance of what a real museum is. The building that has been outgrown or become outmoded for some other specialized use would be no more satisfactory as a museum building (without extensive alterations, at least) than it would be for a restaurant, a department store, a hotel, or any other use for which it was not originally designed. The problem is that the layman does not understand museums. The fact that he *thinks* he understands them changes nothing.

Museum professionals and enlightened laymen who are involved in the planning of museum buildings have to battle those who hold the purse strings. They may also have difficulty with architects, because, even today, the architect who can design a good museum building is a rarity. This is very likely true because the architect, as an ordinary citizen, shares the general ignorance of good museum practice. In other words, he does not know enough to know that he does

not know enough about museums. Some architects of high reputation are incapable of designing good museum buildings, and are in demand even though they have demonstrated their ineptness again and again. There are notable exceptions. The museum profession much admires the building of the Museum of the Great Plains in Lawton, Oklahoma, because its architect had the good sense to visit museums, to take the advice of museum professionals, and to develop in his mind a good picture of the functioning of this particular museum before he put pencil to paper. Another good museum architect is Raymond O. Harrison, author of *The Technical Requirements of Small Museums*. He is a museum director as well as an architect, and this rare combination shows in his plans.

If the most important guidepost in museum architecture is that form must follow function, probably the second is the necessity to strike a balance between the building as an attractive object in its own right and its use as a neutral setting for the exhibits. The building should be in harmony with the museum, and there is no question that an impressive building will attract the visitor and help to put him into a receptive frame of mind. A museum of classical archaeology might well be housed in a modified representation of a Greek or Roman temple. The same building would not be a good choice for a museum of modern science and industry. Similarly, a building of modern design suggesting wealth and refinement would hardly be an appropriate setting for a museum of rugged life on the Great Plains.

We must also consider the interior decoration. Just as we might question unfinished concrete and exposed steel beams as the background for historic paintings, we also should feel uncomfortable to see natural history exhibits in a setting of Victorian ornateness. The collections must be paramount. As the frame enhances the picture and does not overwhelm it or distract attention from it, the museum building must provide a suitable but not prepossessing frame for what exists inside.

Security is the most fundamental requirement of the building, and the architect must keep this need paramount. David Vance has used a schematic diagrm to explain the concept of the "zone of safety."[1] Every legitimate location in the building for the collections—receiving room, photography studio, workrooms, exhibition

1. David Vance, "Planning Ahead—The Registrar's Role in a Building Program," in Dorothy H. Dudley and Irma Bezold Wilkinson, *Museum Registration Methods*, rev. ed. (Washington, D.C.: American Association of Museums, 1968).

halls, etc.—is provided with security, and barriers are set up, in effect, between the collections and unauthorized people. What this means for the museum worker, whether in small museum or large, is that the building (including its interior arrangement, equipment, and so on) must be so designed and used as to provide continuous maximum security for museum objects, the primary function of the museum building.

Awareness of building function should extend to decoration of exhibition halls. For example, ample space should be provided before key exhibits used in the education program for every child in an entire school class to be able to see the exhibit. It may be necessary to raise and tilt the exhibit or to provide one or two risers (platforms) on the floor so that children in the rear can see over the heads of children in front. Do not rely on always having short children in front and tall children in the rear. Herding a group in unfamiliar surroundings is difficult enough. Do not multiply your difficulties unnecessarily.[2]

Museum architecture is not a simple topic. Many considerations enter into the fitting together of the museum's operation and its building. Following is a list, in no particular order, of some of the things involved:

Site—accessibility, parking, room for expansion, attractive setting, freedom from fire risk, noise, impure air.

Building style—suitability for location and for subject matter of museum.

Social considerations—community cultural center, multiplicity of uses.

Exhibit rooms—proper setting for exhibits, style, color, arrangement of rooms, monotony.

Lighting—natural versus artificial, sky, side, windows.

Flexibility of space—movable partitions.

Services—meeting rooms, library, mechanical matters, separation of public from private areas, ease of communication between areas, ease of access of public to appropriate service area (such as the restaurant).

Proportions—room size, ceiling height in reference to materials to be exhibited.

2. A useful device is colored plastic tape placed on the floor where you want the front row of the class to stand. Getting the children to face exactly as you want them to is as simple as saying, "Put your toes on the yellow line." When you refer to a second exhibit, "Now put your toes on the blue line." This effectively, and in a spirit of fun—very important—swings the group around to face in a different direction.

Use of outdoor areas—gardens, terraces, lawn, grounds.

Storage—location, security, size, accessibility, ease of use by staff, by scholars, climate control, several rooms for varied control.

Traffic control—visitor routes through the exhibition halls, lobbies, other public areas, entrances and exits for exhibition areas, elevators, stairways, closing off part of the building at times.

Entrances—services in lobby, ease of access to entrance, attractiveness, turnstiles, number of outside doors.

Visitor conveniences—restrooms, cloakrooms, lunchrooms, seats, orientation, direction, public telephones, sales counter, clocks, mail box.

Technical considerations—fireproof, dampproof, vibrationproof, noiseproof, floors strong for heavy loads, insulated against changes in temperature and humidity.

Doorways—large enough, where needed, not where not needed.

Staircases—fire escapes, supplemental to elevators, improve communication and movement of staff and visitors between floors.

Roof—accessible, usable for social and other purposes.

Shipping-receiving—access, loading dock, service parking, freight elevator, crate storage, secure unpacking and packing.

Temporary exhibits—special requirements.

School classes—schoolbus loading and unloading, parking, lunchroom, cloakroom, restrooms, etc.

Auditorium—projection, chair storage, restroom for speaker, outside access for deliveries.

Meeting rooms—hospitality arrangements.

Workrooms—shop, conservation, exhibit preparation, photography, research with collections, laboratories, dark room, drying room, office and record room, poison room.

Maintenance—guard room, janitors' closets, supply room.

Mechanical—heating, ventilation, air conditioning, exhaust fumes.

Exhibition space—percentage of total.

Facilities for accessioning—reception of objects, accessioning, cataloguing, preparation, study, storage, routes followed through the building as this work is undertaken.

Greenhouse—for plants used in exhibition areas and elsewhere.

The starting point in planning a museum building is knowing what a museum is. Second, one must know what the functioning of the particular museum in question ought to be; and third, a good planner will write down the specific tasks that will be performed in the building. Then, a parallel list describing the space requirements for each function should be made up, grouping functions that can share the same space. The fifth step is to make a schematic chart, a kind of pseudo floor plan called a *space organizational diagram.* Such a diagram shows relative sizes of the needed spaces and their relationships to each other, joined by lines indicating the movement of people and objects from one space to another. In the sixth stage of the planning, an actual floor plan is devised; and finally—at least, in theory—the seventh stage, an exterior structure, an envelope, is placed around the rooms. The planning is thus from the inside out, and it is based on the actual work that is to be facilitated by the building.

While the prime function of a museum building is to provide security for the collections, its second function is to facilitate the work that will be done by the staff and promote the learning experience possible for the visitor. Unfortunately, some architects, especially those whose main purpose is to sculpture monuments to their own egos, place greatest emphasis on the outside of the building and then partition the interior space in an inefficient manner. They appear to design their buildings backward; that is, from the outside in.

EXERCISES—CHAPTER 17

Every museologist need not also be a museum architect, but every museum worker or student needs to be able:

to evaluate the suitability of a museum building and the organization of functions within it;

to advise his superiors in a museum situation regarding improved security, communication, visitor accommodations, and other aspects of space arrangement;

to use "input" from museum professionals whenever a museum building is being planned or an older building is being considered for museum purposes;

to understand the relationship of the physical plant (facilities) to proper museum functioning.

For these exercises, Raymond O. Harrison, *The Technical Requirements of Small Museums,* rev. ed. (Ottawa: Canadian Museums Association, 1969), will be helpful.

1. What are the essential activities of the museum operation (as distinct from "activities" in Guthe's fourth obligation?
2. Discuss windows, doors, basements, and floor coverings in relation to museum requirements.
3. What are the arguments for and against natural lighting and artificial lighting?
4. Imagine that you are the director of a small museum and you have been given the necessary money and authority to make radical changes in the museum housing. You have three options: You may make improvements in your present building, you may acquire an old building previously used for another purpose and adapt it, or you may build a new museum building.
 a. Take a museum with which you are familiar, draw its floor plans, and draw other plans to show the changes you would make. Briefly justify the changes (explain why you would make them). By use of different colors you may be able to show both plans together.
 b. Visit and study an old building in your community, whether or not it is or might become vacant, and draw its floor plans. With additional plans show how it could be altered so that it would serve well as a museum building. Do not neglect any important museum function or service, but if the building is large you need not deal with all of it. That is, you might assume that the museum would not occupy the upper floors or one wing. Choose a building that could, conceivably, be offered to a museum. Such would be school buildings, churches, private homes, post offices, courthouses, city halls, railroad stations, and others. Do not choose a vacant store or a minor part of a building mainly used for some other purpose. Your problem is not only to suggest the removal of walls, adding of doorways and the like, but to show how existing spaces could be used for your museum purposes.
 c. Describe your museum operation (real or imagined) in the way that Harrison begins, that is, by a function-space chart and then by a space organization diagram. From this, develop a set of floor plans for a new building that would serve your operation well.
 d. As a continuation of the option for a new building, where would you locate it? In a park, downtown, on a main highway on the edge of town, in a residential neighborhood, in a slum area, in an industrial area? Choose one or two possible locations in your own region and justify them.

Part III

Museums and Society

18

Historic Preservation

Of a thousand or so known forts and sites of forts in the United States and Canada, at least 80 are maintained as museums. The remarkable thing is not that so few are maintained, but rather that so many are. Our interest in preserving structures of the past goes beyond any practical ends that might be served. Why do we preserve? Any attempt at explanation cannot ignore the myth that age lends importance. "Many a man that couldn't direct you to the drugstore on the corner when he was 30 will get a respectful hearing when age has further impaired his mind," said Finley Peter Dunne.

Of course, if age alone were a criterion of value, a lump of coal or a rock would be worth much more than any artifact. Nostalgia for the "good old days" plays a large part. How good were those days, however? Now that Sears Roebuck and Montgomery Ward catalogues of past years have been republished, one can compare yesterday's prices with today's. How amusing it is to read that in 1897 coffee was 20 cents a pound and a man's all-wool suit cost $10. We must bear in mind, however, that the average worker made 20 cents an hour and worked 60 hours a week.

For the average person today, history has entertainment value, as witness Walt Disney World's "Magic Kingdom," and the pseudo-Victorian decor of a multitude of restaurants, bars, and clothing stores across the country. There is no doubt that entertainment, nostalgia, emotional identification with ancestors, and similar sentiments motivate much of the preservation of old buildings. Many entrepreneurs and entire communities see the tourist's enjoyment of the historical as a handle on his pocketbook. A few years ago, a national news story described the efforts of Eureka Springs, Arkansas, to get a $730,000

Federal urban renewal grant to make itself look older. The downtown section was to be refurbished in 1890's style to attract tourists and declared a historical area. All new buildings would have to follow architectural patterns of the 1890's and such turn-of-the-century trappings as a trolley car were planned.

Another Arkansas attraction, the Ozark Mountain Park, was to include a stagecoach, log cabins, and other typical nostalgic items. Its special drawing power, however, would be the Dogpatch world of Li'l Abner, created by cartoonist Al Capp. Sights, sounds, foods, and—of course—Sadie Hawkins Day would conduct the visitor into a make-believe world of past simplicity and innocence. The replica town was also to have a statue of Dogpatch's most famous military hero, Jubilation T. Cornpone.

Not to be outdone, the Ohio Natural Resources Department decided in 1966 to span the Mohican River to Mohican State Park, near Loudonville, with an imitation covered bridge. A steel bridge with a concrete deck was to be encased in wood so that it would resemble a covered bridge. Thus nostalgia would be served, but not at the price of practicality.

One of the most extreme examples of catering to the tourist's desire to be entertained by history is the transfer of London Bridge to the Arizona desert. The McCulloch Oil Corporation of California purchased the bridge, which had become too small for traffic demands and was gradually sinking into the Thames, as a tourist attraction to promote their newly built resort and retirement town. The 1,005-foot, 130,000-ton granite structure was re-erected at Lake Havasu City and adorned with eight impressive, though unrelated, stone heads, which the owners had purchased from a demolished building in London. In March 1972 the project had cost $7 million.

Is this what historic preservation is all about? Commercialism? Escape for the vacationing worker? Let us look at it from the standpoint of the museum. A *museum object* is a tangible, material, three-dimensional thing that should be preserved, and can be preserved, for educational or aesthetic purposes. An entire building, or even a town, may, therefore, be considered a museum object. A historic house, authentically preserved, restored, and furnished, is really one object. If it were not so large, it would be carted off to a museum building. Indeed, open-air museums do collect buildings and assemble them as exhibits and as research collections. A historic house that remains in place and is administered for museum purposes is sometimes called a

museum, a house museum, a historic house, a historic preservation, or something similar. Some of them could be considered as one-specimen museums.

What is the purpose of historic preservation? The same as for museums—public education. The same definitions and tests that apply to other kinds of museums apply to historic buildings.

Newspapers reveal a worldwide concern by educated people for the preservation of antiquities. It is heartening, for example, to read that in 1971 a new superhighway in England was not allowed to obliterate a recently discovered Roman bathhouse lying in its path. Instead the roads were carried on a concrete vault under which the Roman construction is preserved and exhibited. Similarly, when workers encountered a pre-Columbian (Aztec) temple during the building of present-day Mexico City's subway system, the tracks were diverted around the temple, and the Aztec building became part of a station. Not all antiquities fare so well. Other newspaper accounts tell of the erection of plush residential buildings on the 17th-century rampart wall of Old Delhi (India), and that caustic fumes from nearby factories are destroying the 919-year-old bell of Byodoin Temple in Japan. It will ring no longer but be placed in indoor storage.

Historic preservation becomes controversial when it conflicts with making money or the harsh realities of city management. Buildings ranging from cottages to the Pennsylvania Railroad Terminal in New York City have been smashed and trucked to the dump when the land they stood on became more valuable to someone or some corporation for another purpose. The public loses but can do little when the structures are privately owned. One newspaper editor has put the problem this way, "You can't park cars in a lovely old tree-shaded home or a historic old courthouse, but you seldom take groups of school children to see a parking lot."[1]

Sometimes the problem is the failure of the law to keep pace with modern times. A new destroyer of past remains is scuba diving. Peter Throckmorton reports that in 1969 there were only six competent marine archaeologists in the world, while at the same time there were more than four million skin divers. "In 20 years they have done more harm to archaeological sites in the sea than all the forces of nature together in three millennia."[2] Museums and historical societies must

1. *The Daily Idahonian* (Moscow, Idaho), May 27, 1966.
2. Peter Throckmorton, *Shipwrecks and Archaeology: The Unharvested Sea* (Boston: Atlantic-Little, Brown, 1969).

lead in the fight to preserve underwater antiquities and to have adequate state laws passed to protect the public heritage in public waters. James L. Quinn, Director of the Neville Public Museum in Green Bay, Wisconsin, himself an expert diver and diving teacher, was able to coordinate the efforts of many people in the recovery of a sunken schooner and its contents and in the creation of a new museum of Great Lakes maritime history.[3]

Why bother? Because history is important to us. Someone, I do not recall who, said, "Man consoles himself for what he is by what he was." Who is to say that a romantic look backward is not something most of us need? The Kansas Supreme Court said, "History is no longer a record of past events. It is an illuminating account of the expanding life of man in all its manifestations, revealing how each stage of civilization grows out of preceding stages, revealing how the past still lives in us and still dominates us, and enabling us to profit by what has gone on before. So considered, history is inspirational."[4] The study of our history and respect for it is generally believed to have real value for Americans today and for Americans yet to come.

Carl Sandburg said

. . . when a society or a civilization perishes, one condition may always be found. They forgot where they came from. They lost sight of what brought them along. The hard beginnings were forgotten and the struggles farther along. They became satisfied with themselves. Unity and common under-standing there had been, enough to overcome rot and dissolution, enough to break through their obstacles. But the mockers came. And the deniers were heard. And vision and hope faded. And the custom of greeting became "What's the use?" And men whose forefathers would go anywhere, holding nothing impossible in the genius of man, joined the mockers and the deniers. They lost sight of what brought them along.

North Americans have no monopoly on such sentiment. People of all ages in many countries are actively engaged in preserving the material evidence of their cultural heritage. In Ireland, the Irish Georgian Society was organized in 1958 to acquire and preserve for the public fine examples of old houses. Artisans receive training in plastercasting and other necessary skills. In 1969, representatives of 19

3. James L. Quinn, "Time Capsule at 19 Fathoms," *Museum News*, 48, No. 7 (March 1970), 14.

4. Elizabeth H. Coiner, ed., *Quotes* (Washington, D.C.: National Park Service, 1966).

European countries, concerned with their common European heritage that transcends national boundaries, resolved at a meeting in Brussels to work together for historic preservation on an international scale.

Historic Preservation Defined

Historic preservation is a well-rounded program of scientific study, protection, restoration, maintenance, and interpretation of sites, buildings, and objects significant in American history and culture."[5] "The purpose of any historic preservation—the one and only purpose—is to communicate the lessons of history, in order that the present and the future may learn from the past."[6] These two quotations describe the nature and purpose of historic preservation.

In its simplest terms, preservation is the rescue from demolition or decay of an old building and maintaining it in good condition for public educational or aesthetic reasons. In some instances, the old houses continue to serve as private homes. In others, the buildings are put to some practical use as museums, libraries, or as headquarters for historical societies or public service agencies. More than 2,000 historic houses in the United States and Canada are being preserved for public benefit as examples of our past culture. It is probable that half of the hundreds of millions of "museum visits" in these countries each year are made to historic buildings and sites. (A historic site may or may not have structures remaining on it. Its educational value may lie in its relationship to surrounding settlements and natural features, its topography, natural vegetation, and so on).

Probably the most difficult question that potential preservationists must face is the philosophical one of what to preserve and what not to preserve. A building is not of value only because it is old or associated with a famous person. The test is the same as for a museum object. Would a museum properly choose to collect it and preserve it if it were the size of a breadbox? Is it significant from the standpoint of either architecture or history? Is it a valuable art object, or will it assist in teaching about life in the past? These are the two main considerations for the society or museum involved in historic preservation; that is, art (chiefly architecture), and history (including the

5. Turpin Bannister, definition adopted by the National Trust for Historic Preservation.

6. Kenneth Chorley, "Historic-House Keeping: A Short Course" (seminar held at Cooperstown, N.Y., 1955).

social and cultural history, which is perhaps more akin to sociology and anthropology).

Notice that nothing is said about saving a house because George Washington slept in it, because it once belonged to a United States Senator, or because it happened to be donated to the county for preservation. For a building to be worthy of preservation it must be capable of being shown to the public—interpreted—as an example of something important. It might be a typical example of a Middle Western farm house of the 1880's; a lower-class cottage on the wrong side of the tracks in the 1920's; a house designed by Frank Lloyd Wright; the home for many years of a person influential in public affairs, complete with the furnishings of those years; a place of business or a school; the list of possibilities is endless. One thing is essential, however. The historic preservation must not simply *be* something; it must be *for* something. Interpretation must be the intermediate aim, and education (or aesthetics) the ultimate.

This brings us to practical considerations. The preservation project must have educational value (not simply private, sentimental, entertainment, or hobby value), and the total cost must be within the capability of the sponsoring agency. There must be no vagueness or uncertainty about the administrative responsibility for the project from the beginning, during acquisition and restoration, and, especially, in perpetuity. (Historic houses, like museums, theoretically have perpetual life, once established.) The location of the project is important. Is it secure and accessible? Can it serve the majority of the public where it is? Will it have to be rescued again and again as the city grows and changes? Finally, there is the matter of authenticity and significance. Is the building an honest representation of what it will be said to be? If it has suffered changes over the years, can these be undone?

Kenneth Chorley lists four principles of historic preservation:

1. To be valid, a historic preservation must center upon a building, object, site, or environment of *substantial* historical or cultural importance. (Not everything is worth saving. Not every town has a building worth saving. Your whole county or part of the state may not have a structure worth saving.)
2. The life blood of historic preservation is research. A great amount of study is necessary to a good job of preservation and interpretation. Workers must become thoroughly familiar with a particular slice of past material culture. This information is not easy to come by. Some details may have been

irretrievably lost. What kind of wallpaper, draperies, rugs, and furniture were used in a certain room at a certain date? Who can answer such a question without research, even for his own childhood home after 25 or 50 years?

3. A historic preservation project, like any other museum, must be clear in its purpose, its possibilities and its limitations.

4. The value of any historic preservation project is determined by the quality of its presentation and interpretation. The greatest collection has no real value unless it can lead to the enrichment of human lives. A perfectly preserved building accomplishes nothing until it is presented and interpreted to the public so that it benefits visitors. Just as museum professionals should have a hand in the planning of museums and museum buildings, interpreters should have a part in the basic planning of a preservation project.

Two excellent examples of historic preservation have been documented in motion pictures. The Corbit-Sharp House in Odessa, Delaware, opened to the public in 1959, is a property of the Henry Francis duPont Winterthur Museum and obviously meets the high standards set by the parent institution. With research and care, one of the finest examples of Late Georgian domestic architecture has been restored to its eighteenth-century appearance.

A discussion of historic preservation could not be complete without adequate mention of the world's greatest example, Colonial Williamsburg, Incorporated. As almost everyone knows, Williamsburg, the colonial capital of Virginia, became the object of interest of John D. Rockefeller, Jr. Since 1926, he and his family have provided about $80 million for the restoration, reconstruction, and refurnishing of more than 500 buildings constituting the heart of the colonial city. The 1970 annual report of the Colonial Williamsburg Foundation reported assets of just under $58 million. The operation continues to expand, accommodating vast numbers of tourists annually. While they undoubtedly enjoy their visits, there is no question that Williamsburg is a serious open-air museum based on sound and meticulous research.

The cover of the leaflet listing the filmstrips made and sold by Colonial Williamsburg bears this statement:

With all of the problems confronting our American way of life, both domestically and abroad, there is no time like the present to reflect upon our political and cultural heritage. This is the very same heritage that gives spiritual strength and understanding to Americans and free people every-

where. Far too often we take our basic freedoms for granted. What thought, if any, is given to the men and ideas of the 18th century? These were the important ideas about human liberty, self-government and the rights of man. Little do we realize how much our planter statesman risked giving up in order to unify the colonies and establish a democratic form of government.

These same feelings of patriotism can be conveyed to students and adult organizations by viewing Colonial Williamsburg filmstrips. Like the entire Williamsburg project, they have been widely heralded for their inspirational and educational value by dramatizing living history in the 18th century surroundings.

But compare this official view of Williamsburg with what others say about it. David Lowenthal, in *Forum*, the Columbia University magazine, said:

> There was a day when antiquity was mistrusted because the national mind cherished the newness of the country and was fixed on the future. Even today, obsolescence is planned and the latest edifices vanish unmourned overnight; but more recently, Americans have cultivated a sense of history in the form of narcissistic nostalgia. We protect dinosaur tracks, we put up markers to commemorate the deeds of Billy the Kid, we restore and rebuild Colonial towns. Too often, however, we idealize, museumize, and sanitize the past. Eighteenth century odors in Williamsburg would be such a shock to twentieth century noses that every other impression might be blotted out. But history that is homogenized, cleaned up, and expurgated usually ends as an *entirely artificial recreation of an imaginary past*. Such treatment tends toward a highly selective display of events—selective as to epochs, contents, events, and personalities. History's flow is interrupted, time's continuities are lost to sight. *Historyland remains detached, remote, and essentially lifeless*. (Emphasis added.)

Another example shows that this concern over the accuracy of historic representation by museums is not unique. S. Dillon Ripley, secretary of the Smithsonian Institution, said in his report on the institution's activities for 1968:

> It has become apparent that even such a wonderful museum as our own Museum of History and Technology might fall into the preservation trap. Even a curator trained as a research historian can become infected with a special virus that makes him prey to this trap. When objects are preserved they become shiny and new looking. They also become nice. Some might say all gussied up. Everything becomes pretty and nice, and history itself becomes a storybook experience. In this country, everyone in history was romantic and dashing and lived in a genteel manner. A famous example of this

perversion was the burning by a zealous librarian years ago of some of George Washington's off-color letters. Many exhibits pander to this myth that all our ancestors were upper-middle-class Protestant whites who lived like ladies and gentlemen. The preservation trap is beautifully illustrated in the average historical restoration projects around the country. From the restoration of colonial cities on to the historic house with formal garden, there is an unfailing tendency for the facts to be tidied up, and everything to be restored to such a degree that reality and truth long since have flown out the window. Public taste accepts this for the most part and seems to appreciate the myth—witness the enormous popularity of towns and old houses or the awed visits to (preferably Eighteenth Century) restoration projects.

That the Smithsonian takes seriously the avoidance of "the preservation trap" is shown by their plan to recreate a slum apartment as an exhibit of American life. Charles Blitzer, director of education and training at the Smithsonian, says, "It's the nasty side of life that we're in danger of losing today." He feared that the nation's upper- and middle-class museum visitors may be losing touch with the seamier side of life. Plans were to keep the exhibit area hot in the summer, cold in the winter, provide it with unpleasant smells and even a resident rat or two. Blitzer said that history museums have a scholarly responsibility to attempt to show the reality of life. "The display of the best of the past characterizes our museums," he said, "but the best of the past is not the way it really was."[7]

Assistance

In recent years the federal government has passed laws that give valuable assistance. Specifically, they do such things as provide financial grants to states to make surveys and plans, expand the National Register of Historic Places (which gives a measure of protection—at least federal money cannot be spent to destroy a building on the National Register), provide matching funds for preservation projects, make the preservation of historic sites national policy (in connection with highway construction, for example), and request the Secretary of Commerce to use "maximum effort to preserve Federal, State, and local government parklands and historic sites and the beauty and historic value of such lands and sites."[8] Some states also

7. "The Smithsonian: More Museums in Slums, More Slums in Museums?" *Science*, 154, No. 3753 (2 December 1966), 1152–53.
8. Public Law 89–574, as quoted in *History News*, 21, No. 12, 238.

have antiquities legislation which protects state property and historic sites and structures designated as state monuments. State-level financial assistance is sometimes available. Organizations with preservation projects should consult their state historical societies as well as the National Trust For Historic Preservation, AAM, and AASLH. Several of the publications listed in the bibliography offer practical advice regarding planning for and organizing a preservation project. Before any local group attempts a historic preservation project they should consult the literature and seek professional advice.

Valuable Considerations Related to Historic Preservation

The following checklist may prove valuable in ascertaining whether a preservation project is worthy of the expenditure of time, effort, and money required for success:

Historic Considerations: Is the structure associated with the life or activities of a major historic person (more than the "slept here" type of association)? Is it associated with a major group of organizations in the history of the nation, state, or community (including significant ethnic groups)? Is it associated with a major historic event (cultural, economic, military, social, or political)? Is the building associated with a major recurring event in the history of the community (such as an annual celebration)? Is it associated with a past or continuing institution which has contributed substantially to the life of the city?

Architectural Considerations: Is the structure one of few of its age remaining in the city? Is it a unique local example of a particular architectural style or period? Is it one of few remaining local examples of a particular architectural style or period? Is it one of many good examples in the city of a particular architectural style or period? Is the building the work of a nationally famous architect? Is it a notable work of a major local architect or master builder? Is it an architectural curiosity or a picturesque work of particular artistic merit? Does it reveal original materials and/or workmanship that can be valued in themselves? Has the integrity of the original design been retained, or has it been altered?

Setting Considerations: Is the structure generally visible to the public? Is it, or could it be, an important element in the character of the city? Is it, or could it be, an important element in the character of the neighborhood (either alone or in conjunction with similar structures in the vicinity)? Does it contribute to the architectural continuity of the street? Is the building on its original site? Is its present setting (yards, trees, fences, walls, paving treatment, outbuildings, and so forth) appropriate? Are the structure and site subject to the encroachment of detrimental influences?

Use Considerations: Is the building threatened with demolition by public or private action? Can it be retained in its original or its present use? Does it have sufficient educational value to warrant consideration of museum use? Is it adaptable to productive reuse? Are the building and site accessible, served by utilities, capable of providing parking space, covered by fire and police protection, and so forth, so that they can feasibly be adapted to contemporary use? Can the structure be adapted to a new use without harm to those architectural elements which contribute to its significance?

Cost Considerations: Is preservation or restoration economically feasible? Is continued maintenance after restoration economically feasible?[9]

The following definitions will suggest different degrees of historical accuracy in representations of structures of the past. A danger lies in the inability of the tourist or visitor always to be able to distinguish between the tawdry or cliche-ridden simulations in commercial ventures, at one extreme, and the painstakingly researched replicas prepared by museums and related organizations and agencies at the other.

Preservation is the keeping of something that exists and the safeguarding of it from any further changes than those which it has already undergone.

Restoration is returning an existing building to its original appearance and condition by removing later additions, replacing missing parts, cleaning, painting, and the like.

Reconstruction is constructing again—building something new as a representation of that which has gone. Buildings are sometimes erected on the original stone foundations of the previous buildings they are representing. "To rebuild" is a synonym for "to reconstruct," but it may also be used in the case of a house being moved from its original site to a new location as at an open-air museum. If the house has had to be largely or entirely disassembled in order to move it, it is then rebuilt on its new site. In this case, though rebuilt, the house is original in the sense that all or most of its components are original. The *original* is the first or initial example from which copies are made. A *replica or copy* is a precise duplicate or close reproduction of the original. An *imitation* is something that follows the style or pattern of the original but is not a close copy. A *simulation* is something that assumes the appearance of the original falsely by imitating its identifying characteristics, usually superficial, and stereotyped like a stage set. To *refurbish* is to clean up and make fresh looking. To *refurnish* is to furnish again, usually with the connotation of duplicating the original furnishings as closely as possible. *Historic* is being, itself, a piece of history—having historic value in its own right. *Historical* is

9. Ralph W. Miner, *Conservation of Historic and Cultural Resources* (Chicago: American Society of Planning Officials, 1969). Reprinted by permission.

being about or related to history. (Thus, Lincoln's rocking chair is historic. A pamphlet describing the chair is historical.)

A cardinal rule is that it is better to *preserve* than to restore; better to *restore* than to reconstruct; better to *reconstruct* than to do nothing.

EXERCISES—CHAPTER 18

The main difference between historic preservation and other kinds of museum work is that of scale. If a historic house were small, it could be added to a museum's collections and stored or exhibited in the museum's building along with other objects. Buildings that are significant within the scope of the museum or historical society should be collected, preserved, and interpreted for public education. As a museum worker, a member of a historical society, or even as a private citizen not belonging to such an organization, you could at any time be asked to jump on the bandwagon as someone or some clique seeks popular support for the idea of preserving a particular old building. People who prefer to act emotionally do not welcome cool heads expressing logic. It is logic, however, that gets the good job done well, and that is what concerns us; that, and the combating of public folly.

1. Discuss the relationship of a preserved building to its contents or use. (Include compatibility of style, public safety, proper use of the building, etc.)
2. Discuss the preservation of buildings by age (modern, Victorian, Colonial, etc.) and by use (store, barn, house, courthouse, etc.) Include your judgment as to relative worth, difficulty of getting public support, and any other aspect that occurs to you. The object here is to get you to think of the entire range of historic preservation and to single out those kinds which you would judge to be of most value, at least in your community.
3. Discuss the issue raised in the examples concerning Williamsburg, pro and con, and the creating of slums and hovels as museum exhibits. Distinguish between an art approach and a history approach.
4. What kinds of historic preservation projects would be appropriate to different kinds of museums? (Imagine yourself in a museum of a certain kind. What type of historic preservation might you be interested in?) Try for at least five different examples.
5. Describe a current preservation project in your own community and evaluate it according to the criteria given in the readings. News clippings may help you but you should also interview the people in charge. What is its stated purpose? What is its *actual* purpose, if different? What are its limitations, its good and bad characteristics, its problems, its prospects?

If there is no actual project in your region with which you can become familiar, you may choose the following alternate assignment: Select a likely candidate for historic preservation among the old buildings of your community. Become sufficiently familiar with it so that you can outline procedures for acquiring, restoring, supporting, and interpreting it to good purpose. Your outline should be realistic enough so that it could be used as a guide by a local art museum or historical society.

19
Philosophy and Public Image

In the United States we place great emphasis on public education. Bazin says that this pedagogical habit which we inherited from England has "metamorphosed into a veritable obsession".[1] Our insistence that our museums educate the public may be our special version of applied museography; that is, the use of museum techniques to achieve specific ends. The propaganda value of museums has been well recognized. Governments today in "underdeveloped" countries have found museum exhibit techniques useful in promoting desired behavior. Illiterate populations can learn the rudiments of sanitation, improved agricultural methods, or perhaps be influenced to support the regime in power. The Communist countries of eastern Europe have sought to demonstrate the importance of the peasant and the urban worker in folk museums and in museums of agriculture and industry. The Soviet government founded 542 museums between 1921 and 1936 to reteach history according to Marxist doctrine. Germany created over two thousand regional museums (Heimatmuseen) between the two World Wars. Their purpose was to restore national pride. The folk museums of Scandinavia (and elsewhere) were created and are still operated, more or less, out of a sense of nationalism.

Political boundaries sometimes seem to supersede cultural boundaries in the interpretation of the collections. For example, the Saxon longhouse of ancient origin, which is still characteristic of the farms of northern Germany, is shown in the open-air folk museums of the Netherlands and Denmark as though it were unique to those countries. Labels and guidebooks do not refer to the use of this house type throughout the area of northern Europe settled by the Saxons. The

1. Germain Bazin, *The Museum Age* (New York: Universe Books, 1967), 267.

International Council of Museums has cautioned against the exploitation of museums for nationalistic purposes and recommends instead emphasis on cultural similarities across political boundaries.

The presentation of an official point of view is more likely where museums are owned and managed by the central government than in the United States, where most museums are locally created and controlled.[2] Our museums may at times suffer from a lack of professionalism, but, on the other hand, they are not stereotyped and propagandistic. The American Association of Museums plays a salient role, through accreditation and through its various informational services, in helping American museums to be efficient though democratic.

Two simple equations may sum up the essentially educational and aesthetic purpose of museums in the United States and Canada:

$$objects + care + use = worth\ of\ museum$$
$$and$$
$$\frac{results\ (education,\ inspiration,\ etc.)}{expenditure\ (time,\ energy,\ money,\ opportunities)} = efficiency\ of\ the\ museum$$

In other words, actual achievement compared with potential achievement indicates how well the museum serves the public within its limitations. A simple listing of services or accomplishments is not enough. Judgment as to what *might* have been done is also necessary.

The characteristics of Western culture—devotion to the ideal of universal education; emphasis on accumulation and dissemination of information; awareness of the importance of reinterpreting history; and public appreciation of art—have led to the concentration of the world's museums in the countries of the Western World. They have created the museums of today and made it an expression of our culture. Museums are not universal, though collecting and exhibiting may well be. A museum is a manifestation of a particular cultural situation.

Dichotomies, or opposing points of view, can help us to understand museums. The changing attitude of museums from aloofness and exclusiveness to a quest for democratic popularity illustrates the dichotomy between the museum for the elite and the museum for the masses. A second dichotomy exists between the amateur viewpoint of

2. Although not all our local museums are free of bias or propaganda intent.

the museum as a place to assemble curiosities, relics, and memorabilia for entertainment purposes and the professional viewpoint of the museum as a repository for significant objects, systematically cared for and used for the purposes of education and aesthetics. The art museum philosophy makes aesthetics the criterion—the objects are use for enjoyment—while other museums make education the criterion—the objects are used as significant specimens of the real world. Art presents another dichotomy; representation for the sake of representation versus art for the sake of art (popular art versus fine art, for example).

In the last century, when the modern museum was becoming an important element in American life, museum professionals became very enthusiastic about the educational potential of the museum. Even art museums shared in this enthusiasm as their directors and supporters maintained publicly that the art museum's function included original research and public education as well as acquisition and preservation. Not all art curators today would agree. A reaction against intellectualism as antithetical to the aesthetic experience has occurred. Intellectualism is of the mind; logical, dispassionate, and impersonal. The aesthetic experience is of the "heart"; emotional, sensory, individual, and not adaptable to scientific description. Some persons criticize art museums for not interpreting more, so that the visitor can gain greater understanding, but art curators generally feel this to be outside their proper function. Some would say that stimulation of the reasoning faculties of the brain might diminish the aesthetic experience. Both sides of the argument have devotees, but it will probably remain undecided.

We must nevertheless be aware that art enjoys a position of prestige today. A successful artist is a respected figure, and people of wealth and social standing attach themselves to art museums with a passion. This vogue permeates such a wide segment of society that it even influences other kinds of museums. Museums of science hold art shows and install their ethnological collections in Halls of (African, Oceanic, Indian, etc.) Art. The staff, collections, and expeditions of a prominent university museum in the East are concerned mainly with anthropology and history, yet the exhibits and other activities are those of an art museum. The Museum of the American Indian in New York City celebrated its golden anniversary in 1966. The news release announcing the celebration used such language as: "archaeological and ethnological treasures . . . to preserve the heritage of the aboriginal inhabitants . . . include . . . remarkable examples . . . crafts

expressions . . . finest examples of their type . . . emphasis is placed on esthetic and historic quality . . . balanced cross section of the Indian and his cultural accomplishments . . . Esthetically, the Museum's collection of pre-Columbian objets d'art is outstanding, particularly in terms of its wide coverage of areas and periods of art expression." Yet one would expect this museum to concern itself with the *science* of man, anthropology. My quarrel is not with art curators. They have a right to call attention to the aesthetic qualities of any kind of material—electron microscopes, for that matter. But I am disappointed with curators of history and curators of science who shirk their educational responsibilities and choose the easy, nonintellectual route to the utilization of collections. A curator who wishes to exhibit an American Indian basket can go to a great deal of trouble to explain its function within its particular culture, the techniques used to manufacture it, the instance of culture change which it might exemplify, its stylistic relationships with other cultures, and the like. Or he can put it on a pedestal, shine a spotlight on it, call it "Indian Art," and be finished. I suggest that many "art" exhibits in nonart museums are the result of laziness and faulty museology.

A slovenly attitude toward the distinction between art and ethnology—and especially between art and history—leads to confusion in museums concerning what to collect and how to exhibit the collections. An avowed art museum is not likely to be criticized for not teaching history. On the other hand, the thinking visitor may well be irritated by an art museum approach in a history museum. If museum directors and curators are careless about the distinctions, how can we expect the public to get full benefit from their work? The burden lies on the professional who works in the nonart museum.

Public Image

What is the public image of the museum today? Culture works by stereotypes and prejudgments. We make snap judgments hundreds of times each day, and we have attached bodies of meaning to triggering stimuli. Even such simple things as colors carry meaning. Pink is fine for a baby's dress, but what about the mayor's limousine? Samples of cartoons and articles from newspapers and magazines suggest that the public has such a stereotyped image of the museum. It is regarded as peacefully sleeping—a repository for curiosities of the past—mummies, dinosaurs, suits of armor, and mementos of famous people of yesterday. At the same time, the museum is treated with

reverence: some activities that are acceptable elsewhere seem inappropriate in a museum. During Lyndon Johnson's administration an opera ball held in the Smithsonian's Museum of History and Technology to raise money for the John F. Kennedy Center for the Performing Arts shocked some members of Congress. No doubt the idea of drinking and dancing until three in the morning in a museum seemed inappropriate.

The museum's public image cannot be separated from its external appearance. Is it housed in a large stone building with Roman columns on the facade? Is it in a converted automobile garage built of concrete block? Intangibles also create image—grounds, newspaper publicity, school children's impressions, staff activities—all work together to create public opinions about your museum, perhaps even from persons who have no firsthand experience there.

The media also add to the public idea of the museum. A survey made in the early sixties examined the treatment of museums and museum workers in the mass media: motion pictures, theater, television, fiction, newspapers, and cartoons and jokes. It was found that the media presented the museum as hospitable and friendly, but museum workers as "rather stupid but hard-working"; bland and bespectacled, prodding visitors through the museum; shy, neurotic, and unhappy. A scene from "The Lady from Shanghai" was selected to illustrate that "school children in groups, with rather unattractive teachers, are among the relatively few normal kinds of people ever shown in media representations of museums. Ordinary adults are very seldom shown going to museums, unless they are doing something curious or illegal or unusual."[3] Museums and museum personnel seldom figure in fiction, stage plays or jokes, and the museum's usual appearance in the mass media "is as a relatively strange place. Other than children, the nonmuseum personnel who figure in media museum contexts are likely to be marginal people: murderers, soldiers on leave, models, and others whose relationship to the museum is fortuitous. Thus a child who may have had a number of enriching experiences at museums and who may be very favorably disposed toward them, may then as an adult see museums presented in the mass media as bizarre places frequented by bizarre people."[4]

Amused tolerance is not the only public attitude toward the museum. Lately, open criticism has jolted museum people. In "Is the

3. Charles Winick, "The Public Image of the Museum in America," *Curator*, V, No. 1 (1962).
4. *Ibid.*

Museum a Museum Piece?" Alex Gross wrote, "The real question is whether museums are still necessary to us, at least in their present form. . . . Basically the art museum was (and remains) a place one visits to commune with what are supposed to be the truly meaningful values of life and society, as distinguished from the imperfect poverty-stricken, money-grubbing world outside its walls. The museum was (and is) a place to avoid life rather than to encounter it, a place to congratulate oneself on one's values rather than to doubt them and move on to something better."[5]

Barbara Gold's attack on the museums of Baltimore (mentioned in Chapter 8) and a number of other articles in the public press and even in museum periodicals have questioned whether museums today are doing enough to cure the ills of society. Museums, especially art museums, have been pictured as outmoded playthings of the "Establishment," and, consequently, elitist and racist. They are also sexist, according to the women's liberation movement, being one of the primary bastions of male chauvinism. "The art Establishment is bound by the patronage of the bourgeoisie; by their acquisitiveness and their insistence upon maintaining value judgments which salve their consciences. The art market is kept desirable and chic, since in the bourgeois world everything is viewed first as object, then as property—art, women, etc. Viewing objects as property, the aggressive male ego seeks satisfaction by controlling them. Woman is an object, art is an object, both must be controlled."[6]

Art galleries, art museums, and their patrons have been taken to task for treating lightly the social protest of artists. Even the most heart-rending depictions of human tragedy and injustice are ignored as they form the setting for gallery cocktail parties. Militant spokesmen for minority groups have attacked museums as exploiters of other cultures. American Indians are demanding more and more that artifacts made by their ancestors be returned to them. Many museums have removed their Indian burial exhibits. Museums have been asked to set up "black centers" in the Negro districts of cities. Blacks have said that the purpose of Negro art is to instill pride and identity in black people and demanded that Negro art collections (aboriginal African) have black curators. They have insisted, too, that the racial composition of the museum staff reflect the racial composition of the

5. *The East Village Other*, March 7, 1969.
6. Nancy Spero, "The Whitney and Women," *The Art Gallery Magazine*, (January 1971).

public it serves. Responses to the criticisms have been varied. Museum workers have been indignant; they have been hurt; they have been angry; they have been sympathetic. Upon reflection, the profession generally has agreed to listen and to examine its attitudes and its services. Though the attacks are often emotional, coming from long-frustrated segments of society, the museum response has been, and must continue to be, reasonable. Former AAM President and Director of the Baltimore Museum of Art Charles Parkhurst responded to Gold thus: "I don't feel it's the primary role of the museum to run a school. We have thrust on us a sociological role. We must be careful not to get carried away. Our primary role is collection, conservation, and use. . . . it is important that we play [our role]—to provide pleasure or delectation to anyone who can utilize it. If a museum can afford . . . to go into educational roles in ghetto . . . areas—great. We do not have the resources."

Museums, of course, are not alone; colleges and universities have been attacked on the same grounds. Their spokesmen have responded that institutions of higher learning do not have the funds or the political power to cure social ills. They would accept only a limited role in providing public service to their communities. Theodore D. Lockwood, President of Trinity College in Hartford, Connecticut, said:

[A] development threatening the spirit of free inquiry has been the fervid concern for contemporaneity (or relevance-mongering, as some have called it). Many students and faculty have been justifiably concerned with urgent contemporary issues. Unhappily, this concern has often led to an intense preoccupation with resolving these issues on the campuses. To do otherwise was to be branded irrelevant—a fate worse than death and taxes. In extreme cases there have been insistent demands that colleges become political instruments, dedicated almost exclusively to the eradication of social and economic abuses. No college which cares about its academic integrity can permit this to happen . . . What is needed is to . . . rediscover and reinforce our belief in free and rational inquiry—a belief badly shaken by involvement in emotionally charged issues on and off the campus. Trinity must not become the creature of any ideology or philosophical system; it must retain its academic obligation to search for the truth in a free and open environment, independent of but not insensitive to transient concerns.[7]

Perhaps the true method of determining whether criticisms are justified, however, is to evaluate the effectiveness of the institution. If

7. "The President's Annual Report, 1970–71."

the justification for the art museum is the tenet that important institutions set standards of excellence for society, then we can ask whether the museum is fostering an appreciation for the truly beautiful. In Chapter 8 I noted that "literacy in art" does not rub off on art museum employees. Do we have any better luck with the public at large? Art critics generally say no. They point out that in spite of a great amount of aesthetic education in the schools and a great number of art museums we are still surrounded by ugliness and tastelessness. Our public buildings, our cities, our sprawling commercial developments show no respect for good design, no feeling for form, no sensitivity for cultivated aesthetic values. They would recognize exceptions, of course, but their consensus is that art education and exposure to art result in only an abstract erudition, and that any effect on daily life does not reach the masses of society.

Perhaps the old standards no longer hold, or perhaps they never did apply to our whole society. Certainly, the values of integrity and excellence on which the museum movement is founded appear to be eroding. Colleges and universities are aware of the nationwide inflation of grades, and the awarding of grades may be abolished soon. Our culture is said to be more and more permissive, and authority and laws are not as respected as they once were. Fewer wrongdoers are brought to trial, and fewer are punished. Candidates for high office advocate the abolition of penalties for draft-dodging, and there is growing sentiment for doing away with the dishonorable discharge from military service. Bottled, commercial wine now comes mixed with "the intriguing flavors of tangy pineapple, rich guava, tart lemon, sunny orange and exotic passion fruit." The wrapper on a package of cigars bears this message, "These cigars are predominantly natural tobacco with a substantial amount of non-tobacco ingredients." Matthew Arnold wrote that we can learn two things from history (and therefore, we would add, two things that the history museum has to teach), "one, that we are not superior to our fathers; another that we are shamefully and monstrously inferior to them if we do not advance beyond them." Do we still believe that?

Museologists must ask themselves if the old assumptions regarding the role of the museum in our culture hold true today, or whether it is a whole new ball game. Supreme Court Justice Lewis F. Powell, Jr., speaking to the American Bar Association in August 1972, condemned what he called "the New Ethic," saying that it has become fashionable to question and attack the most basic elements of our society ". . . our

institutions and inherited values are no longer respected" by large segments of the population.

While being concerned about the museum's public image we must keep a proper set of values. Museologists from many countries have reiterated in meetings and in their writings the same sentiments expressed by Mr. Parkhurst and the representatives of colleges and universities. If a museum has qualified staff, can spare their time and provide them with funds, then it may with caution take on a social mission. However, above all it must not lose sight of its essential role as a preserver of objects and a conductor of research.

At the very least we must seek to understand our culture and the directions of its changes; to serve society we must know it. More than that, we must be aware of what society understands about museums. Communication is not soliloquy. We have to be sure we are getting through.

Censorship

A sometimes embarrassing point of contact between the museum and society is censorship. It is conceivable that science and history museums in some communities may receive criticism on religious or political grounds, but legal censorship today is mainly concerned with pornography in art, as far as mueums are concerned. A few years ago censorship had more support from law enforcement than it does today. During the summer of 1966 both houses of the New York state legislature passed a statute, sensibly vetoed by Governor Rockefeller, that would have made it an offense for any shopkeeper to permit anyone under 16 (unless accompanied by a parent or guardian) to enter a premise where objectionable literature could be purchased or nude exhibits were displayed. The statute could have been construed as a ban on many literary classics and would have placed most of the art museum directors of the state in jail.

A few years ago the harassment of art galleries on the West Coast was such that the Western Association of Art Museums issued a policy statement: "The Western Association of Art Museums strongly believes that any interference with the professional selection of works of art for exhibition is censorship. The Association is unalterably opposed to official or private invasions into institutional prerogatives or into the professional judgment of duly appointed gallery directors or curators. The Association defends the public's right to know and the

selector's right to a free and unfrightened aesthetic and scholarly approach and selection." They went on to make several points including: Works of art hardly fall into the province of laws against urging to violence and inciting to riot; the act of an art director who exhibits a controversial piece in spite of some community opposition would probably be legally defensible; the state must adopt contemporary, as opposed to provincial, standards to determine obscenity; the director should emphasize the right of all the public to see and to know, regardless of the opposition of some individuals or segments of society.

In general, nudity is no longer prohibited if some purpose other than pornography can be shown. Thus, if artists today are painting nakedness, the contemporary art curator has an obligation to exhibit these paintings and the general public has the right to come to see them. Obviously, some communities warrant a more conservative position than others. The museum must not harm itself seriously in order to strike a blow for freedom of expression. Good public relations, of course, are essential to the museum, and its staff will be concerned about its image in the public mind.

As a society changes, its culture must change to satisfy different needs. Those who would strike a new balance call on our social and cultural institutions to rise to the challenge of the times. The museum must evolve in its role and thereby continue to serve society. To maintain its integrity, however, it must not waver from its main purpose. No other institution will preserve significant objects of the past. If this should cease to be the main concern of the museum, the museum will no longer exist; it will have become something else.

EXERCISES—CHAPTER 19

Throughout the book we have touched on the subject of this chapter from time to time. How the museum appears to the public is crucial to its success. Everything the museum does will result from its philosophy; or, to be more precise, the behavior of a museum's staff will be determined by their philosophical understandings. Each will have a concept of why the museum exists, what it should collect, what it should exhibit, and so on. If the concepts of the several staff members are not in accord, confusion and dissension are inevitable.

The following article by Polly Long is a good example of a plausible proposition which hinges on matters of museological understanding and

philosophy. Your assignment is to get inside Polly Long's mind to understand what she knows or thinks she knows about museums, and react to it. You may agree or disagree with her point of view, but be aware of her definitions and her museum philosophy.

Why Don't Societies Sell All Their "Junk?"

I have been behind the scenes in many museums and historical societies. Most of these institutions are a sort of cultural iceberg: A great deal of what they have, quantity-wise, is below the surface.

In many instances, for every *quality piece* of art or furniture on view to the public there are 5 to 10 times that number stored in basement rooms or other hidden-away areas.

Recently while walking through the basement of a New England museum to view a certain piece in which I was interested, I passed rack upon rack of American primitive painting—portraits, landscapes and genre—as well as shelf upon shelf of glass and many odd pieces of furniture.

Even if these pieces are catalogued—and in many museums they are on hand for years before any official note is taken of them—they will never be seen except by a few who have access to these treasure rooms.

Museums and historical societies serve the public well as preservers as well as exhibitors. And more often than not, the directors and curators of these institutions have to work against great odds, such as too-small salaries for themselves and their staff, and a general attitude of indifference among the people who control policy and money—the private citizens who are members of the board of directors.

However, it is my feeling that too many well-meaning people wish onto museums pieces that these institutions don't really want.

Particularly with the historical societies and museums in the smaller cities, it is a general practice that rather than hurt the feelings of a well-meaning benefactor who may at a later date be in a position to do much more for the institution, to accept the gifts.

The director, who is expected to maintain—and improve *excellence of the institution*, keeps these gifts in storage.

The tragedy of this policy is that while these objects may be *unworthy of museum display*, they often are highly desirable for individual ownership.

Would it not be appropriate for museums and historical societies to take inventory, at least every 10 years; select those pieces which are *below standard*, and put them up for sale at a public auction? The proceeds from such a sale could be used to buy *top-quality art objects* which could be viewed and appreciated by all.

Can you think of a more pleasant summer afternoon than one spent at an auction on the lawn of any one of the New England historical societies?[8]

8. From a newspaper column in the *Baltimore Sun*. Reprinted by permission. Italics added.

1. Write a reply to "Why Don't Societies Sell All Their 'Junk'?" It may take the form of a letter to the editor, a letter to Polly Long, a column similar to hers, or a short essay. But cover all issues she raises, especially the most vital one of what museums of various kinds should be doing.
2. In Polly Long's article there are 5 italicized phrases. What, specifically, does she mean by these terms? What is your reaction to her meaning in view of her speaking of "museums and historical societies"? Does she make a distinction between art museums and history museums?
3. Write a short essay on the subject of the museum of tomorrow. Include the philosophical questions of the museum's role in society and to what extent, if at all, the good museum of the present needs to change to be the good museum of the future.

20

Practical Matters

After all the general remarks have been made, it is time for specific questions regarding immediate problems faced by individuals and their museums. Unfortunately, a brief book of this kind cannot give all the answers, even if all the questions could be anticipated. Solving these problems is the art of museum work, and there is no magic wand that will create a good museum worker in a short time. However, it is the purpose of this book, and of other basic writings in museology, to help to prepare the individual to make wise choices when confronted with alternatives. Several guides or rules-of-thumb should be of help:

1. The amount of floor space devoted to exhibits should probably be no more than one-third of the total floor space of the building.
2. In the daily operation of the museum, the most important consideration is security; the second is cleanliness.
3. The whole purpose of the museum and all its activities is public education. Any expenditure of time, money, or opportunities must ultimately be justifiable as contributing significantly to this end.
4. The properly run museum operation is one whose values and priorities are in keeping with the order of Guthe's "obligations:" a) collections; b) records; c) exhibits; d) activities.
5. Objects in the museum's collections must be significant. That is, they must be useful in teaching facts and illustrating concepts or artistic achievement which are not only within the museum's scope but are worthy of the museum's attention. Relics, curiosities, personal memorabilia, glorification of specific individuals or specific families—as well as unique,

one-of-a-kind objects of no great aesthetic or educational value—do not belong in a public museum.

Another rule might be suggested to the amateur in the small museum—seek professional help. Read and abide by the literature of museology, and call on professionals in larger museums for advice. This is obvious but not automatic. Anti-intellectualism, or at least, non-intellectualism, is a strong force in American culture. It is not limited to the undereducated but extends high up the educational scale. Museum work is still not commonly respected as a profession by the general public; and the need for trained museum workers and professional procedures is not recognized, by and large, even by those leading citizens who are instrumental in founding and operating museums. It is interesting, I think, that only one sixth of the museums and professional museum workers of the United States are members of the American Association of Museums. A few years ago, prominent and active citizens of a medium-sized city established a museum which they expected to have national importance (the word "national" is in its name). In the same city a good museum with several qualified professionals on its staff already existed. These museologists were not invited to give advice during the planning or any other stage of the development and were turned down when they asked to participate. A recent news story from another city tells that those concerned with the establishment of a new museum sought design help from students of a school of architecture, not from museologists. In yet another location a museum director was trying to assist a local group in establishing a noncompeting museum dealing with a different field, but they secretly changed the time of the supposedly public meeting and organized without him.

This attitude is common. Many laymen who are deriving personal satisfaction from the museum's pursuit of their private concerns feel that placing the museum on a professional basis might spoil that satisfaction. The informed citizen could leave them to their hobby, except when their hobby purports to be a public museum operating in the public interest, and especially when it operates on public funds. The issue then is clear. Public funds and public facilities must be used only for the good of the public; and this good, when it comes to museums, requires professional management according to the principles of modern museology. The best of the small museums are founded and run by devoted, public spirited individuals who seek and accept professional guidance and who, themselves, increase their knowledge through all the means at their disposal.

Let me now address the student or young beginner in museum work who is interested in making a career for himself in the museum profession.

Prepare Yourself

Take college courses that will help to prepare you for museum work. Seek to become as broadly educated as possible. The best background for museum directors and curators is a good, broad, liberal arts education. You must be able to write, speak, use the library, and understand museum visitors psychologically and sociologically. Take art appreciation and anthropology. Take any courses in museology and museography that are available. Give serious consideration to public relations, journalism, radio-television, audio-visual arts, office practice, and library science. Courses as diverse as woodworking, social psychology, and outdoor recreation, are pertinent. Art history is indispensable for art museum work as is American history for work with historical societies and regional history museums. Courses in geology and biology are indispensable in many museums. Indeed, it would be difficult to think of college courses that could not be put to use in museum management. Even physics is useful to the curator who must understand such concepts as relative humidity in protecting his collections, and the curator of science can use the concepts of art appreciation in planning and installing exhibits. Many, if not most, museum workers find themselves in situations requiring broad interests and broad educational backgrounds. Especially in the small museum, the generalist rather than the specialist is most needed. This wide scope in museum work holds great appeal for large numbers of museum professionals. Others are attracted by the opportunity to specialize, but specialization (as in Oriental porcelain) is ordinarily possible only in large museums or in those with specialized collections. In addition to a broad education, of course, the student should take as many courses as possible in one or two of the traditional museum fields: art, American history, anthropology, elementary education, geology, biology.

In addition to regular college attendance, consider the special museum training courses (listed in the AAM's museum training directory). Some of these are held for a few weeks during the summer months; others are short workshops held at various times and in various parts of the country. For the worker in a local history museum, for example, attendance at one of the workshop meetings or seminars

of the American Association for State and Local History can be a very valuable experience. Of considerable worth are the internships offered by some museums.

Introductory theory courses can carry the beginner only so far. There is no substitute for apprenticeship under qualified professionals in a museum of high quality. Hugo G. Rodeck, Director Emeritus of the University of Colorado Museum, says that no program of museum training can be complete without actual work under supervision in an accredited museum. Work as a part-time volunteer if you cannot get a job immediately; get your foot in the door. Museums can always use the free help of seriously interested individuals. Museum professionals are always willing to help beginners.

My next bit of advice is to become involved in the museum profession. Read books, read the journals, belong to museum organizations, attend meetings, workshops, and seminars. Become acquainted with the people working in museums. The student or amateur is often able, at low cost, to attend a regional museum meeting; either an annual regional conference of the American Association of Museums or the meeting of a state or district association. The people attending will be of all ages, wide-ranging in interests, and universally friendly. Such meetings are excellent opportunities to become acquainted with prospective employers.

How to Get a Job

Museum workers have got their first museum jobs in a number of ways:

1. They have started as volunteers. Having proved themselves useful and likable, they began to receive part-time wages and then stepped into staff vacancies.
2. Through personal acquaintance with museum directors, they have been asked to fill vacancies or have been recommended to the directors' colleagues in other museums.
3. They have qualified in open, civil service examinations for governmental museum positions. Museum people work for national and state park, forest, and recreation departments.
4. They have applied to work at a museum of their choice without knowing that that museum had a vacancy.
5. They have answered advertisements of museum job openings.

Vacancies are listed in museum periodicals, especially newsletters. Some museums send out notices of vacancies to other museums and to college departments. Museum conventions have posted listings of job openings, and the larger conventions (such as the annual meeting of the AAM) have a person designated to receive and give out information from both prospective employers and prospective employees.

Probably the most important regular listing of positions open is in the monthly bulletins of the AAM. Individuals seeking positions may also insert their own advertisements, describing their qualifications and the kind of job they are seeking. A museum director may have a vacancy on his staff or know that he will have one soon. Before he announces the vacancy he may read the "jobs wanted" column in the bulletin. He sometimes finds the employee he wants before the fact that he is looking for someone becomes public knowledge.

Once you and the prospective employer have made contact, you must sell yourself. Usually, his job is the only one you know about that you want, but you are only one of several—perhaps many—that he can hire. In writing a letter of application, be brief and businesslike, but list all qualifications that may have importance to the job for which you are applying. No job can be described completely in the few lines of a short notice. Some of the skills the director or board of trustees is looking for may not be in the job description. You may even be able to convince the employer that you are the person to hire, on the basis of skills and education that he did not know he wanted. For example, the job listing may state requirements of an M.A. in history plus competence in some other field, museum training or experience, public-speaking ability, age under 40, and so on. There might be twenty applications for the job, all from individuals who meet the requirements. How is the employer to decide whom to hire? He will check references, he may compare schools and transcripts, he may be influenced by photographs if he has asked for them, but what will really help him to pull top contenders out of the pile are the additional things the applicants' letters contain. For instance, you may have told him in your letter that you are a good carpenter, a good photographer, and that you spent a summer visiting historic houses in New England. These qualifications may fit into his idea of what your job would entail, and he will, therefore, be especially interested in you. If you have a good voice and are not nervous when speaking on the telephone, a call may raise your stock if you have a plausible reason for

calling. On the other hand, if the prospective employer feels that your call was made to pressure him into making a faster decision, he might make one (unfavorable to you) on the spot.

Junior curatorial positions, unless filled by local persons, usually do not involve personal interviews, but most other professional jobs demand one. The top three or four candidates might be asked to visit the museum, meet the staff and the board, and be examined as a potential employee. The interview is a kind of last-minute insurance against a mistake. You can normally expect to have your expenses paid when you travel to be interviewed. If the employer has not specified this in his invitation, you may inquire about it, especially if the cost would be substantial. You may in some instances be willing to gamble. If you feel that you stand a good chance of getting the job but have to pay your own travel expenses in order to have a personal interview, arrange a meeting by telephone. The prospective employer will not let you spend your own money unless you really do have a good chance of getting the position.

In a personal, face-to-face interview you can get a better idea of what the job is, what the working conditions are, and sell yourself in direct relationship to the museum as you see it to be. You can also learn about the climate, the community, and the museum's neighborhood. If you are moving some distance away from home to make a new life for yourself, these things (and others) will be important to you. A good job is not enough. You will have a personal life outside the museum.

In the interview you can present more details of your past education and experience than you put into the letter of application and any forms you had to fill out. Be careful to make a good initial impression. Industrial psychologists have found that the first five minutes of an interview are crucial. If you meet with the board of trustees, remember that they are substantial citizens who are thinking of the museum as it relates to the community. They may be willing to take your word as to your ability to handle the technical details of the position, but they can see for themselves what kind of public representative of the museum you would be. Especially if you are to be the director of a museum that depends on public good will for its support (membership, clubs, volunteers, business gifts, for example), the board will be sure that you can put a simple English sentence together and do not eat your peas with your knife. They may even throw a cocktail party to see how you can handle your liquor. What-

ever the test, you must not allow yourself to be overwhelmed, but present yourself in the best possible light.

This advice does not suggest dishonesty, but rather that you show the prospective employer that in manner, appearance, temperament, philosophy, social poise, (and whatever), as well as in skills and education, you can comfortably fit within the acceptable range of variation for the position. Keep in mind, however, that you are not doing yourself or the museum a service if you allow yourself to be hired under false pretences. The real you is bound to surface sooner or later, and if you are really not what you are expected to be, unpleasantness and termination of your employment are sure to follow. The lack of a good recommendation may then be a handicap in getting another job.

The student or beginner should be willing to take a job that is not exactly what he wants for the rest of his life. Any job you can qualify for, that is not completely abhorrent to you, will give you valuable experience and get you started. While you watch and wait for something more to your liking, you will be learning, making contacts, and experiencing the stimulation of daily contact with other museum people with a regular paycheck coming in. As you learn more about museum work, you will be getting a clearer picture of where you would best fit in. Plan on changing jobs more than once before you "settle down." It commonly happens that a museum professional eventually prefers to work in quite a different kind of job from what he had in mind when he first started. Some museum people change jobs a half-dozen times or more during their careers, although some persons stay with the same museum during most or all of their careers, moving up as higher positions become vacant.

I shall not say anything about the normal requirements of an employer. The rules of work apply in museums as they do anywhere. I would point out, however, that museum work is more than a job, perhaps even more than a profession. The quickest way to raise doubts about yourself in the minds of your superiors is to treat your museum employment like a 9 to 5 office job. Lengthy coffee breaks, unexplained absences, gossiping with other members of the staff, and a lack of attention to necessary routine will show that you really belong in some other kind of organization. Museum work is a calling, a public ministry, a commitment to a better world through the enlightenment of the public. It is done through adherence to high standards in the service of truth and quality. If this sounds as though violins, or

perhaps even a pipe organ, should be playing in the background, association with museum professionals will bear me out.

Museum people feel that their work has great importance, and consequently it is deeply satisfying. They are often frustrated because they see the need to accomplish more than the limitations under which they work will permit. However, museum professionals are not bored with their work. Museum work can be extremely varied, and it can hardly fail to be stimulating and interesting to most people.

Since new museums are being created each week, since older museums are expanding, and since standards for employees are rising, we can expect an expanding job market for some time. Salaries are generally comparable with the public schools, or, for larger museums, with colleges. There is such a great range in salaries that nothing more can be said without saying a great deal. The interested person should see the AAM's latest *Museum Salary and Financial Survey*.

Getting a Museum Started

Perhaps you are in the position of organizing a new museum or putting one on a sound footing. If you have not yet formed your association, you should consult *Organizing a Local Historical Society* by Clement M. Silvestro. His remarks would apply to the organizing of art and science museums as well. You can also get help from state historical societies and well-established museums in your locality.

In general, you need a broad base of public support. Try to expand outward from the nucleus of the club or historical society which got the program started. A museum that continues to be identified primarily with a small group of people with a narrow, hobby interest will always be struggling for funds. A museum that is truly public in all respects can lay greater claim to adequate public financial support in the form of an annual appropriation from tax funds. Get the local newspapers, service clubs, and radio and television stations involved. And, above all, resolve to operate from the beginning according to sound museological principles. No loans. No two-headed calves. No bricks from the old school house or mementos of prominent families. Get professional assistance in whatever form you can, and hire a professional curator as soon as possible.

All of this applies not only to its beginnings, but to the museum as it continues to grow. A day will come when you will need to step back and evaluate what you are doing. You can use the precepts of this book and other basic writings. One of the simplest tests is to hold up the

definition of a museum (Chapter 1). How truly is your operation that of a good, modern museum?

Upgrading Your Museum

The most objective tool yet devised for evaluating museums is the testing for possible accreditation. A precise procedure exists for the examination of a museum which has applied to the American Association of Museums for accreditation, including a visit and on-the-spot detailed inspection by a team of qualified museologists. Accreditation by the AAM is certification by the museum profession that a museum "is carrying on its affairs with at least a minimum level of professional competence."[1] The museum is not graded on a scale of excellence, but if it fails in its bid to become accredited, it is because it is seriously deficient in at least one important aspect of its organization or its operation. The accreditation process is based on the definition of "museum," and here we have come full circle because that was the concern of the very beginning of this book. A museum examining itself, in contemplation of applying for accreditation, asks how well it measures up to the standard of being a permanent institution organized essentially for educational or aesthetic purposes, which has a professional staff, which owns and utilizes tangible objects, cares for them, and exhibits them to the public on a regular basis.

Accreditation improves the profession as a whole by establishing standards, and by focusing attention on all facets of a museum. Nothing is ignored. Accreditation benefits the general public by raising the quality of museums in general, and by pointing out with a kind of "seal of approval" those museums worthy of visitation and support. Accreditation benefits the individual museum by giving it a yardstick for self-evaluation and improvement, by promoting public confidence in it, by assuring other museums that it—being accredited—is trustworthy in the matter of loaned exhibits and objects, and by certifying to supporters and donors—including grant-awarding governmental agencies—that the particular museum is a worthy recipient of financial aid.

1. H. J. Swinney, ed., *Professional Standards for Museum Accreditation* (Washington, D.C.: American Association of Museums, 1978), p. 26. This publication is useful for self-analysis whether or not the museum is ready to apply for accreditation.

Accreditation applies only to museums; that is, not to the histori-
cal society of which the museum may be a part, or to the library,
archives, art school, or other peripheral activity of the museum. Sci-
ence centers, art centers, and visitor centers—not being museums
—are not accredited, nor are individuals, though the accreditation of
the museum depends on the presence of staff members of high profes-
sional qualifications.[2]

The key factor in the procedure is the visit by a team of
museologists, normally two in number and not from the immediate
locality. The museum that has appeared "on paper" to meet minimum
standards may under close scrutiny by outsiders reveal serious flaws.
The visiting committee uses a somewhat lengthy and detailed stand-
ard checklist to examine the museum's governing authority, board of
trustees, staff, membership, finances, physical facilities, collections,
conservation and preservation procedures, security, exhibits and ex-
hibitions, programs and educational activities, and its purposes,
plans, and probable future course. Museums wishing to be consid-
ered for accreditation should ask the AAM for its accreditation
brochure.

EXERCISES—CHAPTER 20

The point of this chapter is twofold: (1) to show that a great amount of trial
and error, "learning the hard way," and the practical experience of thousands of
people over the years has resulted in a system for evaluating the organization
and management of museums—a system against which museums can be
measured for a professional "seal of approval"; and (2) to show that a museum
worker must bring more than intelligence and good will to his job. The employee,
the operation, and the product are all evaluated for such things as efficiency,
high standards, effectiveness, and the like; any lesser performance is not worthy
of the name "museum." "Museum" is a word museum workers respect. If they
did not, they could hardly devote their lives to it, as they do.

2. That is, such institutions are not accredited as museums. They are, however,
accredited by the AAM as planetariums or as centers, according to what they intend to
be; and, while they are excused from owning collections, they are required to be
professionally managed and in the service of society.

1. Write a letter of application for a particular museum opening (either an actual vacancy, or one that you can imagine). If you are submitting this letter to an instructor for evaluation, give him a brief description of the job for which you are applying on a separate sheet of paper. You may invent details, if necessary, as you describe your qualifications for the job.

2. On the basis of your knowledge of good museum practice, evaluate a museum as though you were to award or withhold accreditation. Justify your criticisms and make recommendations for improvements. This should be as thorough as possible, depending, of course, on how well you can get to know the museum you are evaluating. If an intimate knowledge of one museum is impossible, evaluate several as well as you can.

21
The Law

Museums are products of society, and if they are in the mainstream of professional development, they actively serve society. Service involves not only responding to obvious demands, such as those for education, entertainment, and civic pride, but includes also deliberate involvement in the support of social values. In western countries, this takes the form of promoting stability and of advocacy in popular causes—combating drug abuse and environmental pollution, saving endangered species; but in more rigidly organized state systems, service to society includes molding philosophical and political viewpoints, such as those of Marx and Lenin.

Museums everywhere change as society changes, or they become obsolete. Museums must recognize and respond to changing societal and cultural characteristics. In the United States, a significant change in recent years has involved the law, and this change has impinged directly on the museum's board of trustees or other governing body. In most countries of the world, museums are supervised by branches of the national government, such as a ministry of culture; but in the United States and in other countries that have inherited English common law practices with respect to the establishment of charitable enterprises by private citizens, museums tend to be locally or privately controlled. The usual museum governing body is a committee of lay people who represent the public's interests and who are called a board of trustees.[1]

A museum's board of trustees has four main responsibilities: it

1. For a discussion of the organization, responsibility, and legal liabilities of museum boards of trustees, see Alan D. Ullberg with Patricia Ullberg, *Museum Trusteeship* (Washington, D.C.: American Association of Museums, 1981).

sets the scope of the museum and reviews that, as needed (see page 49); it hires the director and monitors his or her performance; it determines the character of the museum by setting museum policy, which the director implements; and it assures adequate and dependable funding for the museum's maintenance, operation, and growth. Properly, the board of trustees treats the museum director as a peer, not as a servant; it does not interact with the staff except through the director; and it does not become involved in museum administration: administration is solely the responsibility and the prerogative of the director.

The board is ultimately and legally responsible and accountable for all that the museum does. This has become a serious consideration. A detailed examination of legal matters must be sought in a book or a training course on museum administration;[2] we merely make some salient observations here.

An underlying cause for concern about legal matters is that we Americans have become a litigious society. People today are much more willing to force proper behavior of individuals or organizations or to seek compensation for damages through the courts than was formerly true. One might cite only the instance of the young man in Colorado who sued his parents for not bringing him up properly. All parents breathed a sigh of relief when a matter-of-fact judge threw the case out of court, ruling that no family is perfect. A little later, however, the Washington State Supreme Court ruled that a child could sue his or her parents for physical neglect.

Our general tendency toward litigiousness has developed together with a decline in traditional protection from legal peril, the "doctrines of immunity." Now, charitable—public service—organizations (and assorted individuals) and governmental employees are no longer immune to attack in the courts for the results of their official activities.

Certain federal laws—sometimes paralleled or supplemented by state laws—have made it illegal for museums to discriminate against minority groups, the physically and mentally handicapped, women, and the elderly, in regard to employment and public services. To give only three illustrations, a museum may not show bias against women in its exhibits; may not, in usual circumstances, refuse to hire a person

2. Consult the publication lists of the professional organizations (American Association for State and Local History, American Association of Museums, etc.). For a correspondence study course in museum administration, address: Correspondence Study, University of Idaho, Moscow, Idaho 83843.

because he or she must use a wheelchair; must not fail to provide alternate interpretation for persons who, because of blindness, deafness, or other handicaps, cannot receive the interpretation in exhibits or programs provided for the general visitor. It has been legally established that the museum's board of trustees has a *fiduciary* responsibility to the public (holding public assets in trust), and therefore must provide protection for the museum's collections and its physical plant.

In regard to boards of trustees, perhaps the most significant legal development in recent years has been the Sibley Hospital Case.[3] That case established clearly the required behavior for boards of trustees: boards must be *diligent,* expending a sincere effort for the good of the museum; non-management on the part of a board of trustees is illegal; boards must be *prudent,* using reasonable care and good judgment to make informed, commendable decisions; boards must be *loyal,* avoiding personal gain by virtue of their positions as trustees ("conflict of interest").

One example of the seriousness of our litigious atmosphere is that museum board members now can be sued as individuals, personally, by members or representatives of the public for failing to serve the public properly—for allowing a passerby to fall on an icy sidewalk, for instance, or for allowing squirrels to get into the collections storage room. The only real defense is liability insurance designed to protect all persons associated with a museum, continuing beyond that association, in regard to their behavior as museum employees or associates. Such insurance is reasonable in cost.[4] As a practical matter, a museum director should recommend it to his or her board.

A simple approach to a museum board's legal liability is provided by the "prudent person" rule. In holding a trustee accountable, the courts insist that he or she behave in discharging board duties and responsibilities as a reasonably prudent person would behave in regard to his or her own personal affairs. To illustrate: just as a wise private citizen would not ordinarily keep a large sum of money in a mattress or in a shoe box on a closet shelf, idle and unproductive, so a museum board member would not ordinarily leave large sums of museum funds at low interest rates in bank savings accounts for an

3. Stern v. Lucy Webb Hayes National Training School for Deaconesses and Missionaries, 381 F. Supp. 1003, 1014 (D.D.C. 1974).

4. Such insurance is often advertised in *Museum News.* For a fuller discussion, see Ullberg with Ullberg, *Museum Trusteeship.*

unnecessarily long time; and board members who do so and do not safely invest such museum funds are guilty of malfeasance.

There are many other laws with which museum administrators must be familiar—laws dealing with protected species, importation and exportation, copyright, contracts, taxes, building codes, and so on. An introductory text on museum theory lacks space to list and explain them.

EXERCISES—CHAPTER 21

1. The reader may think of additional legal issues that affect museums beyond the few given in this chapter—such as regulations involving employee and visitor safety; the question of whether a museum sales shop represents unfair competition to local merchants; or the basis on which a museum might lose its tax-exempt status if it has an income from rentals and sales. Discuss the legal aspects of any particular matter pertaining to museums or museum work that you have knowledge of or can imagine.
2. Discuss the problem a museum board has in delegating to its director the authority to supervise the work of the museum for which the board remains legally responsible.
3. In regard to advocacy (taking a stand on social issues), how far should a public museum in your country and your community go?
4. What are advantages and disadvantages of local control of museums versus central control? What if all museums in the United States were branches of or were supervised by the Smithsonian Institution?
5. If you have knowledge of the functioning of a particular museum board, evaluate its performance in terms of its four proper main responsibilities.
6. Imagine instances of the following kinds of unfair discrimination and suggest a way or ways to correct or to avoid them.
 A. In hiring
 B. In building design
 C. In field trips
 D. In exhibits
 E. In public events
 F. In smoking
7. Describe a hypothetical museum board's behavior in violating the standards established in the Sibley Hospital Case. Refer to all three points.

22

Trends and Tomorrow

Museum people who have attended professional meetings and visited a variety of museums over a period of years will have identified a number of trends in museum development. Some of these trends will continue, and some may even be harbingers of the museum of the future. It behooves museum board members and staff to move with the tide and not to lose sight of the needs and expectations of their publics. It also behooves students who are planning on long and successful museum careers to prepare for what museums *will be,* not for what they were. All museum professionals must be computer-literate, for example.

In previous chapters, some of the current trends or developments were mentioned. Professional museums will become more democratic, in the sense of their using the services of and, in turn, serving ever greater sectors of society. Minorities and the handicapped are not to be shut out or ignored. In time, the ignorant, the disaffected, the socially withdrawn, and the mentally ill will be served.

There will be greater involvement of government, more reliance on federal financial support, and eventually a resolution may be arrived at for the problem that is perennial in many parts of the world: the under-funding of potentially valuable museums. That is, either professional museums, like professional schools, might become accepted by the public for regular, adequate support; or the number of museums might be reduced in number, with larger regions giving better support to the fewer museums remaining, to name two possibilities. Older Americans will remember when every small town had its own high school, and *large* schools were to be found only in overcrowded cities. A development already upon us in the United States is the acceptance of competition among museums for grant

money as a normal activity, to be accommodated in staff planning, budget allocations, and space assignment.

Entertaining activities, public programming, theatrical interpretation of and in exhibits, and lessons for children will probably continue to increase. Museum jobs have opened up for teachers, artists, communications majors, and others (that is, for people who are not trained as curators and directors, or even as museologists). Their products—publications, television and other programs, exhibits, activities—must attain higher standards of excellence and entertainment because of increased public sophistication and because of increased competition for the visitor's leisure time: who but a supportive parent would want to go to the museum to watch children dance on a tiny stage, when one might sit at home, comfortably, with one's shoes off, watching professional ballet on television?

We are in a great technological revolution, probably as far-reaching as the food-producing, printing, and industrial revolutions of the past. The informational, electronic, genetic engineering age is upon us. Museums cannot continue to remain important if they ignore this fact. We must join it, not fight it. Video games, science centers, home computers, television by satellite and cable, high-fidelity sound reproduction—these are signposts. A museum that clings to the technology, or the social conscience, of fifty years ago will not amount to much.

It is high time that we developed into a true profession, and that will involve acceptance of an ethical code, standardization of content and examinations for museum studies, limitation of membership in the profession by the accreditation of museum training and the certification of graduates, and even higher standards for museum practice, in keeping with the new times we are entering.

More attention must be paid to efficiency. The allocation of staff, space, and money must be directly proportional to the importance of the product, the favorable changes made in the minds of people. It is not to the credit of the museum profession that few real attempts have ever been made to ascertain what our museums actually accomplish. Related to the efficiency of a country's museums is co-operation across national boundaries. We are one profession in one world. Our international museum organizations and exchanges of people and exhibitions lag behind our needs and our abilities to use co-operation to humanity's benefit. We have so much to learn from each other, so much to share. A museum trainee should think seriously of becoming fluent in foreign languages. Museums and museum organizations must do all they can to support international travel and communication.

Museums today, even before they change greatly, can serve the growing movement for adult or lifelong learning. Museums are less limited than schools and professional museum staffs are allowed more leeway in preparing imaginative public presentations. Museums can become important community and neighborhood educational centers for a wide clientele. Grant money is likely to be supportive of this new emphasis, and its tangible results may achieve greater public commitment than museums now enjoy. Related to expanded museum emphases is the growth of outdoor museums, such as "living history" demonstration historical farms. With vision, such open-air museums could be established everywhere by universities and traditional museums, serving to lend roots to our all too rootless society, preserve skills and ways of life that are slipping out of our grasp, and educate young and old as few techniques can.

Documentation of the present, too, is a worthwhile activity for the professional museum that can accept that social science obligation. The simple fact is that the sources of documentation used by historians leave great gaps concerning the ordinary lives of ordinary people. No other agency today is likely to close these gaps for future historians and social scientists if our museums and historical societies do not do it. The "collecting of today for tomorrow" has become something of a national effort in Sweden and is considered a fundamental museum responsibility in eastern Europe. Such work in North America is practically nonexistent.

The disparity can be related to the development of museology as a science, or at least as a field of study in its own right. The study of museology is less developed in the United States than elsewhere; our orientation to museums seems to be more pragmatically based. Individual museums here seem to concentrate on achieving particular results, goals they have set, and are less interested in relating to museums worldwide according to a philosophical basis. One might ask "What's wrong with that?" What might be wrong is that the goals we set could fall far short of what we ought to be aiming to achieve. It is an interesting difference, one of many perhaps, between East and West. In my view, our museums would become more efficient—more productive and socially valuable—if we moved in the direction of museological science; if our collecting, our research, and our public presentations were better founded, better organized, and used to better purpose.

Eventually, it seems likely that the museum, the archives, the library, the center, the adult and continuing-education schools, and other aspects of our culture will merge, using television, computers,

and marvels not yet dreamed of, to create, store, and disseminate information and education of all kinds. Even should the public professional museum evolve into or be incorporated into a larger, more complex public service agency, however, the museum in the basic sense will continue to exist. Human beings, after all, have a collecting instinct, it would appear. The museum will live, at least, in the individual's personal collection of attractive and interesting objects, and on the public level it will serve as the collecting and preserving branch for tangible documentation. What other institution is concerned with objects as objects? With that orientation, who else, as foreign colleagues might put it, can help to relate humanity to material reality?

EXERCISES—CHAPTER 22

1. If you have some familiarity with museums that has extended over a period of time, what developments or trends have you, personally, experienced? Or, if you do not have such time depth in your museum experience, what aspect of the program, operation, or activities of a museum or museums with which you have some familiarity seems especially outmoded, or by contrast what seems progressive, up-to-date, or even ahead of its time? You may profit by visiting a museum and talking with its professional staff regarding this question.

2. In a museum, a school, a business or in any other organizational situation you have observed, what examples of discrimination against minorities or the handicapped have you seen? If you had the authority and the power to do so, how would you correct such examples?

3. What might a museum do to serve as a community center for continuing education, out-reach, or nontraditional learning? (Many names have been used to describe what is largely one kind of activity, organized teaching outside the school classroom.) Be imaginative. Use an actual museum and community if you can.

4. If you have experienced interpretation at a historic house or site, or at an outdoor museum, describe and evaluate it. Was it a form of "living history?" Did it add to or detract from your enjoyment of the visit and the benefit you derived from it? Can you regard that interpretation as a solid connection with the future of museum work?

5. Documenting of the present was discussed earlier in the book (see page 61). At this point, limit your response to these two questions:
a. Do you see documentation of the present as an important activity of history museums in the future?

b. Where should the responsibility for such collecting, if any, lie—at the national, state or provincial, regional, or local level? Explain your opinions.

6. Look ahead a reasonable length of time (long enough for significant changes, short enough for you to have confidence in your vision). Describe a typical museum of moderate size. You do not have to accept the author's suggestions.

Recommended Resources

No commercial materials have been produced specifically for museum training, but instructors can make good use of items made for other purposes. An occasional television program is worth videotaping to provide a basis for classroom discussion. Over the years, I have made great use of motion pictures, as well as my own slide collection. Most of the films I have used are no longer available, except for the excellent Colonial Williamsburg productions. The motion picture *Museum* (29' color, American Federation of Arts) is useful for illustrating the work of a large art museum; it was made at the Art Institute of Chicago. The Smithsonian Institution has several interesting filmstrips, some general, some technical; and the American Association for State and Local History (AASLH) has a large number of audio-visual teaching aids that instructors and museum staffs should be aware of. AASLH, the American Association of Museums (AAM), and other professional organizations here and abroad issue publications lists that should be in the hands of all museum studies instructors and museum directors.

Finally, the professional journals *Museum News* (AAM), *History News* (AASLH), *Museums Journal* (Museums Association [British]), as well as the publications of regional museum associations, specialized groups, and national and international organizations are of continuing value. All museum professionals and museum trainees are urged to belong to museum organizations at all levels and are encouraged to obtain and use their publications and attend their meetings.

The following publications are suggested as the nucleus of a library for museum work. The museum professional will add more technical and more specialized books as they are needed; and each museum must have, in addition, reference books for the identification of the objects in its collections and for research in the preparing of exhibit interpretation.

I apologize to foreign colleagues for limiting the following list largely to North American publications. Readers elsewhere are urged to acquaint themselves with the publications that are available to them wherever they are. Their

national committee members of the International Council of Museums (ICOM) may be of assistance in that regard. There are, of course, excellent journals and books published in many countries of the world, and the fact that we in the United States make less use of them than they deserve is our loss.

Alderson, William T., and Shirley Payne Low. *Interpretation of Historic Sites.* Nashville: American Association for State and Local History, 1976.
This book makes a good bridge between Tilden's standard work on outdoor interpretation and interpretation in the museum. It does not, however, deal with the latter.

Alexander, Edward P. *Museums in Motion: An Introduction to the History and Functions of Museums.* Nashville: American Association for State and Local History, 1979.
This book helps to place the contemporary museum in the perspective of historical development. Museum studies instructors, please note.

America's Museums: The Belmont Report. Washington, D.C.: American Association of Museums, 1969.
On the nature and conditions of museums in the United States.

American Association of Museums Historic Sites Committee. *An Annotated Bibliography for the Development and Operation of Historic Sites.* Washington, D.C.: American Association of Museums, 1982.

American Association of Museums Committee on Ethics. *Museum Ethics.* Washington, D.C.: American Association of Museums, 1978.

American Association of Museums. *The Official Museum Products and Services Directory.* Washington, D.C.: American Association of Museums, 1982.
A practical aid to museum administration.

American Association of Museums. *The Official Museum Directory.* Washington, D.C.: American Association of Museums, 1982.
Periodically revised, this is the best source of information about the museums of the United States and Canada.

Bazin, Germain. *The Museum Age.* New York: Universe Books, 1967. A very readable and excellently illustrated history of museums.

Brawne, Michael. *The New Museum: Architecture and Display.* New York: Frederick A. Praeger, 1965.
A good, attractive, and illustrated description of some recently built or remodeled art museum buildings in various parts of the world. Useful and stimulating essays on technical matters as well as a long introduction on the theory of planning museum buildings.

Chenhall, Robert G. *Museum Cataloging in the Computer Age.* Nashville: American Association for State and Local History, 1975.

————. *Nomenclature for Museum Cataloging: A System for Classifying Man-Made Objects.* Nashville: American Association for State and Local History, 1978.
Recommended for history museums.

Computers and Their Potential Applications in Museums. New York: Arno Press, 1968.

The Conservation of Cultural Property. Museums and Monuments, Vol. XI. Paris: UNESCO, 1968.
Articles by some two dozen authors on the preservation of a variety of materials, monuments, and sites.

Cummings, Carlos E. *East is East and West is West.* Buffalo: Buffalo Museum of Science, 1940.
An evaluation of the New York world fair of 1939 from a museum point of view.

Daughtrey, William H., Jr., and Malvern J. Gross, Jr. *Museum Accounting Handbook.* Washington, D.C.: American Association of Museums, 1978.
Probably beyond the small operation, but useful for bookkeepers.

Developing the Self-Guiding Trail in the National Forests. United States Department of Agriculture, Forest Service Miscellaneous Publications 968. Washington, D.C.: U.S. Government Printing Office, 1964.

Dudley, Dorothy H., and Irma Bezold Wilkinson. *Museum Registration Methods.* 3rd ed., rev. Washington, D.C.: American Association of Museums, 1979.
The standard reference on registration, cataloguing, preservation, and related matters.

Fall, Frieda K. *Art Objects: Their Care and Preservation.* Washington, D.C.: Museum Publications, 1967; enlarged and revised version, La Jolla, California: Laurance McGilvery, 1972.
A useful summary of techniques for the preservation and handling of a wide range of materials.

Feeley, Jennifer. *Museum Studies Library Shelf List.* San Francisco: Center for Museum Studies, John F. Kennedy University, 1983.
Produced initially as a removable center section of the *Museum Studies Journal* 1, No. 1 (Spring 1983), this first edition is useful and inexpensive. It is an organized listing of more than four hundred publications related to museum work. Address: The Center for Museum Studies, 1717 Seventeenth Avenue, San Francisco, California 94103, or in care of John F. Kennedy University, 12 Altarinda Road, Orinda, California 94563.

Field Manual for Museums. Museums and Monuments, Vol. XII. Paris: UNESCO, 1970.

An authoritative description of expeditions and field collecting in all the natural history fields.

Guldbeck, Per E. *The Care of Historical Collections.* Nashville: American Association for State and Local History, 1972.
The best inexpensive guide to the preservation of all kinds of materials.

Guthe, Carl E. *The Management of Small History Museums.* Nashville: American Association for State and Local History, 1959, 1964.

———. *So You Want a Good Museum.* Washington, D.C.: American Association of Museums, 1957, 1973.
Perhaps the best short introduction to museology.

Harrison, Raymond O. *The Technical Requirements of Small Museums.* Ottawa: Canadian Museums Association, 1969.
The best available source on the museum building; planning, lighting, heating, floors, etc.

Historic Preservation Tomorrow. Williamsburg: National Trust for Historic Preservation and Colonial Williamsburg, 1967.
Subtitled "Principles & Guidelines for Historic Preservation in the United States"; inexpensive introduction to the topic, with bibliography.

Kane, Lucile M. *A Guide to the Care and Administration of Manuscripts.* Nashville: American Association for State and Local History, 1960, 1966.

Keck, Caroline K. *A Handbook on the Care of Paintings.* Nashville: American Association for State and Local History, 1965.
Useful advice for the small museum.

———, et al. *A Primer on Museum Security.* Cooperstown: New York State Historical Association, 1966.
A good summary, including physical security, environmental security, insurance, and related matters.

MacBeath, George, and S. James Gooding, eds. *Basic Museum Management.* Ottawa: Canadian Museums Association, 1969.
Excellent short survey of museology.

Miller, Ronald L. *Personnel Policies for Museums: A Handbook for Management.* Washington, D.C.: American Association of Museums, 1980.
Not for everybody, but a useful guide for the museum director.

Morris, Desmond. *The Biology of Art.* New York: Alfred A. Knopf, 1962.

Murdock, George Peter. *Outline of World Cultures.* New Haven: Human Relations Area Files, Inc., 1975.
Useful for identifying and locating obscure tribal groups; revised periodically.

Museum Studies: A Curriculum Guide for Universities and Museums. Washington, D.C.: American Association of Museums, 1973.
Excellent short guide for instructors and developers of museum training.

Museum Techniques in Fundamental Education. Educational Studies and Documents, No. 17. Paris: UNESCO, 1956.
The UNESCO view of applied museography.

Museums and the Environment: A Handbook for Education. New York: American Association of Museums (Arkville Press), 1971.
The teaching of human ecology by museums through exhibits and activities.

Museums, Imagination and Education. Museums and Monuments, Vol. XV. Paris: UNESCO, 1973.
Twelve articles by 13 authors dealing with education, extension services, "outreach," and applied museography in different parts of the world.

Museums: Their New Audience. Washington, D.C.: American Association of Museums, 1973.

Naumer, Helmuth J. *Of Mutual Respect and Other Things: An Essay on Museum Trusteeship.* Washington, D.C.: American Association of Museums, 1977.
Every director and every board member should read this.

Neal, Arminta. *Exhibits for the Small Museum: A Handbook.* Nashville: American Association for State and Local History, 1976.

———. *HELP! For the Small Museum.* Boulder: Pruett Press, 1969. Subtitled "Handbook of Exhibit Ideas and Methods," offers elementary and practical advice and information regarding exhibit construction.

Nelson, Charles A., and Frederick J. Turk. *Financial Management for the Arts: A Guidebook for Arts Organizations.* New York: American Council for the Arts, 1975.

The Organization of Museums: Practical Advice. Museums and Monuments, Vol. IX. Paris: UNESCO, 1960.
For years, the only thing approaching a textbook in museum training. Articles by museum experts on a variety of topics.

Phelan, Marilyn. *Museums and the Law.* Nashville: American Association for State and Local History, 1982.

Plenderlieth, H. J. *The Conservation of Antiquities and Works of Art.* London: Oxford University Press, 1966.
The standard reference work on preservation. Should be in every museum library.

Rath, Frederick L., Jr., and Merrilyn Rogers O'Connell. *A Bibliography on Historical Organization Practices,* volumes 1-6. Nashville: American Association for State and Local History, 1975–1983.
A multivolume reference series on administration, documentation, interpretation, conservation, historic preservation, and research.

Russell, Charles. *Museums and Our Children.* New York: Central Book Company, 1956.
Very detailed guide to educational programs and activities for children in museums.

Schlereth, Thomas J., editor. *Material Culture Studies in America.* Nashville: American Association for State and Local History, 1982.

Shomon, Joseph J., ed. *Manual of Outdoor Interpretation.* New York: National Audubon Society, 1968.
The Nature Centers Division of the National Audubon Society, 1130 Fifth Avenue, New York, New York 10028, also has other related publications.

Silvestro, Clement M. *Organizing a Local Historical Society.* Madison, Wisconsin: American Association for State and Local History, 1959.

Swinney, H. J., editor. *Professional Standards for Museum Accreditation.* Washington, D.C.: American Association of Museums, 1978.
Probably more than any other single publication, this code of standards for museum work defines professionalism in the United States.

Temporary and Traveling Exhibitions. Museums and Monuments, Vol. X. Paris: UNESCO, 1963.
Thorough treatment of the subject by several authors. Good illustrations.

Tilden, Freeman. *Interpreting Our Heritage.* Chapel Hill: University of North Carolina Press, 1957.
A pioneering, illustrated introduction to outdoor, or park, interpretation.

Ullberg, Alan D., with Patricia Ullberg. *Museum Trusteeship.* Washington, D.C.: American Association of Museums, 1981.
Essential for all museums.

UNESCO Regional Seminar on the Educational Role of Museums. Educational Studies and Documents, No. 38. Paris: UNESCO, 1960.
Definitions and descriptions of all kinds of museums and their programs.

Wittlin, Alma S. *Museums: In Search of a Usable Future.* Cambridge, Massachusetts: M.I.T. Press, 1970.
Recommended for the history of museums.

Index

No separate glossary of museological terms has been included in this book because reference to definitions is given here in the index. Merely find in the index the term in which you are interested. The page or pages on which that term has been defined or used in an important way will be given. Lengthy treatments of main topics are, of course, referred to in the table of contents.